Childe Hassam
An Island Garden Revisited

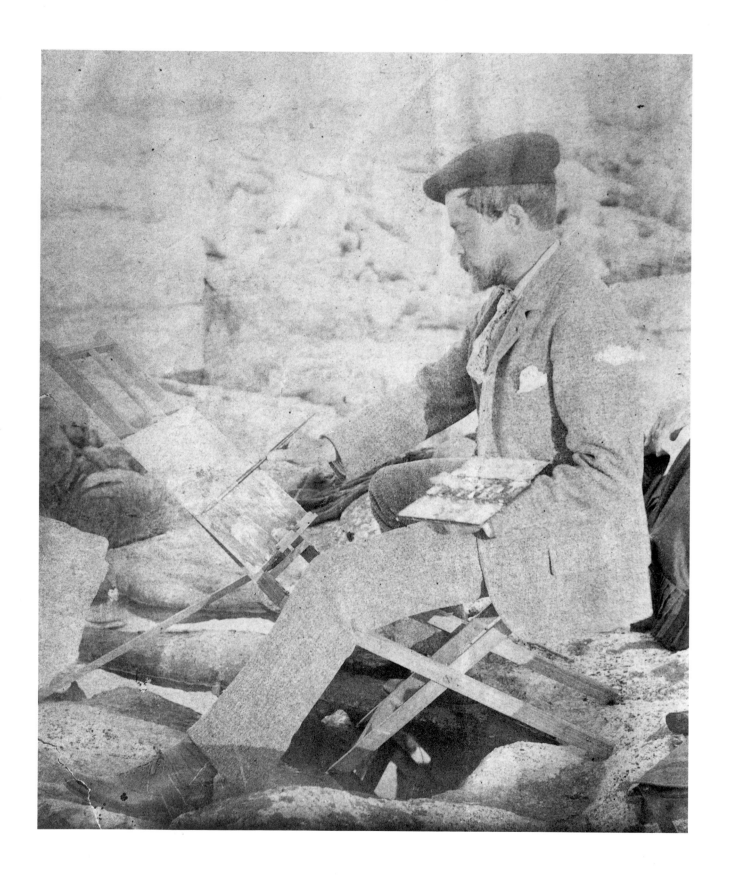

Childe Hassam
An Island Garden Revisited

DAVID PARK CURRY

DENVER ART MUSEUM
in association with
W. W. NORTON & COMPANY
New York London

The text of this book is composed in Monotype Bembo,
with composition by Michael & Winifred Bixler.
Manufacturing by Balding & Mansell Ltd.
Book design by Katy Homans.

First Edition

Library of Congress Cataloging-in-Publication Data

Curry, David Park.
Childe Hassam : an island garden revisited / David Park Curry.
p. cm.
Includes bibliographical references.
1. Hassam, Childe, 1859–1935—Criticism and interpretation.
2. Celia Thaxter's Garden (Appledore Island, Me.) in art.
3. Appledore Island (Me.) in art.
4. Isles of Shoals (Me. and N.H.) in art.
I. Title.
N6537.H367C8 1990
759. 13—dc20
89–77023

ISBN 0–393–02869–0

W.W. Norton & Company, Inc., 500 Fifth Avenue, New York, N.Y. 10110
W.W. Norton & Company, Ltd., 37 Great Russell Street, London WC1B 3NU
1 2 3 4 5 6 7 8 9 0

EXHIBITION ITINERARY:

Yale University Art Museum April 4 – June 10, 1990

The Denver Art Museum July 4 – September 9, 1990

The National Museum of American Art October 5, 1990 – January 7, 1991

COVER:
Childe Hassam
Isles of Shoals, c. 1890
Pastel, 9¾ x 12¼ inches
Private collection,
Courtesy Hirschl and Adler Galleries, New York

FRONTISPIECE:
Childe Hassam painting at Appledore, c. 1886
Photograph
Courtesy the Boston Public Library, Rare Books Department

Contents

Foreword

FOR NEARLY A QUARTER OF A CENTURY, AMERICA'S FOREMOST IMPRESSIONIST PAINTER periodically visited the Isles of Shoals, off the New Hampshire coast. There he created works that are generally acknowledged to be his finest. Yet, while individual pictures from the Shoals number among the most familiar icons in late nineteenth-century American art, the extent and range of Hassam's activity on Appledore may come as a pleasant surprise. Until now, a comprehensive selection of his lyrical Shoals images has not been made available through exhibition.

The Yale University Art Gallery, the Denver Art Museum, and the National Museum of American Art are pleased to present "Childe Hassam: An Island Garden Revisited." We acknowledge with particular gratitude the generosity of the IBM Corporation, which fully supported the exhibition organization as well as special public-education programs at each venue. The Luce Foundation for Scholarship in American Art generously funded the research and publication of this book, which was written by David Park Curry, Deputy Director for Collections at the Virginia Museum of Fine Arts, Richmond, and formerly Gates Foundation Curator of American Art at the Denver Art Museum. He and Helen A. Cooper, Curator of American Paintings and Sculpture at the Yale University Art Gallery, co-organized the exhibition. We would like to thank them both.

Above all, we are profoundly grateful to the lenders, both public and private, who have kindly lent their treasured oils, watercolors, and pastels to our collaborative effort. We hope that an opportunity to view this important body of works, brought together just this once, will in some measure repay them for the temporarily empty spaces on their walls.

Mary Gardner Neill
Director
The Yale University Art Gallery

Louis Inman Sharp
Director
The Denver Art Museum

Elizabeth Broun
Director
*The National Museum of American Art,
Smithsonian Institution*

Acknowledgments

I COULD NOT HAVE REVISITED THE ISLAND GARDEN WITHOUT THE COUNSEL, ASSISTANCE, AND understanding of a host of friends and colleagues. Were Celia Thaxter's parlor still extant, these generous scholars, curators, collectors, and dealers would fill it to bursting, and the evening's conversation would be lively indeed. Lacking a salon, I conversed with them separately, or in small groups, yet each has made a lasting contribution to my study, and I am greatly in their collective debt.

This project belongs as much to Helen Cooper, Curator of American Paintings and Sculpture at the Yale University Art Gallery, as it does to me. I have profited from Helen's unflagging energies, enjoyed the benefits of her discerning eye and her extraordinarily deft loan negotiations, and exchanged with her ideas that significantly shaped the final text. Our hectic travels to look at paintings together were exhilarating and instructive, and her insights greatly strengthened my selection of images for discussion in these pages.

Neither book nor exhibition could have taken final form without the generous participation of Kathleen Burnside and Stuart Feld of the Hirschl and Adler Galleries. Borrowing time from their own busy schedules, they not only provided access to specific works hidden away in private collections, but also gave freely of their connoisseurship, kindly introducing us to whole segments of the Shoals series that are so little published as to have, as yet, escaped general public notice. I have tried to identify these areas in text, captions, or notes, for the whole story by no means appears here, and one hopes that the Burnside/Feld catalogue raisonné on Hassam will soon reach eager readers. In the meantime, I am truly grateful for advance information.

Assembling these fine oils, watercolors, and pastels would have been out of the question had not generous private collectors supported the project from the outset. The leadership of Mr. and Mrs. Arthur G. Altschul of New York immeasurably enriched the ultimate quality of both book and exhibition. Theirs is a long history of unselfishly sharing distinguished American paintings with the public.

The list of names associated with the project threatens to become as long as the old guest register at Appledore House, next door to Celia Thaxter's garden. At the Yale University Art Gallery I am particularly grateful to Paula B. Freedman, Assistant Curator of American Paintings and Sculpture, who contributed heavily to the organization of the exhibition. I would also like to thank Susan Frankenbach and Diane Hart in the registrar's office, Beverly Rogers, secretary, and gallery director, Mary Gardener Neill. Sarah Buie designed the subtle and elegant installation at Yale, while Catharine Waters provided handsome graphics.

At the Denver Art Museum I had the support of three remarkably talented administrative assistants—Jane Fudge, Karen McKelvy, and Shirley Roehrs. Each in turn kept my departmental affairs in order as I worked on the book, and all gathered and organized the material from which it was

finally written. I am also indebted to two volunteers: Virginia Stratton researched questions of garden history, advised me on matters horticultural, and monitored publication permissions. Carol O'Brien dauntlessly undertook the massive task of assembling plates and figures for the book. Lloyd Rule and Cynthia Nakamura provided dependable in-house photographic services. Lori Mellon ably scripted grant proposals that funded the project. To my director and friend, Lewis Inman Sharp, I owe special thanks for his supportive understanding of the processes and pressures entailed by primary research.

At the Denver Botanic Garden I greatly enjoyed working with Bea Taplin, chairman of the board, whose determination flowered in our recreation of Celia Thaxter's island garden. I am also grateful to Gayle Weinstein, Julie Dulapa, Diana F. Hunt, and to Solange Gignac in the library.

Projects of this kind are, by definition, expensive. Research and publication of this book was made possible by a generous grant from the Luce Foundation for Scholarship in American Art. I am indebted to the foundation, led by Robert Armstrong, for the luxury of conducting primary research with full financial support. Grants officer Mary Jane Crook made working with the foundation a genuine pleasure.

The IBM Corporation sponsored the accompanying exhibition. Their immensely generous support enabled us to cover not only the general costs of exhibition organization, but also special educational programs for the public at each venue. We would especially like to thank Richard Borglund.

The National Endowment for the Arts, a federal agency, provided the seed monies that allowed an idea to grow into a book and exhibition. The Endowment also provided special funds for the Denver showing of Hassam's work. My extensive travels for research and exhibition development were further supported by generous grants from Denver Art Museum patrons: Mr. and Mrs. Alvin Cohen, and Mrs. Estelle Wolf. Frederick R. Mayer, chairman of the board, kindly airlifted me to a number of important research destinations.

Many members of the art world encouraged this project, extending their hospitality, sharing their files and records, and allowing us to examine their pictures. We are grateful to them all.

At the Addison Gallery of American Art, Phillips Academy, Andover: Susan Faxon; at the American Academy and Institute of Arts and Letters, New York: Nancy Johnson; at the Art Institute of Chicago: Milo M. Naeve and Anndora Morginson; at the Ball State University Art Gallery: Julia Muney and Brian Moore; at the Baltimore Museum of Art: Sona Johnston; at the Beinecke Rare Book and Manuscript Library, Yale University: Ralph W. Franklin; at the Boston Public Library: Sinclair Hitchings and his staff; at the Brooklyn Museum: Barbara Gallati; at the Carnegie Museum of Art: Gillian Belnap and Diana Strazdes; at Christie's: Jay Cantor; at the Columbus Museum of Art: Steven W. Roesen; at the Corcoran Gallery of Art: Franklin Kelly; at the Dallas Art Museum: Jody Cohen; at the Dayton Art Institute: Bruce H. Evans and Dominique H. Vasseur; at the Detroit Institute of Arts: Nancy Rivard Shaw; at the Fine Arts Museums of San Francisco: Marc Simpson; at the Florence Griswold Museum, Old Lyme: Jeffrey Anderson and Debra Fillos; at the Fogg Art Museum, Harvard University: Jane Montgomery and Phoebe Peebles; at the Grand Rapids Art Museum: Paul W. Richelson; at the High Museum of Art: Judy L. Larson; at the Hirshhorn Museum and Sculpture Garden: Judith Zilczer; at the Honolulu Academy of Arts: James Jensen; at the Houghton Library, Harvard University: Melanie Wisner; at the Indianapolis Museum of Art: Ellen W. Lee and

Robert Yassin; at the Mead Art Museum, Amherst College: Judith Barter; at the Metropolitan Museum of Art: Alice Cooney Frelinghuysen, John Howatt and David Keil; at the Minneapolis Institute of Art: Rosamond Hurrell and George Keyes; at the Montclair Art Museum: Laura Luchetti; at the Museum of Art, Rhode Island School of Design: Christopher Monkhouse, Deborah Johnson, and Laura Urbanelli; at the Museum of Fine Arts, Boston: Theodore Stebbins, Carol Troyen, Trevor Fairbrother; at the National Gallery of Art, the print room and library staffs; at the National Museum of American Art: Emily Bernard, Elizabeth Broun, Cecelia Chin, Joann Moser, Martina Norelli, and Abigail Terrones; at the Nelson-Atkins Museum of Art: Henry Adams, Marc Wilson; at the Newark Museum: Gary A. Reynolds; at the Portland Art Museum: Ruth Cloudman; at the Portsmouth Public Library: Sherman Pridham, Richard Winslow; at the Rose Art Museum, Brandeis University: Carl Belz and Lisa M. Leary; at the Shaklee Corporation, San Francisco: David Chamberlain and Karen Topping; at the Smith College Museum of Art: Linda Muehlig and Ann H. Sievers; at the Smithsonian Institution, Office of Horticulture: Susan Gurney; at Sotheby's: the photography staff; at the Star Island Corporation: Donna Titus; at Strawbery Banke, Inc.: Janet Clark, Karin Cullity, and Robin Mason; at the Toledo Museum of Art: Patricia Whitesides; at the University of New Hampshire, Department of Special Collections: Ronald Bergeron and Gary Sampson; at the Virginia Museum of Fine Arts: Lisa Hummel, Paul Perrot, and Elizabeth Stacy and her staff; at the Walters Art Gallery: William Johnston; at the White House, Office of the Curator: Betty Monkman and Rex Scouten; at the Wichita Art Museum: Barbara Odevseff; at the Worcester Art Museum: Sally Freitag, Joann Carroll, and Susan E. Strickler.

We are also grateful to Warren Adelson; The Archives of American Art; Frank Bartow; Bruce and Nancy Benson; Ara Danikian; the Director Investing Corporation; Charles C. Eldredge; The Frick Art Reference Library; the Gallery of Art, Washington University, St. Louis; Mr. and Mrs. Robin Graham; Allison Greene; Jennifer Groel; Dorothy Haines; Mr. and Mrs. Hugh Halff, Jr.; David Henry; Mr. and Mrs. Raymond Horowitz; the Israel Museum, Jerusalem; Mr. and Mrs. George M. Kaufman; Mary Ellen Ledwith; Raymond Liddell; JoAnne Lyons; Mrs. Jane R. Mayer; Irwin D. Novak; David Orr; Gerald and Katy Peters; Mr. and Mrs. Perry T. Rathbone; Mr. and Mrs. Rodman Rockefeller; Donna Seldin; the Shearson Lehman Hutton Collection; Patterson Sims; Thomas Smith; Steve and Sue Victor; the brothers Vose; the Warner Collection of Gulf States Paper Corporation; Henry Weisblatt; Mr. and Mrs. Brayton Wilbur, Jr.; and anonymous private collectors.

Doreen Bolger, Helen Cooper, Jane Fudge, George Shackelford, Martha Mayer Smith, and Virginia Stratton kindly read drafts of the manuscript, making suggestions that greatly clarified the final text. Jim Mairs at W. W. Norton brought it forth with his usual energy, speed, and skill. I value his guidance and patience during all phases of this book project, and I am also indebted to my perspicacious editor, Patty Peltekos. I also thank our ever-flexible book designer, Katy Homans.

Finally, my deepest thanks to the patient Rebecca. It was she, after all, who watered my plants.

David Park Curry
Curator of Painting and Sculpture, and Gates Foundation Curator of American Art,
The Denver Art Museum December 15, 1989

Lenders to the Exhibition

THE EXHIBITION WAS JOINTLY ORGANIZED BY HELEN COOPER, CURATOR OF AMERICAN Paintings and Sculpture at the Yale University Art Gallery, and David Park Curry, Curator of Paintings and Sculpture and Gates Foundation Curator of American Art at the Denver Art Museum. We acknowledge with gratitude the generosity of the IBM Corporation, whose complete financial support made it possible for us to present approximately fifty of the finest Shoals images at the Yale University Art Gallery (4 April – 10 June 1990), the Denver Art Museum (4 July – 9 September 1990), and the National Museum of American Art (5 October 1990 – 7 January 1991). Additional monies for the Denver showing were provided by the National Endowment for the Arts, a federal agency.

We are indebted to both institutions and private individuals who kindly shared their precious oils, watercolors, and pastels with museum visitors in New Haven, Denver, and Washington. Pictures from the exhibition are designated on a separate list.

Mr. and Mrs. Arthur G. Altschul

The Art Institute of Chicago

The Ball State University Art Gallery

The Baltimore Museum of Art

The Beinecke Rare Book & Manuscript Library, Yale University

The Trustees of the Boston Public Library

The Brooklyn Museum

The Dayton Art Institute

The Director Investing Corporation

Mr. and Mrs. Hugh Halff, Jr.

Mr. and Mrs. Raymond J. Horowitz

The Israel Museum

Mr. and Mrs. George M. Kaufman

Mrs. Jane R. Mayer

The Metropolitan Museum of Art

The Minneapolis Institute of Arts

The Museum of Fine Arts, Boston

The National Museum of American Art
The Nelson-Atkins Museum of Art
The Gerald Peters Gallery
The Portland Art Museum, Portland, Oregon
Mr. and Mrs. Rodman Rockefeller
The Rose Art Museum, Brandeis University
The Shaklee Corporation
The Shearson Lehman Hutton Collection
The Toledo Museum of Art
The Warner Collection of Gulf States Paper Corporation
Mr. and Mrs. Brayton Wilbur, Jr.
The Worcester Art Museum
Private collectors

Our access to privately owned pictures was significantly facilitated by the wholehearted cooperation of the Hirschl and Adler Galleries, New York, whose staff is currently preparing a catalogue raisonné of Childe Hassam's enormous oeuvre, under the direction of Kathleen Burnside and Stuart Feld. We are deeply indebted to them for their openhanded support of this project.

Other dealers who led us to specific works of art include the Adams-Davidson Galleries, Washington, D.C.; the Arvest Galleries, Boston; the Gerald Peters Gallery, Santa Fe; JoAnne Lyons Gallery, Aspen; the Keny and Johnson Gallery, Columbus; the Vose Gallery, Boston; and the Coe-Kerr Gallery; the Graham Gallery; the Spanierman Gallery; and the Richard York Gallery; all in New York City.

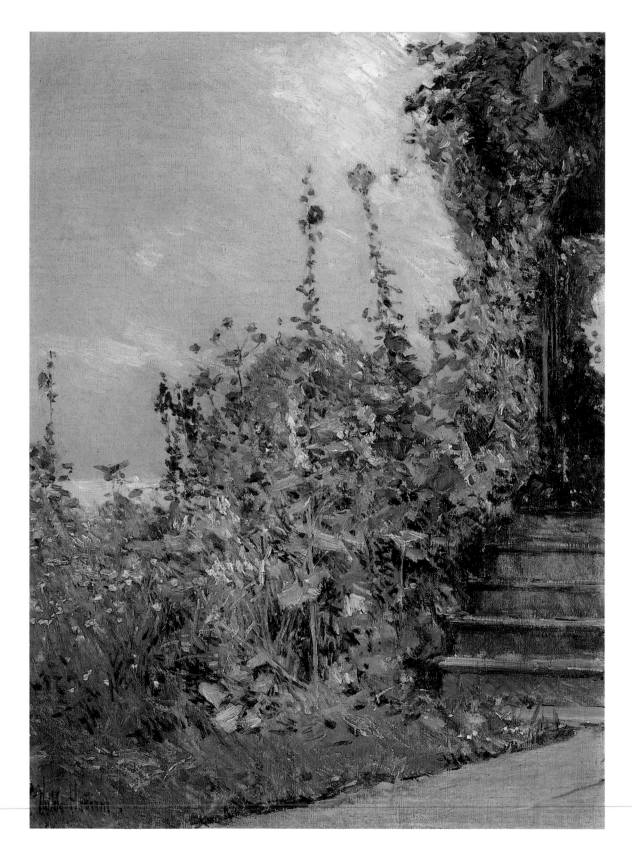

PLATE I
Childe Hassam
Celia Thaxter's Garden, Appledore, Isles of Shoals, 1890–93
Oil on canvas, 13 x 9⁷⁄₁₆ inches
The Warner Collection of Gulf States Paper Corporation,
Tuscaloosa, Alabama, Courtesy Hirschl and Adler Galleries, New York

Prologue: A Summer Place

Appledore is one of the Isles of Shoals. Before the day of the automobile [it was] a famous summer resort. Celia Thaxter made the islands known to a great many—in those far-off days I painted there ... many pleasant summers.

CHILDE HASSAM[1]

In summer places by the sea, the windows and doors ... stand open to every breeze.

BRENDAN GILL[2]

OVER HIS LENGTHY CAREER, FREDERICK CHILDE HASSAM (1859–1935), AMERICA'S FOREMOST impressionist, created a vast oeuvre—nearly four thousand oils, watercolors, pastels, drawings, and prints. Approximately 10 percent of his work depicts the Isles of Shoals, a group of granite outcroppings lying ten miles off the coast of New Hampshire, near Portsmouth.[3]

On these seemingly inhospitable rocks, poet and journalist Celia Laighton Thaxter (1835–94) established an informal salon and cultivated her celebrated garden. A lighthouse keeper's daughter, Thaxter served as an aesthetic beacon, attracting nineteenth-century artists, writers, and musicians to her flower-filled parlor on Appledore Island. From distant Po Hill, on the coast, John Greenleaf Whittier could see the sun flashing off Thaxter's cottage windows, and he mused what Appledore would be without her, "a mere pile of rocks, I imagine, dead as the moon's old volcanic mountains. Thee have given them an atmosphere."[4]

The jewel-like flowers of Thaxter's island garden crowned a remote kingdom whose environment was soothing yet stimulating. The poet herself wrote:

The eternal sound of the sea on every side has a tendency to wear away the edge of human thought and perception; sharp outlines become blurred and softened like a sketch in charcoal ... [5]

Appledore was a place where the imagination could flourish. Inspired by impressions of the parlor's cultured atmosphere, the garden's brilliant color, and the landscape's wild beauty, Hassam executed

some of his most successful works at the Isles of Shoals, where he conducted periodic summer painting campaigns from the mid-1880s until about 1916. The finest Shoals images, created between 1889 and 1912, coincide with the full flowering of Hassam's powers as a painter (Plate 1).

Native New Englander Brendan Gill began his book *Summer Places* with this thought:

> *In our northerly climate, summer is but one of four seasons—a matter of a few delectable weeks of sun and flowering—and yet I doubt if I am alone in finding that my memories of summer are far more numerous, as well as far more vivid, than my memories of any other season. It is a time of adventure, of taking chances, of letting go.*[6]

Fresh and invigorating, the Isles of Shoals pictures stand out vividly against Hassam's huge body of work as a whole. Memories of long-gone summers reach across the years, for his best pieces are still charged with the artist's sense of adventure as he took chances with composition, let go with color. Seeking his own voice, the young Hassam was as yet open to new ideas, and his paintings offer a concentrated sampling in which oft-made generalizations about the sources, aims, and methods of late nineteenth-century American art can be better understood.

While Hassam's French connection was recognized so early in his career that any reference to Claude Monet became an annoyance to him, impressionism was but one of three strong currents flowing through his art. Two others surged up earlier: popular culture made familiar through Hassam's work as an illustrator; and the lessons of early nineteenth-century British landscape painting, reinforced by the artistic leanings of Boston during the 1860s and 1870s, and furthered by Hassam's travels to England in the 1880s. Oils, watercolors, and pastels painted at the Shoals are energized by the artist's sensuous embrace of light and color effects, but they also reveal his efforts to maintain a balanced synthesis between line and color. His attention to subjects from modern life as well as purely artistic concerns reflects a knowledge of both English and French art theory, making the Shoals pictures particularly instructive. Not all his work bears the stamp of conviction with which he recorded the colorful flowers and rocks of Appledore on canvas or paper.[7] The fruits of Hassam's labors there divide neatly into several groups. The earliest dated works include a single concentrated series of lighthouse images, painted in watercolor in 1886, on the eve of his departure for Paris.[8] Fresh from a three-year stint in the French capital, Hassam returned to the Shoals, creating lavish images of Thaxter's flowers from 1889 until 1894. He also illustrated her book, *An Island Garden*, which appeared in 1894, the year of her death.

For Hassam, the Isles of Shoals kept their allure long after Celia Thaxter died. He told his associate J. Alden Weir that "the place is filled with ghosts," but he continued to summer on Appledore until 1916, refreshing himself both physically and mentally. Hassam found that "the rocks and the sea are the few things that do not change and they are wonderfully beautiful."[9] At the turn of the century, he undertook a third extended series of images, this time depicting the resort beyond Thaxter's

garden fence. As the years went by, Hassam concentrated increasingly on the island's rocky terrain, lapped by the waters of the Atlantic.

Withdrawal and isolation allow time for reflection and experimentation, benefits familiar to those lucky enough to enjoy summer places by the sea.[10] Critics were quick to recognize the vitality of Hassam's images of the Shoals, painted far away from the hustle of Boston and New York. One wrote that Hassam's freely executed rock and water sketches were "dashed off as if to loosen up one's muscles for more intense concentration."[11]

Another critic recognized early on that the beauty of the Shoals would endure in Hassam's work, giving

> the world which cannot get to Appledore Island an idea of the peculiar wealth of color which the marine atmosphere, or else some fairy spell of the place, lends to the poppies and marigolds which grow in the poet's garden.[12]

Landscape artists of the late nineteenth and early twentieth centuries were well aware that glimpses of rocks and flowers could be transformed from nature into art. The following text moves from Celia Thaxter's parlor on Appledore, into her garden and out onto the rocks in an effort to chronicle the development and significance of Childe Hassam's paintings of the Isles of Shoals. Many voices fill these pages, for in poetry, prose, history, and criticism, as well as in music and painting, it is possible to revisit the island garden, giving substance to memories of a now-lost summer place.

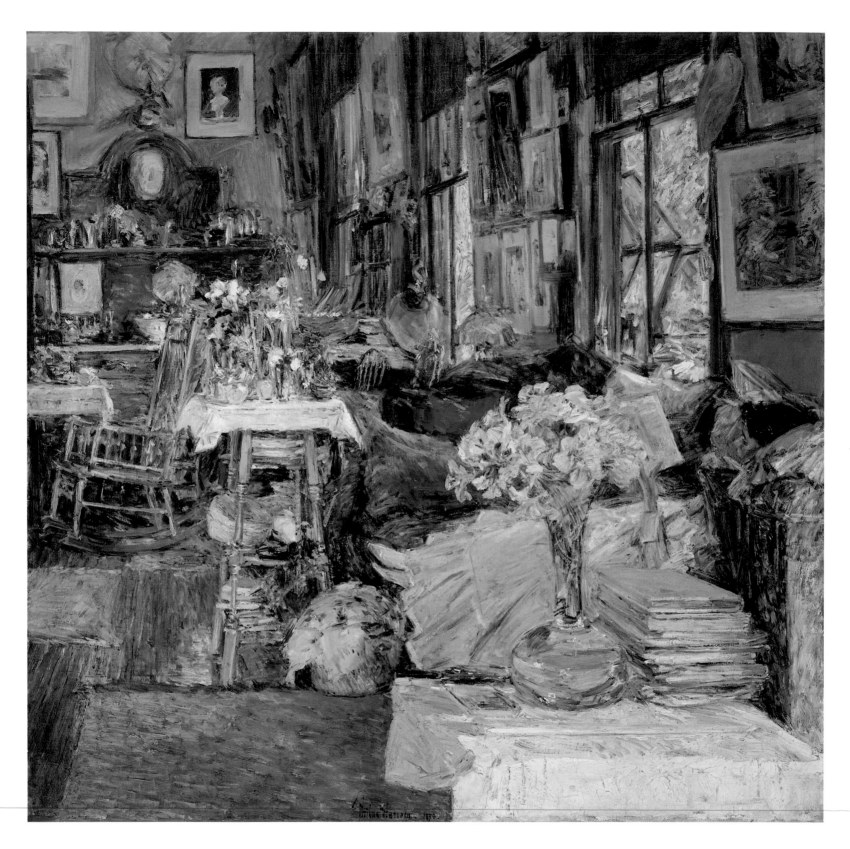

PLATE 2
Childe Hassam
The Room of Flowers, 1894
Oil on canvas, 34 x 34 inches
Mr. and Mrs. Arthur G. Altschul

In Celia Thaxter's Parlor

"Like the musician, the painter, the poet, and the rest, the true lover of flowers is born, not made."

CELIA THAXTER[1]

"Long chords of color . . . filled the room with an atmosphere which made it seem like living in a rainbow."

CANDACE WHEELER[2]

IN THE ROOM OF FLOWERS CHILDE HASSAM LOVINGLY RECORDED AN INTIMATE GLIMPSE OF Celia Thaxter's cottage parlor on Appledore Island (Plate 2). The artist painted the room in 1894, the year the poet died. That same year a Boston publisher brought out Thaxter's last book, *An Island Garden*, embellished with Hassam's illustrations and vignettes.[3]

Lying ten miles out in the Atlantic's watery wastes, Appledore has always been remote. Thaxter's parlor is long gone, swept away by fire in 1914. Her once-famous poetry and prose go virtually unread.[4] Likewise, Hassam's drawings, watercolors, and oils of Appledore Island are scattered to the four winds. But in compelling images like *The Room of Flowers*, the faint perfume of a once heady artistic atmosphere has lingered for nearly a century.

The picture's square format, assertive broken brushwork, and blond palette reveal Hassam as a progressive late nineteenth-century artist.[5] His green and gold color harmony hoists the "greenery-yallery" banner of the Aesthetic Movement, a fundamentally bourgeois decorative arts campaign that, under the slogan "art for art's sake," innocently inaugurated the era of abstract painting.[6] The parlor walls are encrusted with genteel clutter—paintings, photographs, prints, and plaster casts. Light, casually strewn chairs, overstuffed sofas, and teetering stacks of reading material mark the room as a comfortable yet refined haven. In the foreground of Hassam's canvas, half hidden amidst tables laden with flowers, a young woman in white reclines gracefully, glancing through a book.[7] Shadowy grays on the page between the girl's fingers suggest that the book might be illustrated.

One of his most haunting works, *The Room of Flowers* sets out the elements that made Hassam's summer sojourns on the Isles of Shoals among the most fruitful of his long career. We see a

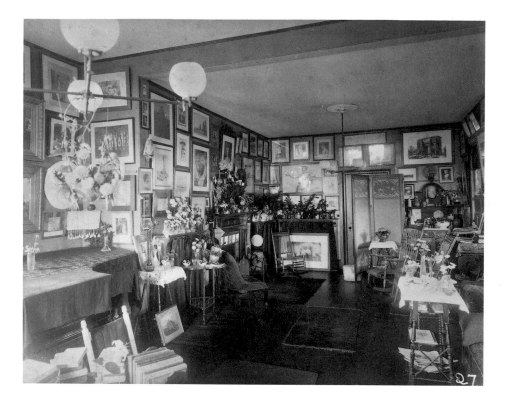

FIGURE I.I
Celia Thaxter's parlor,
c. 1890
Original photograph by
Connor, Portsmouth,
New Hampshire
Collection of
Analesa Adams

high degree of formalism with a strong emphasis upon design. The shimmering palette of gorgeous color has been applied with a vigorous brush to achieve a complex, textured surface. Hassam's facture includes passages both painterly and linear, long thought to be typical of American, as opposed to French, impressionism. Finally, the artist's choice of subject, while traditional, proves on further examination to be rich with subtle meaning.

An old photograph, shot at about the same time Hassam was painting here, gives us a fuller view of the parlor corner. The camera lens takes in details—a Piranesi print, a snapshot of the head of Michelangelo's *David*, a reproduction of Millet's *Sower*. We see an aesthetic screen, a fireplace ornamented with hand-painted tiles, and an imposing grand piano (Fig. 1.1).[8]

Like leaves pressed in a keepsake album, details of Hassam's picture stimulate our collective recollection of an important cultural nexus. In Thaxter's parlor on Appledore Island, artists, writers, and musicians, primarily from Boston, gathered to paint pictures, to tell stories, and to make music. Her remarkable salon, a pavilion in a lavish garden, celebrated progressive art, music, and literature in a beautiful natural environment. Once deemed the "most idiosyncratic watering-place in the Union," Appledore became the prototype for American summer art colonies of the early twentieth century.[9]

As "the Rose of the Isles," Thaxter held summer court on Appledore for over a quarter of a century. In 1894, the year Hassam painted his picture, Thaxter described her room of flowers:

> Opening out on the long piazza over the flower beds, and extending almost its whole length, runs the large, light, airy room where a group of happy people gather to pass the swiftly flying summers here at the Isles of Shoals. This room is made first for music; on the polished floor is no carpet to muffle sound, only a few rugs here and there, like patches of warm green moss on the pine-needle color given by the polish to the natural hue of the wood. There are no heavy draperies to muffle the windows, nothing to absorb the sound. The piano stands midway at one side; there are couches, sofas with pillows of many shades of dull, rich color, but mostly of warm shades of green. There are low bookcases round the walls, the books screened by short curtains of pleasant olive-green; the high walls to the ceiling are covered with pictures, and flowers are everywhere.[10]

In *An Island Garden*, Thaxter evoked the fleeting charm of her luminous chamber, afloat on a floral sea:

> All summer long within this pleasant room the flowers hold carnival in every possible combination of beauty. All summer long it is kept fresh and radiant with their loveliness,—a wonder of bloom, color, and fragrance. Year after year a long procession of charming people come and go within its doors, and the flowers that glow for their delight seem to listen with them to the music that stirs each blossom upon its stem.[11]

Horace Greeley admired "Mrs. Thaxter's pen pictures."[12] Her intoxicating prose, full of finely wrought, multihued passages, still can mesmerize the modern reader. Nathaniel Hawthorne called Celia Thaxter the island "Miranda."[13] And under her seemingly magical aegis, Hassam's lifetime devotion to the beautiful in art set deep roots and began to blossom.

The Shoals were especially congenial during a period when rapid urbanization caused a general, somewhat uneasy turning towards rural subject matter and a longing for the supposedly more innocent past. Isolation permitted focus, and the consistent availability of specific subjects from nature —flowers, rocks, water—allowed the city-dwelling Hassam to experiment in peace, incorporating into his own artistic vocabulary the various stimuli he had felt on his travels. Hassam's periods of summer residency at the Shoals intertwine with his formative travels to Europe in the 1880s and 1890s, when he encountered examples of English and French art that helped chart the course, as we will see, for his unique brand of American impressionism.[14]

Thaxter's childhood on these lonely rocks fostered an untrammeled, intuitive approach to life. She and her brothers spent their early years among the Isles of Shoals, with no other playmates save each other and few playthings beyond the islands' outcroppings, flora, and fauna. Thaxter herself remembered her childish delight in springtime, "as the first blades of grass . . . pricked through the soil. . . . Better than a shopful of toys they were to me!"[15]

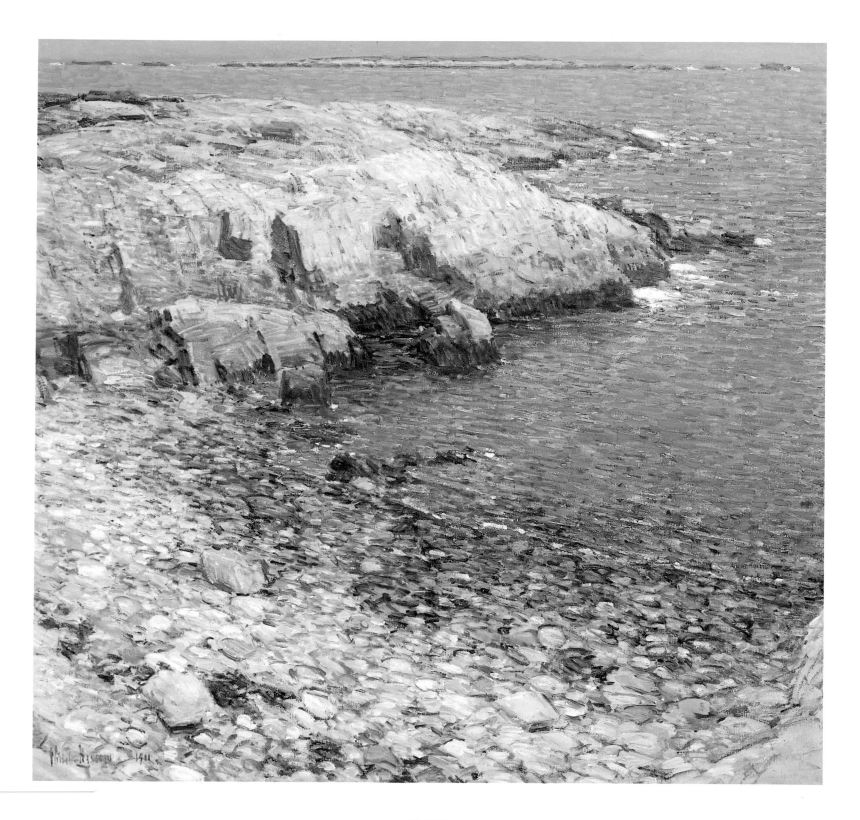

PLATE 3
Childe Hassam
Isles of Shoals, Broad Cove, 1911
Oil on canvas, 34½ x 36 inches
The Honolulu Academy of Arts,
Purchase and gift of Mrs. Robert P. Griffing, Jr., and Miss Renee Halbedl, 1964

As Celia's imagination flourished, her powers of observation grew sharp and discriminating. When they were grown, her brother Cedric wrote to her of the landscape a stone's throw from her parlor (Plate 3):

> *Everything reminds me of you today. The ocean is swept by a gentle north wind; as I write I can look from the window down to Broad Cove, where we have gathered . . . mosses . . . so many times together [and to] Norwegian Cove [where] you used to reach down into deep ponds at the risk of tumbling in yourself, after precious specimens of green moss. I think of the wonderful fairyland over at Neptune's Hall, where we used to imagine we saw magic rings drawn in the grass, where the fairies used to dance and sing, as we thought.* [16]

"To the heart of nature must one be drawn in such a life," Thaxter said, and one of her biographers noted, "The development wrought in her eager character by those early days of exceptional experience gives a new sense of what our poor humanity may achieve, left face to face with the vast powers of nature." [17]

Celia and her family removed to the Shoals in 1839, when her father, Thomas Laighton, purchased four of the islands, including Hog Island, which he renamed Appledore. [18] He served as keeper of the White Island Light for six years, and eventually became interested in trying to revive the fishing industry, moribund on the Isles since the eighteenth century. He also hoped to create an off-shore resort hotel.

In partnership with Levi Thaxter, a well-connected Harvard graduate, Celia's father founded Appledore House in 1847. [19] It opened to the public on June 15, 1848, and flourished for nearly half a century (Fig. 1.2). [20] A mutual friend wrote that Thaxter and Laighton

> *have bought the most beautiful of the islands; are going to bring it under cultivation, have a board-ing-house for invalids and aesthetic visitors, and do something to civilize the inhabitants of the other islands.* [21]

By the time the two partners erected Appledore House, the Isles of Shoals already had a lengthy history. French explorers sited the Shoals as early as 1603. In April, 1614, Captain John Smith visited the islands shortly before his encounter with Pocahontas on the mainland. For a time, this "many of barren rocks" bore his name. [22] Between 1615 and 1620, the Isles of Shoals became the center of the fishing industry in America. The islands were well situated, but not particularly hospitable. A few years after Captain Smith's visit, Christopher Levett complained, "upon these Islands I neither could see one good timber-tree nor so much good ground as to make a garden." [23] A prognosis for the glorious flowering that Hassam was to paint several centuries later couldn't have been less encouraging. In 1778 most of the Shoalers migrated to the mainland, and from the revolutionary war until the mid-nineteenth century, the population dwindled to almost nothing. [24]

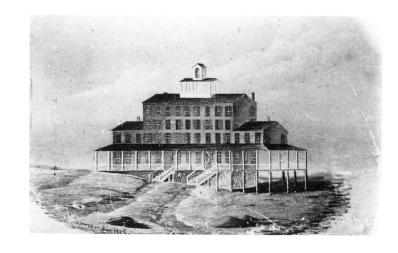

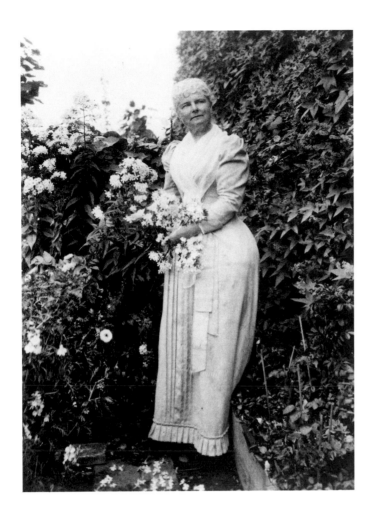

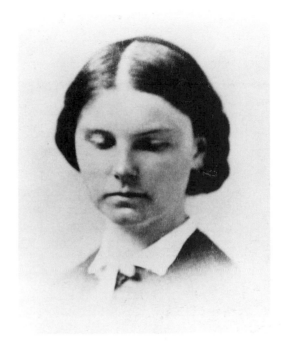

FIGURE 1.6
Celia Thaxter in her
garden, 1887
Photograph
Courtesy Rosamond
Thaxter

FIGURE 1.7
Celia Thaxter at age 15
Photograph
Courtesy Rosamond
Thaxter

Laighton's efforts to revive the fishing industry did not amount to much, but his idea for a hotel did. His ambitious concept evolved into the first significant off-shore resort hotel in America. He added a north wing in 1859 and a south wing in 1872 (Fig. 1.3). Laighton eventually installed such amenities as a floating dock, bathing pool, tennis courts, and bowling alley (Fig. 1.4).[25] A rival hotel opened on nearby Star Island in 1873, but by 1877 the Laighton family had acquired that property and was operating both hotels. In its heyday, the Shoals accommodated several hundred guests at a time. Hassam would have pursued his painting campaigns on the Shoals in complete comfort.[26]

Advertising copy extolled the virtues of this "ideal summer resort of the Highest class" (Fig. 1.5). Although only sixty miles away from Boston, the Shoals offered fresh air, peace, and quiet: "No noise. No dust. No Trolleys," proclaimed a typical broadside. The invigorating climate, intriguing rock formations, and wild vegetation attracted a host of visitors: "A rest cure in these isles is a thing of joy. The climate is perfect. The sunsets glorious."[27] These attractions were not lost on Hassam,

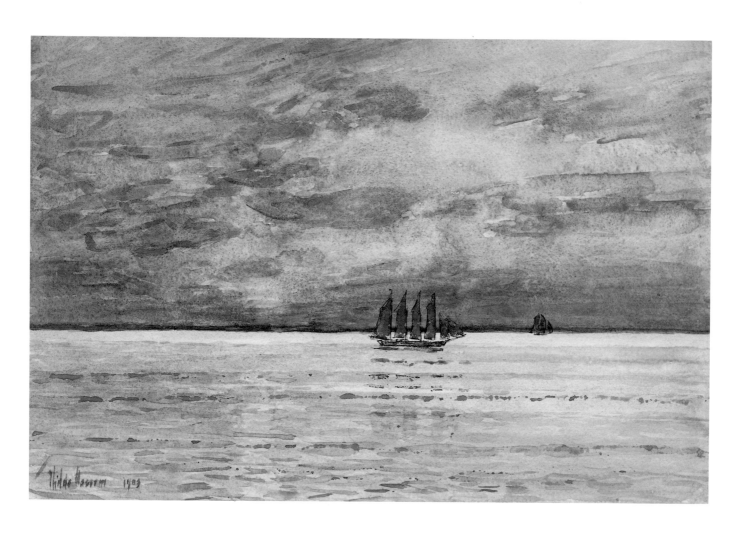

PLATE 4
Childe Hassam
Fourmaster Schooner, 1903
Watercolor, 13 ½ x 19 inches
The Gerald Peters Gallery, Santa Fe, New Mexico

whose luminous watercolor, *Fourmaster Schooner* bears witness to the truth in Shoals advertising (Plate 4).

Romantic legends of pirates, ghosts, and treasures clung like moss to the rocks of Appledore and the other islands. They were "full of historic associations" as the poster promised. But for the select few—the aesthetic visitors—Appledore's brightest attraction went unannounced save by word of mouth. It was Celia Thaxter's informal salon:

> *For many years the group of musicians, artists, literary people and their friends have made a famous circle at Appledore. Although many features are similar to a winter drawing room, the surroundings give a peculiar charm to the place, and the hostess makes the needed force to hold and attract the different visitors. Since practical America has not too many salons for the cultivation of the higher things, it is pleasant to think of the long time appreciation of poetry and art of Appledore.*[28]

When Hassam made his first voyage to this American Cythera in the mid-1880s, Thaxter was well established, at the height of her intellectual power and critical acclaim (Fig. 1.6). A visitor recalled her appearance:

> *She wore light grey or white dresses, usually made simply and according to her own style, not changing with the prevailing fashions. She nearly always wore a soft white kerchief fastened with an old-fashioned brooch. Her hair was very white, her eyes very blue, and her cheeks very pink; and she had an adorable smile which lighted up her whole face when she greeted you. I fell in love with her at once, of course. . . .*[29]

The poet had always been a beauty (Fig. 1.7). In 1871 the writer C. T. Young made this comment:

> *Celia Thaxter was, I sometimes think, the most beautiful woman I ever saw, not the most splendid nor the most regular in feature, but the most graceful, the most easy, the most complete—with the suggestion of perfect physical adequacy and mental health in every look and motion. She abounded in life, it was like breathing a new life to look at her.*[30]

Levi Thaxter certainly thought so. A man "of birth and education," an ornithologist and Robert Browning scholar, Thaxter acted for a time as Celia Laighton's tutor.[31] Thomas Laighton's wellborn business partner may have been an unlikely hotelier, but he proved an ardent suitor. Thaxter married the considerably younger Miss Laighton in September 1851.[32] The marriage gained the bride access to the Boston/Cambridge literati.[33] Her own career began a decade later with publication of a somewhat melancholy poem, "Landlocked," in *The Atlantic Monthly* (see Fig. 1.11).

Despite her marriage and her three children, Thaxter continued to help her mother and brothers run the Appledore House during the summertime. In the early days of the hotel, distinguished guests included Henry Ward Beecher, Thomas Wentworth Higginson, Richard Henry Dana, and

Nathaniel Hawthorne. The watercolorist Ellen Robbins, who eventually occupied a studio on the island, was Levi Thaxter's cousin. William Morris Hunt was Thaxter's best friend. Celia recalled Hunt's drawings "pinned up against the parlor wall, which was like a wondrous scrapbook."[34] Hunt's last work of art was an Appledore drawing, and he met his untimely end by drowning in the reservoir behind the hotel.[35]

The Thaxter family's prominence, and more importantly Mrs. Thaxter's engaging personality, insured that writers of the stature of William Dean Howells and Sarah Orne Jewett found time to vacation on Appledore. So did Thomas Bailey Aldrich, James and Annie Fields, Lucy Larcom, James Russell Lowell, James Whitcomb Riley, Harriet Prescott Spofford, and Harriet Beecher Stowe. Frances H. Burnett named her character Little Lord Fauntleroy after Celia's brother Cedric.[36]

John Greenleaf Whittier was a special friend to Celia, and they corresponded frequently. The charm of the hostess beams from her letter recalling Whittier's visit to her garden. "Poppies nodded their scarlet heads between the rails" and "How good you were to let me put flowers in your buttonhole," she wrote.[37] Much later Hassam recalled meeting Whittier as "a very old man" in Celia Thaxter's parlor.[38]

Artists William Trost Richards and Alfred Thompson Bricher painted at the Shoals. So did Olaf Brauner, Ignaz Gaugengigl, and others.[39] Writers and painters shared with musicians an interest in rural summer pleasures, and counterparts to the pictures can be found not only in literature, but also in music. Julius Eichberg, William Mason, John K. Paine, and Ole Bull were among the musicians to visit Appledore.[40]

Hassam's trips to the Shoals overlap with those of watercolorist Ellen Robbins as well as his friends and fellow painters J. Appleton Brown and Ross Sterling Turner. Brown and Turner appear in an old photograph from 1889 along with two pianists and a singer (Fig. 1.8).[41]

In Thaxter's parlor, reproductions of old masters were interspersed with contemporary art of the era. She was not immune to the charms of "the Divine Guido," that most popular of Italian Baroque painters during the Victorian era. A reproductive engraving of Guido Reni's *Aurora* is typical of the paintings she mentioned early in her correspondence.[42] Over the years, her collection continued to grow, and it widened in scope. "The room is so charming! There are thirty-two pictures in it now," she wrote with satisfaction in 1874.[43] Many of the artists who sojourned at the Shoals gave Thaxter original drawings, watercolors, and oils to add to her reproductions. Childe Hassam's stark image of the White Island Light hung directly under a print of Millet's oil, *The Sower* (Fig. 1.9).

At the time, Millet's picture was considered an example of naturalism on an epic scale, imbued with radical social ideas and unsettling political overtones. *The Sower* was open to multiple interpretations: as noble peasant, as antidote to the evils of industrialization, as performer of either biblical act or political gesture. One version of the oil painting belonged to William Morris Hunt, a frequent guest at Appledore House.[44] Such a picture would have stimulated lively discussion in the parlor.

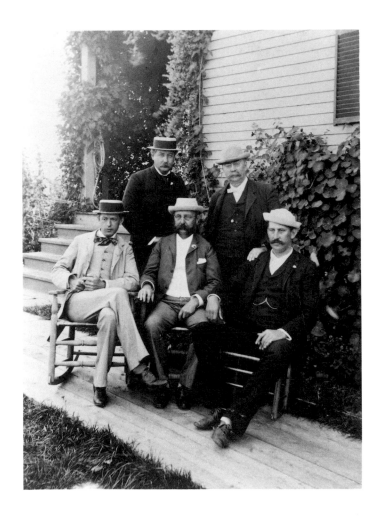

FIGURE I.8
Artists and musicians at
Appledore, 1889
Photograph
Collection Rosamond
Thaxter
standing: Ross Sterling
Turner (l); William
Mason
seated: J. Appleton
Brown (l); J. K. Paine,
William Winch

FIGURE I.9
Jean François Millet
The Sower, 1850
Oil on canvas
40 x 32½ inches
Courtesy Museum of
Fine Arts, Boston,
Gift of Quincy Adams
Shaw through Quincy A.
Shaw, Jr., and Mrs.
Marian Shaw Haughton,
1917

In about 1888, a reporter saw the "walls literally covered with pictures and hung this season with new flower pieces by Ellen Robbins and Ross Turner."[45] But if we compare still lifes by Ellen Robbins and Childe Hassam, it is easy to see why Hassam's works are the ones most vividly remembered today (Plates 5, 6).[46] The harsh edges and forthright local color of Robbins' carnations and poppies seem austere set against the subtle tonalities and color gradations of Hassam's voluptuous bowl of yellow roses.

Whatever their talents, the creative people who gathered around Thaxter received full measure of her enthusiasm:

> *Artists who sang to her, or those who rehearsed the finest music on the piano or violin or flute, or those who brought their pictures and put them before her while she listened,—they alone . . . understood what these things signified, and how she was lifted quite away by them from the ordinary level of life. They were inspired to do for her what they could seldom do for any other creature. . . .*[47]

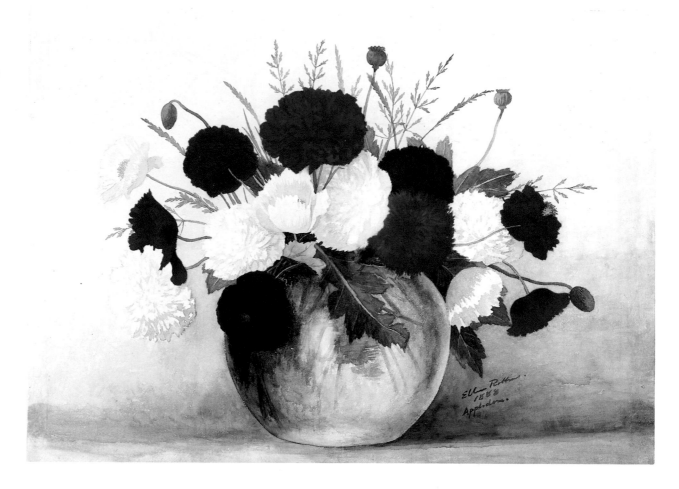

It was hard not to be drawn into her magic circle. She wrote:

> *Professor Paine, you know, of Harvard,—happened to come here,—came for a week and stayed six and more; and though he did not intend to play, and I never asked him, he found out how much it was to me, and played to me hours every day.* [48]

Thaxter's warm welcome reached out especially to young artists. She wrote to Hassam's contemporary:

> *J. Appleton Brown, where are you? There are two young lady pupils down here for you. . . . And J. K. Paine is playing Beethoven sonatas morning, noon and night in my little parlor, divinely, oh divinely! . . . Are you not coming? It is too beautiful and you ought to be enjoying it.* [49]

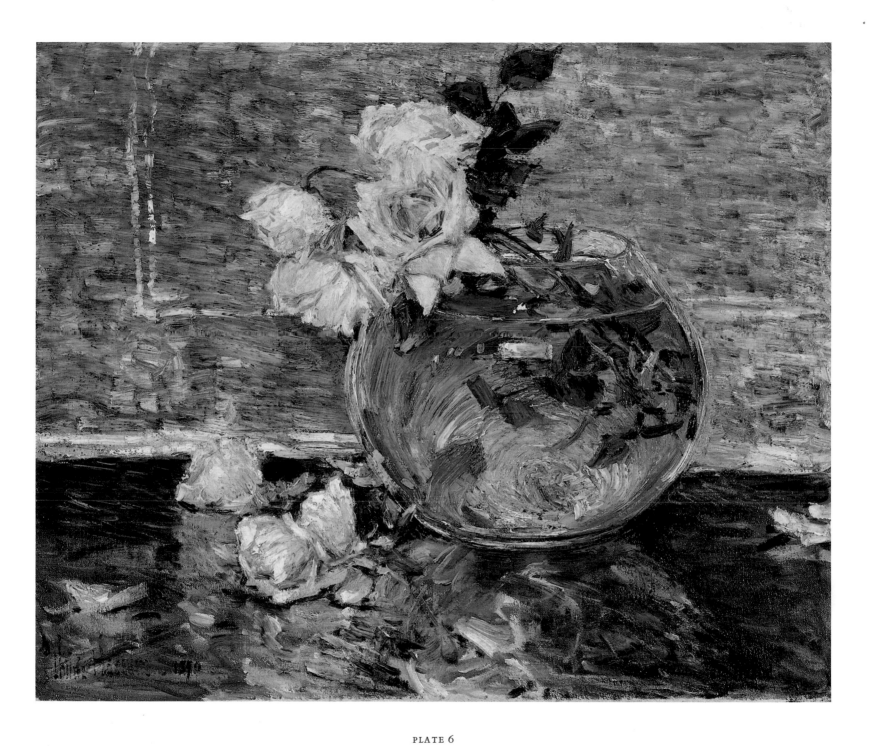

PLATE 6
Childe Hassam
Roses in a Vase, 1890
Oil on canvas, 20 x 24 inches
The Baltimore Museum of Art, the Helen and Abram Eisenberg Collection, 1967

FIGURE 1.10
Tourist rowing near
bathing sheds, Appledore,
c. 1900
Photograph
Courtesy private
collection

Youthful enthusiasm infuses Hassam's most compelling Shoals pictures, and is also evident in his few written references to the islands:

> *Do come over here! now! quick! Laurence Hutton is here with a lot of letters of Mark Twain's.—and Mrs. Thaxter's garden is beautiful, perfectly beautiful.*[50]

Thaxter's granddaughter recalled Hassam's high spirits:

> *On one occasion . . . Childe Hassam and Appleton Brown greatly annoyed a most temperate fellow artist, Levi's cousin Ellen Robbins, by sneaking into her studio and filling her Franklin stove with empty champagne bottles. She was not amused when, the next damp day, she tried to light her fire and was choked by smoke.*[51]

The dashing young artist was not above flirting with female guests at Appledore. One recounted, "Hassam is *so* jolly," and retailed to her friend the artist's mischievous dalliance with her sister: "Just imagine, the next thing we shall read in the *New York Tribune* that Martha Walther and Childe Hassam have *rowed* to England . . . These sea-side resorts are really dangerous."[52]

Thaxter was down-to-earth and full of spunk, the perfect match to the creative young people

who surrounded her. Despite her exalted acquaintances, she was quite able, as she ruefully admitted, to "read Dante and peel squash."[53] In one letter she reveled in simple pleasures (Fig. 1.10):

> *This is what I enjoy! To wear my old clothes every day, grub in the ground, dig dandelions, and eat them too, plant my seeds and watch them, fly on the tricycle, row in a boat, get into my dressing-gown right after tea, and make lovely rag rugs all the evening, and nobody to disturb us, this is fun!*[54]

Considerably older than Hassam, Thaxter was one of his earliest muses. Although she speaks little of Hassam in her correspondence, Thaxter wrote several exalted sonnets charged with admiration for his talents as a painter. One reads in part

> *A crescent with its glory just begun,*
> *A spark from the great central fires sublime,*
> *A crescent that shall orb into a sun,*
> *And burn in splendor through the mists of time.*[55]

Thaxter's poetic conceit might seem inept unless we realize that she was writing of plants as well as planets. The crescent refers to a marigold seed which would bloom as a "full-rayed orb."[56] The crescent also relates to a cipher Hassam sometimes placed above his signature. It looks rather like a crescent moon, similar to the ornament Thaxter often wore in her hair.[57] Thaxter's metaphor probably informs his choice of cipher.

Thaxter and Hassam had much in common. At the time they became acquainted, both poet and painter were, in a sense, popular artists. It was she who convinced him to drop his mundane first name, Frederick, becoming the far more exotic "Childe Hassam."[58]

Thaxter made much of her living by writing for periodicals, and a number of her art projects were frankly commercial.[59] The practical Yankee poet wrote briskly to her publisher:

> *Will you be kind enough to put in a word about the selection of the paper on which [my poems] are printed, that it shall be firm enough to take kindly the water-colors with which I illustrate the volumes.*[60]

She illuminated copies of her own writings by hand, offering them for sale. On a copy of "Land-locked," green leafage and periwinkle blue blossoms recall dried flowers that sometimes fall from a yellowed envelope postmarked Appledore (Fig. 1.11).[61] And, however clumsy her execution, Thaxter precisely caught the evanescent red-orange blush of a New England coastal sunset. Her sketchy images quite literally amplify the text: "O wistful eyes that watch the steadfast hill, longing for level line of solemn sea!" The sheet typifies Thaxter's interest in illuminated texts, and presages her eventual collaboration with Hassam on illustrated verses and stories.

Hassam also looked to the popular press for part of his livelihood. Like many important American painters, he started his artistic career as an illustrator (Fig. 1.12). After one-man shows in

FIGURE 1.11
Celia Thaxter
"Landlocked," 1880s
Manuscript, illuminated
with watercolor
By permission of the
Houghton Library,
Harvard University

FIGURE 1.12
Childe Hassam
*Church Point, Portsmouth,
New Hampshire*, 1883
Gouache
Private collection,
Courtesy Hirschl and
Adler Galleries, New York

FIGURE 1.13
After Childe Hassam
On the Beach, 1884
Woodcut
From Celia Thaxter,
*Idyls and Pastorals: A
Home Gallery of Poetry
and Art*, Boston, 1886

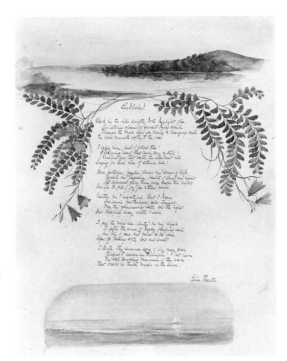

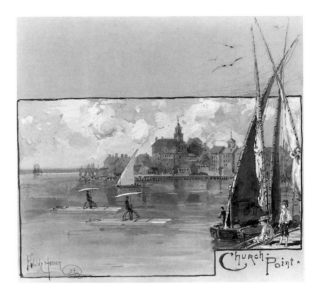

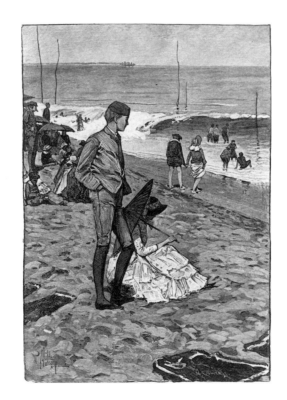

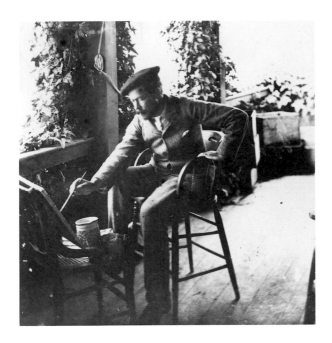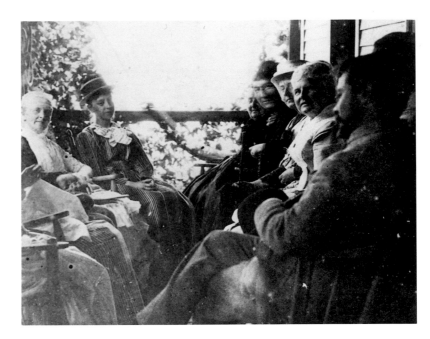

1882 and 1883, Hassam also began to enjoy a reputation in the Boston area for watercolors. However, he continued to create illustrations long after turning to easel painting.

Hassam's talent as a watercolorist provided his initial entrée into the circle of artists, writers, and musicians who gathered in Thaxter's Appledore parlor. Artist and writer met at some point around 1880. Thaxter was studying painting in Boston with Ross Turner. And sometime between 1883 and 1885, Hassam served briefly as Thaxter's substitute teacher.[62] It was not long before Hassam was providing free-lance illustrations for some of Thaxter's publications, and he continued to do so until the poet's death in 1894.

His image of young people at the seashore accompanied Thaxter's poem "On the Beach," published in 1886 (Fig. 1.13). Typically for her, Thaxter's poem contrasts the ocean's seemingly innocent appearance with its hidden power, but Hassam's illustration prefigures the leisurely nature of his entire Shoals experience: "Amid its frolic foam and scattered spray . . . The tired dwellers of the city play . . ." Hassam chose almost uniformly pleasant subjects. Whenever at the Shoals, he submerged himself in a "sweet summer dream."[63]

A photograph, probably taken by Thaxter's son Karl, shows Hassam painting a watercolor on the porch just outside the parlor (Fig. 1.14). Although the precise date of Hassam's first trip to Appledore remains uncertain, he had traveled to the Thaxter farm in Kittery, Maine—only ten miles from the Shoals—by October of 1881.[64] Hassam may have visited the Shoals by 1884.[65] He was clearly at ease on Appledore by 1886, when Karl photographed him on the porch, seated next to Celia and surrounded by other guests, including his wife (Fig. 1.15).

FIGURE 1.14
Karl Thaxter (attributed)
Childe Hassam painting a watercolor on the porch of Celia Thaxter's home on Appledore, c. 1886
Photograph
The Worcester Art Museum, Gift of Rosamond Thaxter, 1969

FIGURE 1.15
Karl Thaxter
Childe Hassam and ladies on Celia Thaxter's porch, c. 1886
Photograph
Courtesy Rosamond Thaxter
Seated, l to r: Mrs. Hepworth, Amy L. Stoddard, Miss Charlotte Dana, Mrs. Childe Hassam, Mary G. Stoddard, Celia Thaxter, Childe Hassam.

FIGURE 1.16
Childe Hassam
Among the Isles of Shoals,
1890
Oil on canvas
12¼ x 18¼ inches
Private collection,
Courtesy Sotheby's Inc.,
New York

Thaxter's support of her favorite young artists was not limited to uplifting conversation. Thaxter told her erstwhile teacher Turner, who maintained a studio on Appledore:

> *I went up to look at your quarters in the afternoon, they are most pleasant . . . you must not forget to bring frames and mats and have one of your pictures always for sale in my room, on the easel, and others beside. That is the place where they will sell best, because so many eyes will see them.*[66]

We don't have a similar letter between Thaxter and Hassam, but she owned a number of his paintings, including *Among the Isles of Shoals,* obviously titled after one of her most famous books (Fig. 1.16). During their visit in 1890, she gave Hassam and his wife a book of her poems, inscribed, "To my dear Maud and Childe Hassam with the faithful and sincere love of Celia Thaxter." She penned several sonnets, some of them tinged with motherly advice, and these are bound into the book.[67] Thaxter featured Hassam's paintings prominently in her salon. A visitor recalled spending the morning in her parlor and commented, "Childe Hassam has some very fine pictures over there."[68]

The parlor seems to have functioned both as sales gallery and studio:

> *You were not supposed to go up and speak to Mrs. Thaxter when you entered, as she was always busy with her sketching, illustrating her books printed on watercolor paper, which were often sold for fifty dollars before she could finish them. The guests slipped quietly into a cushioned window seat, or an old-fashioned chair, and were soon lost in admiration of some new picture placed upon the easel by the artist for Mrs. Thaxter's criticism, and with the privilege of purchase by the guests. Meanwhile William Mason or John K. Paine would be transporting us into musical heights . . .* [69]

In Celia Thaxter's parlor "the study of nature and art was always going forward either on or around her work-table."[70] As she sat in the company of her aesthetic friends, she steadily illuminated manuscripts or decorated china blanks (Fig. 1.17). Thaxter chose most of her motifs, whether penned or painted, from the rocks and plants that surrounded her on Appledore Island (Fig. 1.18). She queried the poet Thomas Bailey Aldrich whether his wife would prefer

> *a bunch of violets, or a bough of peach blossom, or the grey green olive, or the Roman anemone, or an autumn cluster of crimson wild vine and dead poppy-head and red rose haw, with a sad verse burned in the porcelain, or a peacock green jar with white daisies . . .*[71]

As a young woman Celia had made a scrapbook of island seaweeds (Fig. 1.19). Annie Fields noted that Thaxter's "knowledge of the flowers, and especially of the seaweeds with which she decorated [porcelain], was so exact that she did not require the originals before her vision. They were painted upon her mind's eye."[72] Thaxter was also quite candid about her practical use of design sources:

> *I have painted this winter one hundred and fourteen pieces for different people,—cups, saucers, plates of all kinds, a great deal of immensely careful and elaborate work. Some Japanese things I have been doing are really lovely,—plates, tinted first pale sea-green, and a Japanese lady, a beauty, no clodhopper, in the middle of each, with birds or butterflies or bats or turtles, swallows, dragon-flies, lizards, beetles, any and every thing, on the border, with flowers and grasses or leaves, all copied from the Japanese, not evolved out of my inner consciousness, and so sure to be good.*[73]

In Thaxter's hands, a cup or bowl could become the basis for intellectual exchange. A friend sent her a verse written in modern Greek from Sophocles' *Oedipus at Colonus*: "Watched by the eye of olive-guarding Zeus and by gray-eyed Athena." Thaxter got her husband and son to hunt up the ancient Greek letters, which she then painted on several pieces of china, noting, "This is the way the inscription was written in the Cumaean Sibyl's Cave, in these beautiful ancient characters" (Fig. 1.20).[74]

A passage from *An Island Garden* describes the care with which she filled the bowl:

> *There is a large, low bowl, celadon-tinted, and decorated with the boughs and fruit of the Olive on the gray-green background. This is filled with magnificent Jacqueminot Roses, so large, so deep in color as to fully merit the word. Sometimes they are mixed with pink Gabrielle de Luizets and old-fashioned Damask Roses, and the bowl is set where the light falls just as it should to give the splendor of the flowers its full effect.*[75]

Thaxter's considered arrangement of the bowl and its thoughtful placement in her parlor reveal her devotion to domestic aestheticism. And a lucrative demand for her bowls, pitchers, and vases qualifies her as a full-fledged participant in the Aesthetic Movement's revival of arts and crafts during the course of her friendship with Hassam.[76] The artist himself participated in the era's cult of domesticity by

FIGURE 1.17
Celia Thaxter at her
painting table, c. 1890
Photograph
Courtesy Portsmouth
Library

FIGURE 1.18
Celia Thaxter
Basket with seaweed
motifs, after 1877
Hand-decorated china
Courtesy Portsmouth
Library

FIGURE 1.19
Pressed seaweed
Scrapbook page
From *Seaweeds gathered at
the Isles of Shoals in 1857*
By permission of the
Houghton Library,
Harvard University

FIGURE 1.20
Celia Thaxter
Bowl with olive motif,
after 1877
Hand-decorated china
Courtesy Portsmouth
Library

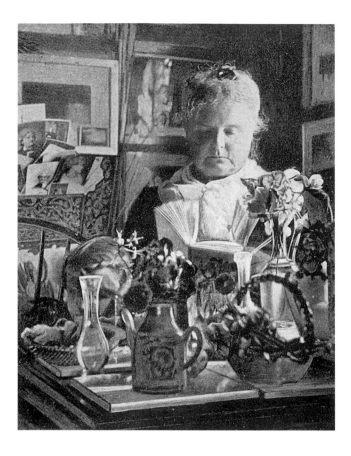

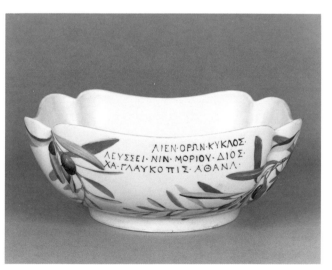

FIGURE 1.21
Celia Thaxter's Appledore
cottage with newly
extended porch, c. 1887
Photograph
Courtesy Portsmouth
Library

choosing to sit amidst bowls of roses in Thaxter's parlor, drawing strength and inspiration from that essentially feminine environment.

To accommodate the burgeoning popularity of her salon, Thaxter had the parlor enlarged in 1887. A photograph of her cottage was taken soon after the extension was completed (Fig. 1.21). Hops and other vines have not yet regrown to smother the porch in shade. That fall, Thaxter wrote to Ellen Robbins:

> *the fire is made of bits of the west end of my room, the floor of which has walked off over the grass towards the water in the most amazing fashion. . . . And the piazza will go still further. . . . Such a big room, Ellen! you'll have a place to paint with some comfort.*[77]

A reporter noted:

> *As [Thaxter's] parlor has been enlarged during the year, she is able to entertain a greater number of visitors than ever before, and mornings and evenings favored guests from the cottages and hotel enjoy conversation and music of the most refreshing and inspiring kind. The room itself is a fitting framework for musicales and conversations.*[78]

On Appledore, new construction usually took place in autumn, after summer guests had departed. In 1888 the Laighton family determined to build a number of cottages to help make money.[79] Thaxter

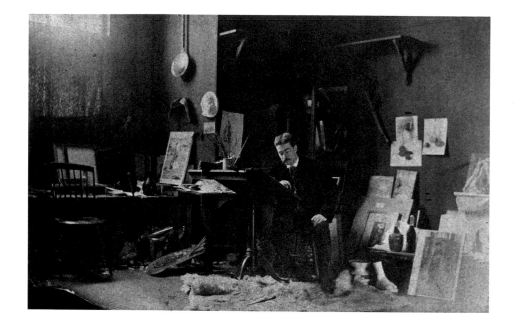

FIGURE 1.22
Childe Hassam in his
studio, c. 1890
Photograph
Courtesy Portsmouth
Library

noted with some relief, "There is not a soul on the island except ourselves and the workmen, who are busy on the cottages, happily out of sight from here, whose saws and hammers sound afar off."[80]

Hassam's studio was undoubtedly built at this time. He was photographed there with his illustration for "On the Beach" propped up in the left corner (Fig. 1.22).[81] Nothing survives now but a ruined foundation.

A young woman, perhaps like the one reading in *The Room of Flowers*, recalled her attendance at a salon:

> *Each morning at eleven we would rush for the best seats on sofa or chairs facing the piano and listen to divine music . . . What concerts we had and how like boys [the artists and musicians] all were! Just enjoying their holidays and 'making music' when they wished and playing what they wanted. And in such an atmosphere of beauty! Something to appeal to the eye and ear and even the sense of smell, with the scent of honeysuckle coming in through the many windows. . . .*[82]

"Oh do go on! We are cormorants!" said Mrs. Thaxter, always hungry for more music. Her refreshing lack of pretension wafted like a cooling breeze through her parlor. It did not matter that her decor was less than de rigueur:

> *The room, though plain and simple as to the furniture proper, was a very bower of beauty and delight with its store of treasures and gems of art and nature. I cannot tell what it was that gave such an air of warmth and luxuriousness to the rustic, even perhaps awkwardly-constructed furniture, unless it was*

the extraordinary beauty and richness of the colors of the flowers which were lavished everywhere. . . . all [her] very common flowers [were] quite old-fashioned and out of date in greenhouses and gardens of good society . . . [83]

In the writing and rewriting of intellectual history, the parlor on Appledore Island has fared better than some. Van Wyck Brooks' *New England Indian Summer* (1940), gave the various intellectual quests of the Bostonians somewhat sardonic treatment, but he remained sympathetic to Thaxter, "the most luminous of [the] little moons" to revolve around New England's cultural giants, and he admired her "sky parlor" where

> *[Whittier] read his poems aloud and she read hers. The visitors came in crowds, as the years went on, writers, musicians and landscape-artists, to hear Mrs. Thaxter read her poems, in the long, light, airy room . . . Eastward lay the open sea, and westward, as the sun poured in, one saw the peaks rising, a hundred miles away. Celia Thaxter's poems were literary water-colours. . . . graceful, touching, fragile, evanescent.* [84]

Scholars continue to find significance in the salon at Appledore. Historian Roger Stein designates Thaxter's activities, along with the building of Trinity Church, Boston, as one of two poles delimiting the Aesthetic Movement in New England:

> *Trinity Church and Celia Thaxter's decorative work—two instances of the functioning of Aesthetic-movement ideas and educational patterns in New England—bracket the extremes of public and private, of art for monumental and for domestic space, and of the resources open to male and female creators and their audiences.* [85]

Stein's analysis serves as a succinct reminder that we must view Celia Thaxter's parlor as a standard late-nineteenth-century aesthetic environment, a "cushioned feminine nest" as Henry James put it. Thaxter's choices conform to cultural expectations of the era. She was unable to elude the cult of domesticity that postulated a distinctly separate home environment created by women as a soothing antidote to the male-dominated, materialistic workaday world. Her activities as poet, journalist, illustrator, china painter, and hostess enabled her to earn a living while remaining well within the bounds of propriety.

In considering Thaxter's parlor as a type, Henry James' description of a Boston interior comes to mind:

> *[he] had always heard Boston was a city of culture, and now there was culture in Miss Chancellor's tables and sofas, in the books that were everywhere, on little shelves like brackets (as if a book were a statuette), in photographs and watercolors that covered the walls, in the curtains that were festooned rather stiffly in the doorways.* [86]

FIGURE I.23
Celia Thaxter's parlor,
c. 1890
Photograph
Courtesy Star Island
Corporation

FIGURE I.24
Mrs. James T. Fields (l) at
home with Miss Sarah
Orne Jewett,
37 Charles Street, Boston,
c. 1890
Photograph
The Boston Atheneum

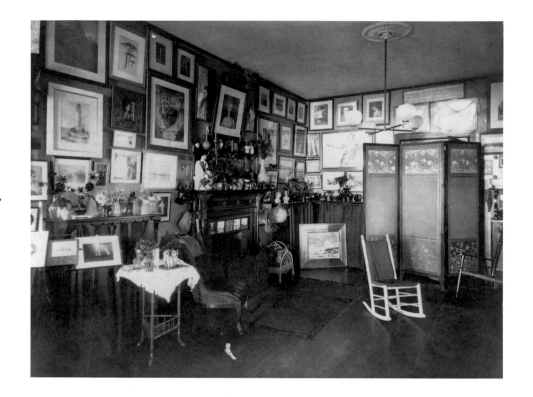

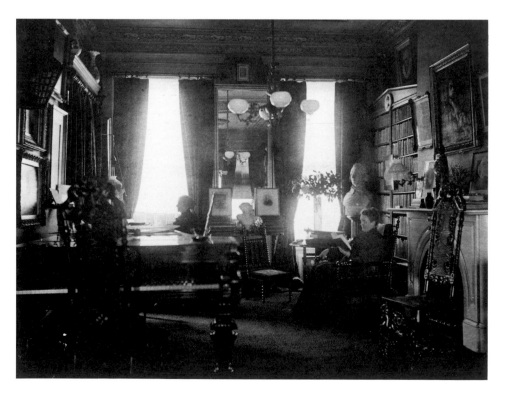

Although chosen for country rather than city use, decor in the Thaxter parlor was fairly standard, as is evident when we compare it to the Boston drawing room of her friend Annie Fields. The two women in the photograph, Fields and Sarah Orne Jewett, often visited Appledore (Figs. 1.23, 1.24).

Thaxter's parlor was filled with reminders of "lady's fancy work," including the overstuffed pillows, embroidered table covers, and draped bookshelves. Like many a Victorian lady, Thaxter maintained blooming plants in window pots during the winter months. This common practice was illustrated in the popular press (Fig. 1.25) and described by Celia herself:

> *I have taken the plants in hand, and really the desert blossoms like the Rose; ten windows full; they are really splendid. A Passion Flower is running round the top at the rate of seven knots an hour, and I have Roses, Geraniums, clouds of pink Oxalis, Abutilon, and Callas in bloom; every day I spend an hour over those ten windows.*[87]

Thaxter quoted Emerson: "Hast thou . . . Loved the wood Rose and left it on its stalk?"[88] In good weather, Victorian ladies were encouraged to gather natural specimens and bring them into the home as beautiful and instructive keepsakes (Fig. 1.26). The seaweeds that young Celia gathered and preserved in an album look like mysteriously complete feathery drawings (Fig. 1.27). They are preceded by an inscription taken from Tennyson's poem, "Maud": "Frail, but of force to withstand the cataract seas that snap the three-decker's oaken spine."[89] The text seems an apt summation of the roles and expectations that surrounded Thaxter.

Another natural treasure hung in the Thaxter parlor at Appledore. She had been given a "large pearly shell of the whelk tribe," beautiful in itself, a "mass of glimmering rainbows":

> I did not know what to do with it. I do not like flowers in shells as a rule, and I think the shells are best on the beach where they belong, but I was fond of the giver, so I sought some way of utilizing the gift. . . . I bored three holes in its edge and suspended it from one of the severely simple chandeliers with almost invisible wires.[90]

Thaxter filled the shell with fresh flowers, twisting vines around the wires to conceal them. This "heavenly apparition afloat in mid air" is visible in photographs of her parlor, and recalls the kind of home project touted by ladies' magazines and books on handicrafts (Fig. 1.28). A guest remembered the shell, "hanging over the center-table of books, and filled with nasturtiums, pansies, and some blue flowers . . . dearly loved by the woman of Appledore."[91]

The same visitor also noted

> a painting of Violets under the mantel, and vines hanging over it; a writing desk in the corner, also with flowers on it; and a head or bust, life-size, garlanded with a running vine,—a Morning Glory, I think.[92]

Thaxter even made shell jewelry, such as the delicate necklace she wore to meet Robert Browning in Italy (Fig. 1.29). Thaxter carefully strung the tiny shells in graded color groupings, golden brown, rose brown, pale pink, pale yellow, and cream, and tied them with peach satin ribbons.

As Hassam's elegant palette in *The Room of Flowers* reminds us, the parlor's color scheme was fashionable. Maria Oakey Dewing asserted in *Beauty in the Household*, her book on interior decoration, "Yellow is, in truth, warmth itself . . . a color that can be contrasted with various shades of itself more unerringly than any other color."[93]

A sense of Thaxter's aesthetic clutter is conveyed in Hassam's oil painting of the parlor on Appledore. But more importantly, we see that Hassam, like Thaxter, responded appropriately to the cultural values espoused all around him.

By now it is hardly news that women and flowers were endlessly associated in Victorian imagery. Hassam's many such pictures are the fruits of a widely shared cultural experience (Fig. 1.30).[94] But, as is true of most significant American artists who got their start as illustrators, Hassam went far beyond the limits of popular taste for narration and anecdote.

Painted by the seashore, but not necessarily at the Shoals, *Summer Evening* captures a pensive melancholy that often imbues easel paintings of the era (Plate 7). The Boston School was especially noted for images of women toying with expensive antique objects or luxuriant flowers, placed in dimly lit interiors by tantalizing open windows. *Summer Evening* tells no story, but suggests the pondering of open-ended possibilities at a time when the status of women was undergoing radical

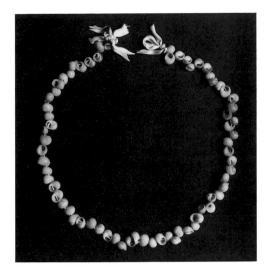

change. The waning light in *Summer Evening* casts its long shadows on a society's unquestioned acceptance of old sexual roles and divisions.

In contrast to *Summer Evening*, Hassam's Appledore pictures are filled with bright sunshine. *The Altar and Shrine*, one of two interior scenes to ornament Thaxter's book, *An Island Garden*, is awash in morning light (Plate 8). Actually, the parlor was the stage for both morning and evening gatherings. A visitor noted:

> There may be those who still recall weird evenings in her cottage, when by the light of a shaded candle and the dying embers of a wood fire upon the hearth, she would read . . . a thrilling account of "A Wreck" or "The Story of a Blood Curdling Murder." How great a contrast with the morning scene in her long parlor, fairly ablaze with flowers cut from her own garden, and arranged, each wonderful variety by itself, in the quaintest and daintiest of crystal vases.[95]

With hot reds and oranges, blithe pinks, rich yellows, and dulled greens, Hassam has painted the draped bookcase to the left of the tiled fireplace. He also included two occasional tables. As Hassam's title indicates, the bookcase was known as "The Altar." One of the tables was called "The Shrine." Thaxter described this sacred spot where art and nature comingled:

> To the left of this altar of flowers is a little table, upon which a picture stands and leans against the wall at the back. In the picture two Tea Roses long since faded live yet in their exquisite hues, never indeed to die. Before this I keep always a few of the fairest flowers, and call this table the shrine.[96]

FIGURE 1.28
Shell container
From H. T. Will,
Window Gardens, 1877
Courtesy Smithsonian
Institution, Office of
Horticulture

FIGURE 1.29
Celia Thaxter
Necklace, c. 1880
Seashells, satin ribbon
By permission of the
Houghton Library,
Harvard University

FIGURE 1.30
Arranging a Bouquet
Woodcut
From *Vick's Monthly
Magazine*, Vol. X (1887)
Courtesy Smithsonian
Institution, Office of
Horticulture

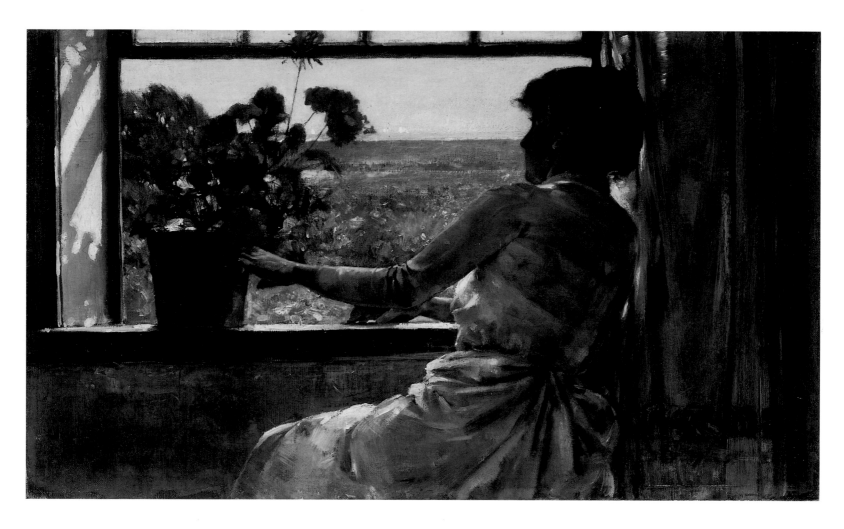

PLATE 7
Childe Hassam
Summer Evening, 1886
Oil on canvas, 12⅛ x 20¼ inches
Private collection, Courtesy Christie's, New York

Well might Hassam have chosen this motif. While he modestly obscured any obvious reference to his own pictures, an old photograph of the spot reveals not only one of Hassam's lighthouse watercolors on display in the parlor, but also a pastel similar to Plate 32 leaning against the wall (Fig. 1.31). The seascape over the mantle, partly hidden by flowers in the old photograph, might be by Hassam as well.

The artist edited the space for pictorial purposes, slightly compressing its soaring Victorian scale and deleting some of the artworks visible in the photograph, including a tondo image of the young Celia Thaxter with her son. Hassam does render clearly a profile photograph of the writer Annie Fields, however. After Thaxter's sudden death in 1894, this old family friend did as much to preserve the poet's memory in print as Hassam did in paint.

As resident priestess, Thaxter arranged both altar and shrine

> *almost as one would paint a picture, or compose a sonata. In fact, she said to one of the musicians who was there, J. K. Paine, Professor of Music at Harvard, "Johnny, don't you think there should be a deep note here?"*[97]

The arrangement of the flowers in the parlor was quite time-consuming. "Often I have counted as many as one hundred and fifty different flowers," marveled one visitor.[98] Another declared:

> *It was not by chance that she had accomplished this glorious color scheme, for she worked over it for hours each day, putting a touch here and another there . . . When I asked her how she did it all she said was, "My dear, it means the work of a ploughman. I get up at five in the morning and pick my flowers; and then, with the help of my faithful maid, who fills the many vases for me, I begin to arrange, changing vases many times until I get just the effect I want."*[99]

The Altar and Shrine carries little sense of the arranger's labor, but much of her splendid success. Hassam's watercolor was quickly executed, his touch swift and sure. Reproduced in *An Island Garden*, Hassam's picture is complemented by Thaxter's detailed evocation:

> *On one low bookcase are Shirley Poppies in a roseate cloud. . . . I begin on the left end of this bookcase . . . and into the glasses put the radiant blossoms with an infinite enjoyment of the work. The glasses (thirty-two in all) themselves are beautiful: nearly all are white, clear and pure, with a few pale green and paler rose and delicate blue, one or two of richer pink, all brilliantly clear and filled with absolutely colorless water, through which the stems show their slender green lengths . . . I put first the dazzling white, single Poppy, the Bride, to lead the sweet procession,—a marvelous blossom, whose pure white is half transparent. . . . then a dozen or more of delicate tissue-paper-like blossoms of snow . . . with petals so thin that a bright color behind them shows through their filmy texture; then . . . Snowdrift, which being double makes a deeper body of whiteness flecked with softest shadow. Then I begin with the palest rose tints, placing them next, and slightly mingling a few with the last white ones,—a rose tint delicate as the palm of a baby's hand; then the next, with a faint suffusion of a blush, and go on to*

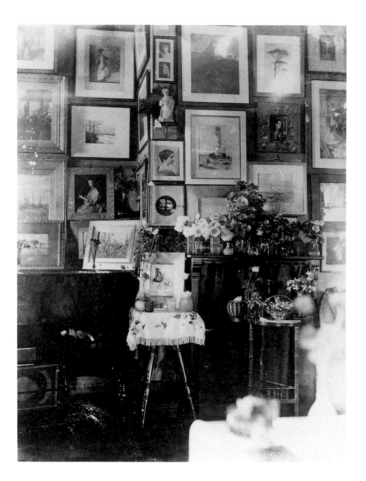

FIGURE 1.31
Celia Thaxter's parlor,
Appledore Island, c. 1890
Photograph
Courtesy Rosamond
Thaxter

the next shade, still very delicate, not deeper than the soft hue on the lips of the great whelk shells in southern seas; then the Damask Rose color and all tints of tender pink, then the deeper tones to clear, rich cherry, and on the glowing crimson, through a mass of this to burning maroon. . . . The color gathers, softly flushing from the snow white at one end, through all rose, pink, cherry, and crimson shades, to the note of darkest red; the long stems of tender green showing through the clear glass, the radiant tempered gold of each flower illuminating the whole. Here and there a few leaves, stalks and buds . . . are sparingly interspersed at the back. The effect of this arrangement is perfectly beautiful . . . like the rose of dawn.[100]

One thin wash overlaps another in Hassam's picture, building up to a sensuous surface bursting with nuanced color.

A Favorite Corner is Hassam's only other glimpse of Thaxter's parlor to be reproduced in *An Island Garden* (Plate 9). Again the poet described what the painter saw:

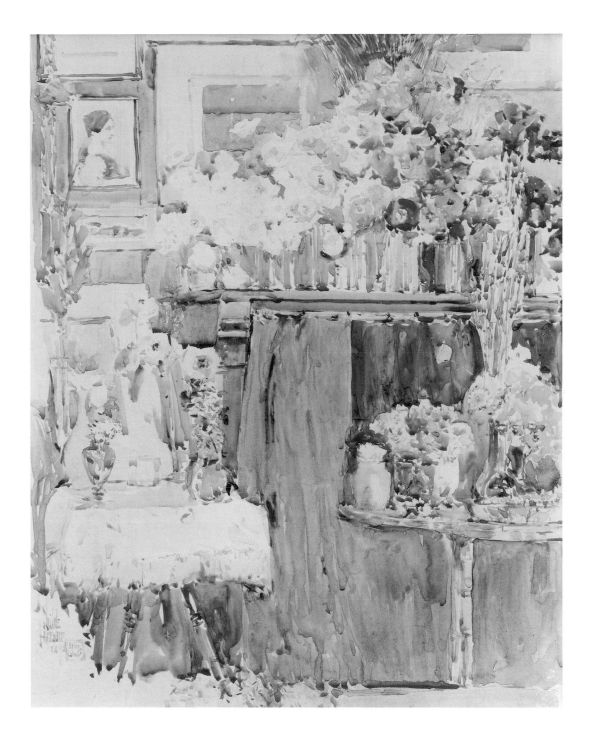

PLATE 8
Childe Hassam
The Altar and Shrine, 1892
Watercolor, 15 x 12 inches
Private collection

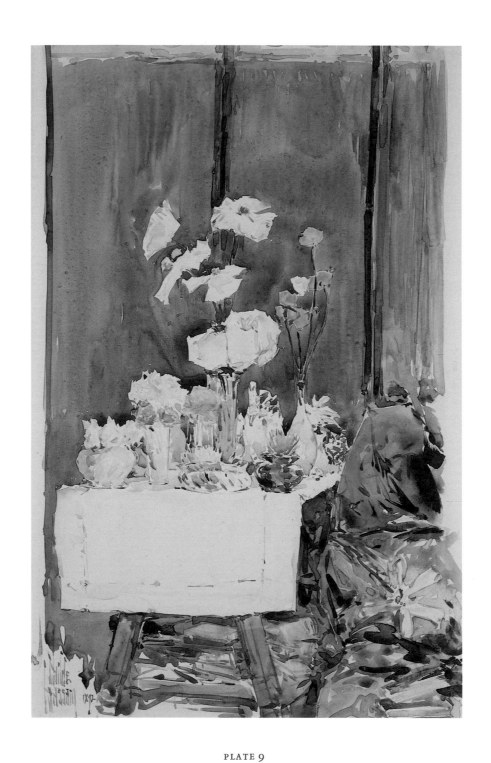

PLATE 9
Childe Hassam
A Favorite Corner, 1892
Watercolor, 9½ x 14½ inches
Private collection, Courtesy Hirschl and Adler Galleries, New York

Near my own seat in a sofa corner at one of the south windows stands yet another small table, covered with a snow-white linen cloth embroidered in silk as white and lustrous as silver. On this are gathered every day all the loveliest flowers as they blossom, that I may touch them, dwell on them, breathe their delightful fragrance and adore them.[101]

Thaxter enumerates the vases of flowers on the table in detail, but Hassam painted only some of them. Even though his picture was intended as a book illustration, the artist was moving away from information-laden anecdote towards suggestive works of art that stand independent of written text.

Flowers coordinated with their vases and set in linear arrangements were advocated by James McNeill Whistler in the 1870s and 1880s, and can be recognized as a hallmark of the Aesthetic Movement's fascination with artfully achieved, carefully controlled color effects. Thaxter's arrangements, and her comment that flowers "look loveliest, I think, when each color is kept by itself," suggest the possibility that she was aware of Whistler's color-coordinated schemes for interior decoration.[102] These received a great deal of publicity in the press, and were certainly talked of in artistic circles outside London:

I have lately seen a drawing-room furnished according to [Whistler's] designs, in which simplicity was the greatest charm. It was one of his most successful harmonies in white and gold. The walls were pale golden, a rug of a darker shade lay on the floor, white and gold cretonne covered the furniture and covered the windows. The only ornaments were a few small drawings and sketches on the walls, and small white glass jars full of pale spring flowers on the mantel. Cool and light, and yet filled with a rich golden glow, it was . . . a contrast to the over-crowded, dark drawing-rooms of the day . . .[103]

Thaxter noted:

For the Princess Beatrice, which is a divine pale pink, a shade of rose refined and exquisite, there are glasses of clear pink that repeat the hues of the flowers with magical gradations and reflections. For the white kinds there are white vases, the most effective of ground glass, the opaque surface of which matches the tone of the flowers.[104]

Hassam, too, was affected by Whistlerian ideals. In 1903 he wrote to Weir from the Shoals that he had just reread Whistler's *Ten O'Clock Lecture* "with the greatest pleasure." Hassam continued, "I had not read it for ten years. How true it is! and it is reassuring too!"[105] Painted during the decade between readings, *Improvisation* is a Whistlerian visual harmony, self-consciously aesthetic in its linkage of art and music, complete with flowers as contrasting color notes (Fig. 1.32).

In 1927 Hassam told an interviewer about painting the picture at the Isles of Shoals, commenting that the sitter was Thaxter's niece, Margaret Laighton. Hassam obviously continued to imitate Thaxter's flower arrangements after her death (Plate 10). Elegant coloration lets *Improvisation* rise above its rather awkward composition. Evidently the Shoals still brought up pleasant memories

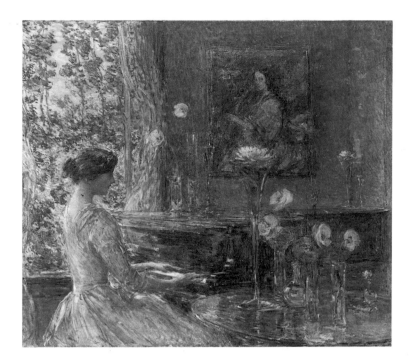

FIGURE 1.32
Childe Hassam
Improvisation, 1899
Oil on canvas
30 x 33⅞ inches
The National Museum of
American Art, Smith-
sonian Institution,
Gift of John Gellatly, 1929

for him.[106] While *Improvisation* depicts neither Thaxter's parlor nor the landscape of Appledore Island, it evokes the elements that made her salon memorable.

During the salon's heyday, as Thaxter cut and gathered her flowers, Hassam scattered them pictorially in little vignettes across the pages of *An Island Garden*. Margaret pinks, nasturtiums, pansies, sweet peas, and others add their humble beauty to the splendor of Thaxter's prose (Plate 11). Celia Thaxter would have had a strong hand in the publisher's presentation of her thoughts on gardening. That she chose Hassam to create the illustrations evidences her high regard for his work. A book of her poems, illuminated by Hassam in monochromatic washes, indicates that at least on one occasion, Hassam must have sat side by side with Thaxter in the parlor, drawing on already printed pages (Fig. 1.33).

Thaxter could be merciless about weak artists. She complained in several letters of Miss Plympton's "fatuous work" illustrating her *Stories and Poems for Children* (1883). Thaxter found the illustrations both feeble and affected, as "a dilapidated infant on a bare hillside being picked up by an appletree branch, like a potato on a fork." She demanded republication of that book without the offending illustrations.[107] Ascerbic correspondence with her publisher also records her preference for olive green bindings—"not the dark blue green, or the light, bright green, but *olive* green."[108]

The appearance of *An Island Garden* doubtless owes something to *The New Day: A Poem in Songs and Sonnets* (1876). This precious little book of poetry was written by Richard Watson Gilder.

PLATE 10
Childe Hassam
Improvisation (detail), 1899
Oil on canvas
The National Museum of American Art, Smithsonian Institution,
Gift of John Gellatly, 1929

Helena De Kay, the author's wife, designed floral vignettes similar to those Hassam eventually created for *An Island Garden* (Fig. 1.34, Plate 12). Thaxter praised Gilder's work when it first came out:

> I am at this present wild about R. W. Gilder's poem, "The New Day;" it is the most exquisite thing I have seen in these modern times. The whole book, with its peacocks' feathers and poppies and daisies and wild roses, is so beautiful.[109]

Hassam later recalled meeting Gilder as part of the aesthetic literary circle gathered in Thaxter's parlor. The two men were quite drawn to one another:

> Gilder came to my studio one day [and] looked at a bowl of nasturtiums, one of the things that I was doing . . . using the figure with the flowers in an arrangement to make a beautiful combination of color and line. . . . Gilder looked at it and said, "I think you will come to see that picture one of your finest." I have hung on to it ever since. That is very interesting, isn't it. If poets are seers.[110]

The New Day was printed by the Cambridge Press, the same art press that later produced *An Island Garden*, and both books had aesthetic gold-embossed covers (Figs. 1.35, 1.36). The stylized gilt flower on the cover of *An Island Garden* is remarkably similar to a rose motif created by Helena De Kay for another book of her husband's poems, published in 1892.

Gilder's admiration for contemporary art was evident on the pages of *The Century Magazine*, which he edited. In 1891 he printed Thaxter's poem, "Moonlight," based on a picture by Childe

I.

THERE was a field green and fragrant with grass and flowers, and flooded with light from the sun, and the air of it throbbed with the songs of birds. It was yet morning when a great darkness came, and fire followed lightning over the face of it, and the singing birds fell dead upon the blackened grass. The thunder and the flame passed, but it was still dark, — till a ray of light touched the field's edge and grew, little by little. Then one who listened heard — not the song of birds again, but the flutter of broken wings.

FIGURE I.33
Childe Hassam
Illuminated page, c. 1890
Watercolor over set type
From Celia Thaxter,
"In Autumn"
Courtesy Boston Public
Library, Rare Books
Department

FIGURE I.34
Henry Marsh
After Helena De Kay
Vignette for
The New Day, 1876
Wood engraving
Courtesy Denver
Public Library

FIGURE I.35
Sarah Wyman Whitman
Cover for
An Island Garden, 1894
Embossed fabric
Private collection

FIGURE I.36
Helena De Kay
Cover for *The New Day*,
1876
Embossed fabric
Courtesy Denver
Public Library

PLATE 13
Childe Hassam
Moonlight, Isles of Shoals, 1892
Oil on canvas, 24 x 20 inches
Private collection, Courtesy Arvest Galleries, Boston

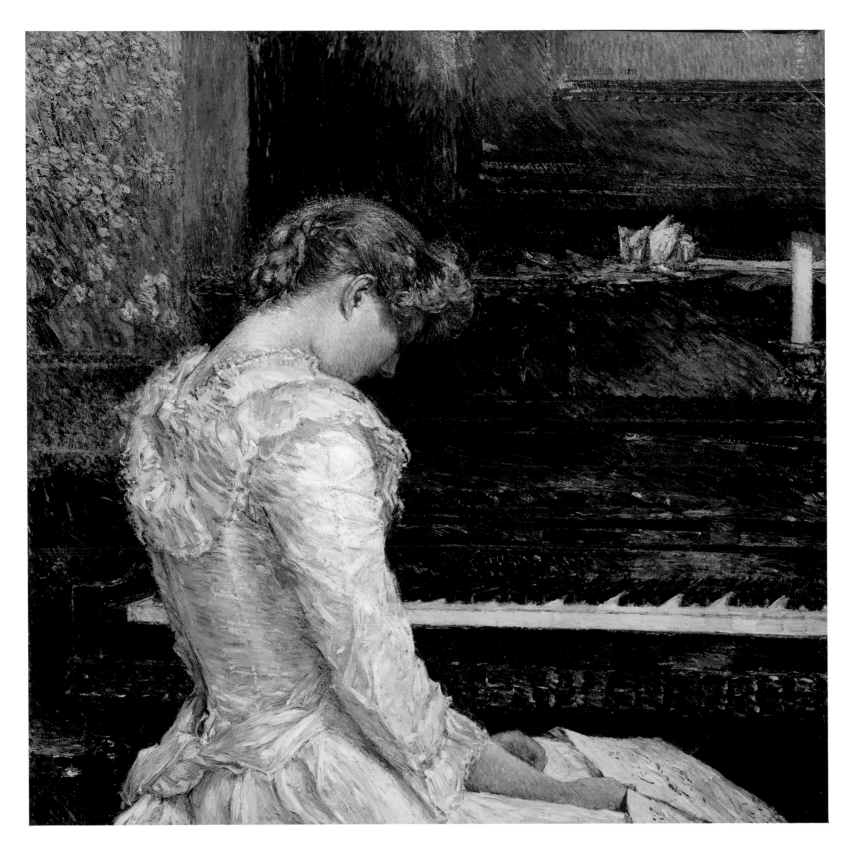

PLATE 14
Childe Hassam
The Sonata, 1893
Oil on canvas, 32 x 32 inches
The Nelson-Atkins Museum of Art, Kansas City, Missouri,
Gift of Mr. and Mrs. Joseph S. Atha, 1952

PLATE 15
Childe Hassam
The Room of Flowers (detail), 1894
Oil on canvas
Mr. and Mrs. Arthur G. Altschul

Hassam. "The infinite, illimitable sky, wherein the . . . moon . . . in stillness down the quiet deeps doth swim" is caught in a number of Hassam moonlights from this period (Plate 13). Both painter and poet felt "the awful beauty of the night, the solemn tenderness, the peace profound, the mystery . . ."[111]

Mysteries—subtle color, suggested content—empower Hassam's best studio canvases. Roughly contemporary with beautiful illustrated books of the era, *The Sonata* is a synthetic visual poem that gathers together the aesthetic components of Appledore—art, music, flowers (Plate 14). Clearly, Hassam occupies a front-line position in the cult of beauty that dominated American painting during the last decades of the nineteenth century. While the power of aestheticism gradually eroded as Europe and America moved towards modern abstract art, Childe Hassam remained a champion of beauty for its own sake until his death in 1935.

Sonata's alternate title is *The Marechal Neil Rose*. Hassam was not a military man, but, especially after the watershed of World War I, when the struggle for visual abstraction became increasingly heated, Hassam did battle for beauty in word as well as in deed. The alternate title has militant overtones: Marechal Neil was a French hero who distinguished himself in the Crimean War. In clues as subtle as the yellow rose or as blatant as Hassam's boisterously patriotic Flag series, we see that American impressionists, like their French counterparts, did not insulate themselves from the social change occurring all around them.[112]

However, they remain primarily artists, not reporters. In the work of Childe Hassam particularly—light, color, indeed all that makes painting beautiful—formed a fortress of aestheticism that shut out what Hassam himself scornfully called "the Fool Fringe" of art. There is a seductive element of escapism in Hassam's oeuvre. Dreamily, the *Sonata*'s pianist droops in reverie—fragile, scented, lovely as her yellow rose.

The music in Hassam's mind when he painted this picture was Beethoven's *Appassionata* sonata, and at the upper right corner of the picture, we glimpse what is probably an Isles of Shoals moonlight scene. At the Shoals Hassam conceived some of his most impassioned works.

Thaxter's favorite table appears one more time, at the heart of *The Room of Flowers* (Plate 15). The blossoms she so lovingly placed on her table—the crimson Burgundy rose, an opening jacqueminot bud, a few rich pinks, the Bon Silene and La France roses, a single water lily, a few sweet peas and poppies—all are jumbled by Hassam's brush into a luscious tangle of radiant, textured pigments.[113] For in Celia Thaxter's parlor, Hassam was stirred by the most seductive harmonies. As the poet said of the painter, "Let him touch a flower, and . . . its soul is his."[114]

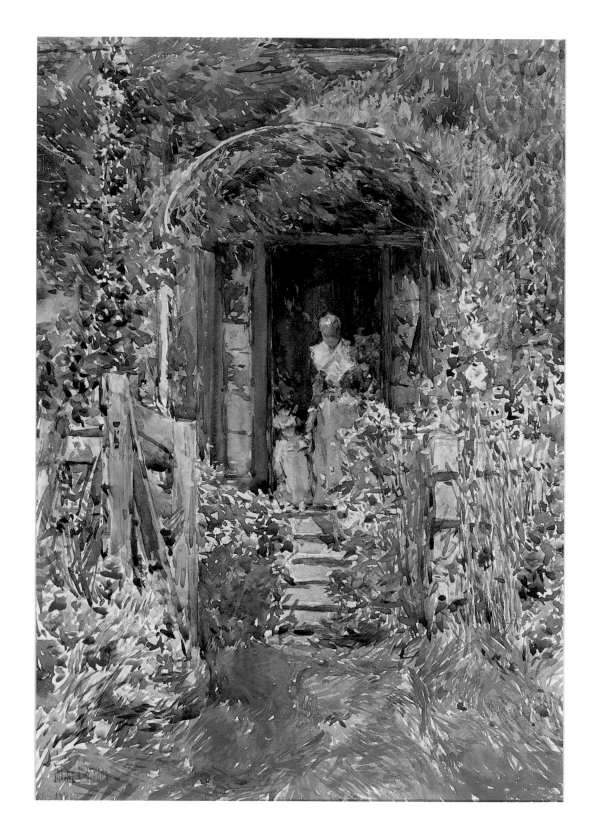

PLATE 16
Childe Hassam
The Garden in Its Glory, 1892
Watercolor, 19¹⁵⁄₁₆ x 13⅞ inches
The National Museum of American Art, Smithsonian Institution,
Gift of John Gellatly, 1929

The Garden in Its Glory

*One blossom . . . breathes a glory of color into sense and spirit which
is enough to kindle the dullest imagination.*

CELIA THAXTER[1]

SHROUDED IN LARGE-LEAVED VINES, THAXTER'S COTTAGE FLOATED ABOVE HER ISLAND
garden. She wrote:

> The wild bird's song that breaks from without into the sonata makes no discord. Open doors and windows lead out on the vine-wreathed veranda, with the garden beyond steeped in sunshine, a sea of exquisite color swaying in the light.[2]

A virtuoso demonstration of Hassam's powers as a watercolorist, *The Garden in Its Glory* depicts Celia Thaxter emerging from the cool depths of her parlor, heading towards the steps that led down to her flower beds (Plate 16). One hand holds a generous bouquet of red blossoms, the other guides her favorite grandson, Elliott Thaxter.

"Down into the sweet plot I go and gather a few [poppies]," the poet warbled in the pages of *An Island Garden*.[3] She took them back into the parlor to arrange on the "Altar and Shrine" for contemplation. But interior scenes are far outnumbered by garden views in Hassam's pictures of the Shoals. The salon nourished Hassam's art, but the garden, not the parlor, was the chief object of his contemplation between 1890 and 1894.

The Garden in Its Glory is one of the most elaborate pieces Hassam painted for Thaxter's book. He observed the poet from the south side of the garden, facing the house. Hassam opened the gate to look through the flower beds and up the steps towards the cottage threshold (Fig. 2.1).

Thaxter's garden plan indicates that Hassam would have seen two beds given over to Shirley poppies, usually red and pink (Fig. 2.2).[4] Asters, ranging from white to pinks through purples, were planted at the north and south ends of the beds. On both sides of the south gate, Thaxter planted sweet peas, whose color range parallels the asters. She described the mixture of red, white, and blue flowers that grew over the arched trellis:

> I put down two Tropaeolum Lobbianum Lucifers, a new scarlet variety of these delicate Nasturtiums, that they might climb together over the broad arch. Some time ago I had planted there also some

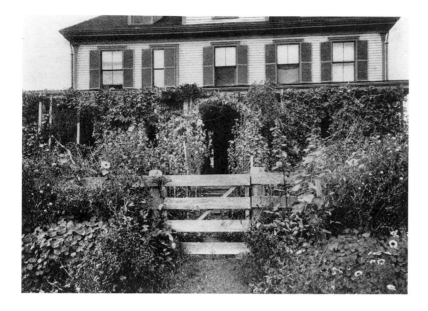

PLAN OF GARDEN WITH LIST OF FLOWERS

1 Akebia Quinata	15 Echinocystus Lobata	29 Lilies	44 Sweet Peas
2 Asa Gray Nasturtiums	16 Foxgloves	30 Love-in-a-Mist	45 Sweet Rocket
3 Asters	17 Golden Banner Coreopsis	31 Margaret Pinks	46 Sweet William
4 Asters and Lavatera	18 Helianthus	32 Marigolds	47 Sunflowers
5 Bachelors' Buttons	19 Hollyhocks	33 Mignonette	48 Tall Phlox
6 Bride Poppies	20 Honeysuckles	34 Oriental Poppy	49 Tea Roses
7 Clematis, white	21 Hop	35 Peonies	50 Travelers' Joy
8 Clematis, blue	22 Hugelia	36 Picotee Pinks	51 Verbenas
9 Cleome Pungens	23 Iceland Poppies	37 Poppies	52 Vines
10 Columbine	24 Jacqueminot, Damask, and La	38 Rose-colored Iceland Poppies	53 Violets
11 Coreopsis Coronata and Coreopsis	France Roses	39 Rose Campion	54 Wallflowers
flowers	25 Japan Honeysuckles	40 Scotch Roses	55 Water Lilies
12 Coreopsis Lanceolata	26 Japan Hop	41 Shirley Poppies	56 White Lilies
13 Crimson Phlox	27 Larkspur	42 Single Dahlias	57 Wistaria
14 Damask Rose	28 Lavender	43 Snowdrops, etc.	

NOTE.—The garden is 50 ft. long by 15 ft. wide, and is surrounded by a border of all sorts of mixed flowers. A bank of flowers at the southwest corner slopes from the garden fence.

FIGURE 2.1
Mrs. Thaxter's garden,
Appledore, 1905
Photograph
Courtesy Becky Marden

FIGURE 2.2
Celia Thaxter
Plan of garden with list
of flowers
From *An Island Garden*,
1894
Private collection

Mexican Morning-glories sent me by an unknown friend, and if they come up, and Coboea, Nasturtiums, and Morning-glories all climb together and clasp hands with Honey-suckle, Wistaria, and Wild Cucumber, my porch will, indeed, be a bower of beauty![5]

Lush as it sounds, we should not take the poet's text as the final word on what the artist witnessed in the garden. Rather, we can assume that Hassam exercised artistic prerogative in choosing and arranging the colors of his flower pictures.[6]

Although *The Garden in Its Glory* was created to illustrate Thaxter's book, Hassam was not particularly concerned with capturing specific flowers or faces here. He generalized what he observed, reducing the details recorded in an old photograph (Fig. 2.3). His watercolor is based on a scheme of primary red and yellow, set amidst greens softened by bluish grays and whites.[7]

In a complicated bit of color stitchery, Hassam created a primary triangle in the heart of the image: blue dress, red flowers, and tiny yellow dots under the figure of Thaxter. The surface of the sheet is dappled with discrete dabs of bright pigment. Hassam centered the composition with a niche established by the arched trellis. Within it, surrounded by abundant foliage and flowers, the essentially featureless woman and child take on an iconic resonance.

Earlier in his career, Hassam used a similar composition to embellish a children's book (Fig. 2.4) And he returned to this general format again later, drawing and then etching *The Steps* in 1915 (Plate 17, Fig. 2.5). In Hassam's study for the etching, blues and greens repeat the color scheme of his earlier children's illustration.

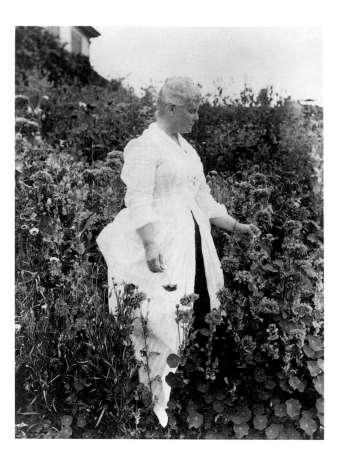

These comparisons remind us that the prolific Hassam maintained a formulaic approach to his art. He often worked on a relatively small scale and he reused compositional devices regularly over extended time periods. No matter what the subject, medium, or purpose of his image, reportage never got the upper hand over artistic decision.

An oil simply titled *In the Garden* served as a frontispiece to Thaxter's book (Plate 18).[8] Hassam caught the poet standing near the garden's west gate. Amidst her beloved blossoms, she is a solid yet graceful figure lost in reverie. The artist used blue outlining to define the board fence, as well as head, hands, and figure—right down to the silver crescent Thaxter wore in her hair. In contrast, the flowers are a painterly accumulation of pigments dragged over and through one another to create a sense of luxuriant bloom. Orange enlivens scarlet to suggest the glow of the paper-thin petals, some of which have scattered in the deep grass. White strokes are pulled atop red to create a shimmering pink, different from the premixed solid pink that he also applied. Sometimes Hassam loaded the brush with several colors at once, to entangle them in a single stroke.

The painted image is close to a photograph taken from a different viewpoint (Fig. 2.6). In the oil, unlike the photograph, we glimpse the mainland's distant shore through tall stands of hollyhocks.

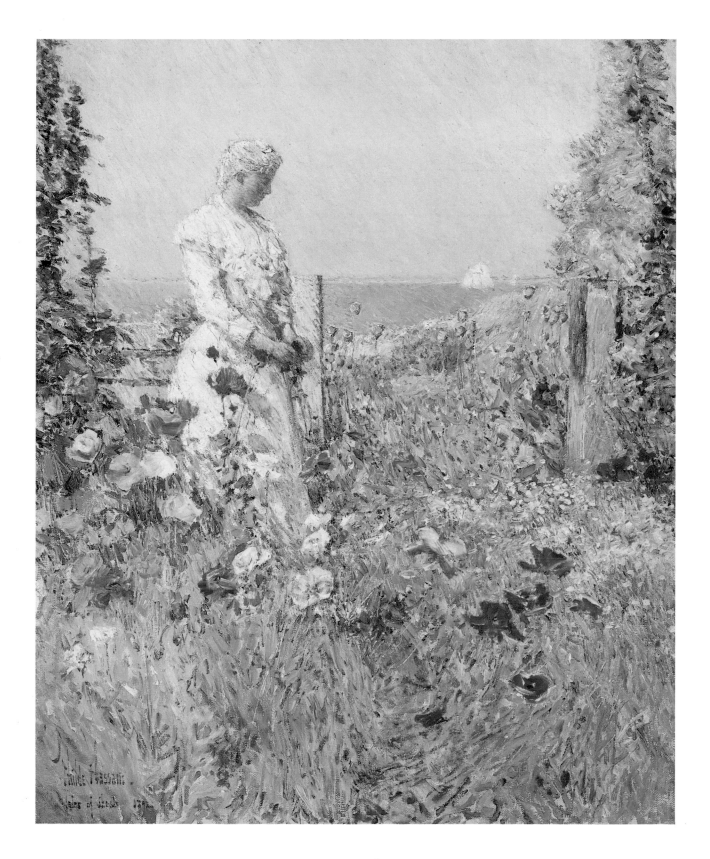

This compositional device—deep space framed by foreground foliage—appears many times in the Shoals pictures.

As he painted *In the Garden*, Hassam might have seen some or all of the following blossoms: Iceland poppy, sweet rocket, bachelor's button, *Coreopsis lanceolata*, crimson phlox, rose campion, aster, hollyhock, larkspur. The biggest single bed was devoted to Iceland poppies.[9] Thaxter wrote specifically of these yellow, orange, and pink blossoms. But Hassam's flowers read simply as intense scribbles and splashes of yellow, red, pink, and white. We can be sure there are poppies, but we cannot determine their variety on the basis of this canvas, nor can we differentiate most of the other possible flowers. Accurate description was not the point of the picture. An impression came from Hassam's brush as detail came from Thaxter's pen:

> *In the Iceland Poppy bed the ardent light has wooed a graceful company of drooping buds to blow, and their cups of delicate fire . . . sway lightly on stems as slender as grass. In sheltered corners the Forget-me-not spreads its cool, heaven-blue clusters; by the fence "the Larkspurs listen" while they wait; the large purple Pansies shrink and turn from the too brilliant gaze of the sun. Rose Campions, Tea Roses, Mignonette, Marigolds, Coreopsis, the rows of Sweet Peas, the broad-leaved Hollyhocks and the rest, rejoice and grow visibly with every moment of the glorious day. Clematis and Honeysuckle almost seem to hurry, Nasturtiums reach their shield-like leaves and wind the stems thereof round any and every stick and string they can touch by which to lift themselves, here and there showing their first glowing flowers, and climbing eagerly. The long large buds of the white Clematis, the earliest of all, are swelling visibly before my eyes, and the buds of the early June Honeysuckle are reddening at the end of every spray. In one corner a tall purple Columbine hangs its myriad clustered bells. . . . Cornflowers like living sparks of . . . rose and azure, white and purple, twinkle all over the place, and the heavenly procession begins in good earnest.*[10]

Other works in oil, watercolor, and pastel note down segments of the Thaxter's "little pleasance," punctuated by the angles of cottage, steps, and fence.[11] In these, as in most of the Shoals pictures, the human element is downplayed.

A watercolor now titled *Dexter's Garden* was painted from the southwest corner of the garden, outside the fence (Plate 19).[12] Hassam looked up towards the northeast, catching the corner of the Thaxter cottage. By the garden gate we glimpse the arched trellis. The chimneys to the right are probably those of North Cottage, which was once owned by Levi Thaxter, Celia's husband. Over some areas of thin green wash in the foreground Hassam applied touches of richer greens in large, single strokes. Behind the flowers, he left plenty of white paper untouched, maintaining the brightness of the sheet. The picture seems alive with primary color. Agitated dots of bright yellow suggest the flowers and contrast with a rich blue sky, painted as smoothly as Hassam would have done in oil. Sky and flowers are linked with last-minute additions of sky-blue dots in the flower area.[13]

PLATE 19
Childe Hassam
Dexter's Garden, 1892
Watercolor, 19¹³⁄₁₆ x 14⅛ inches
The National Museum of American Art, Smithsonian Institution,
Gift of John Gellatly, 1929

Another image, this time an oil, concentrates on the northeast corner of the piazza, where steps led down to a boardwalk between the cottage and the hotel. Thaxter indicated hollyhocks and hops for this spot. These plants are distinguishable in the painting (Fig. 2.7) and in a photograph of the same spot by Thaxter's son Karl (Fig. 2.8).[14]

But many of Hassam's floral pictures remain somewhat ambiguous, for the garden was an ever-changing entity. Many of the flowers Thaxter discussed in her text do not even appear on her garden plan. Blossoming cycles in the maritime climate on her tiny island don't always conform to the mainland's familiar seasonal march. On Appledore flowers bloomed "as if the order of nature were set aside."[15] Moreover, Thaxter planted sequences of her favorite flowers to extend their blooming periods far beyond the usual couple of weeks.[16] So we don't know precisely what Hassam saw, nor can we determine exactly how he altered and changed his observations to suit his own artistic purposes.

A rare pastel, *Hollyhocks, Isles of Shoals*, seems to be based on the southwest corner of the garden (Plate 20). Hollyhocks thrived under Thaxter's care:

> *One enormous red Hollyhock grew thirteen feet high by actual measurement before it stopped last year. . . . Oh, but he was superb! . . . he swayed to and fro in the wind, a stately column of beauty and grace.*

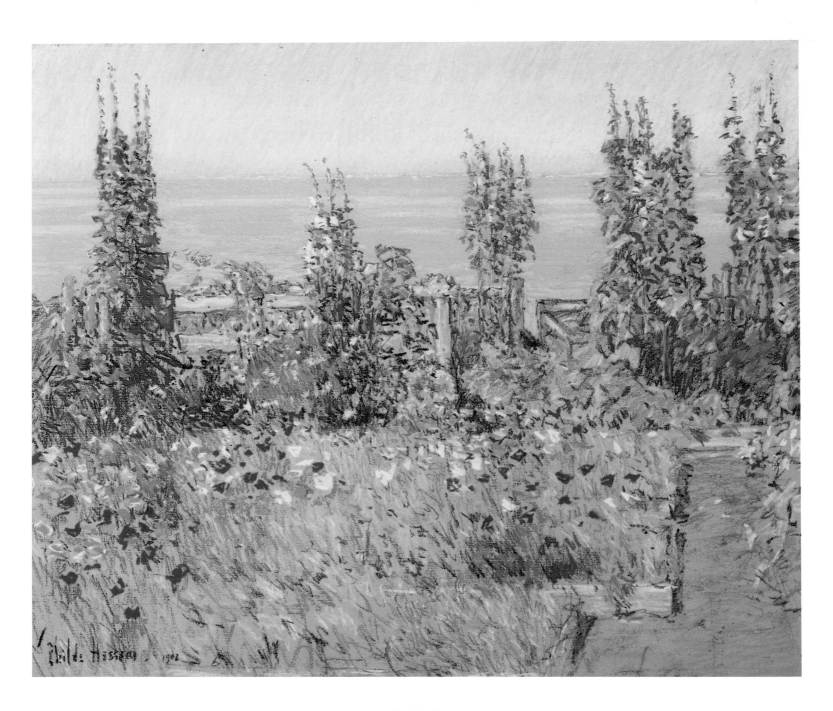

PLATE 20
Childe Hassam
Hollyhocks, Isles of Shoals, 1902
Pastel, 18½ x 22 inches
Private collection, Courtesy JoAnne Lyons Gallery, Aspen, Colorado

A black-red comrade leaned against him and mingled its rich blossoms with his brighter color, and near him were rose, pink, and cherry, and white spikes of bloom, lovely to behold.[17]

Hassam accurately conveys stately spires of hollyhock, as well as larkspur, planted near the board fence. But while large poppy beds were set perpendicular to the south gate on Thaxter's plan, the shape of the beds as drawn by Hassam does not coincide with the layout near either garden gate, or anywhere else for that matter. Instead, Hassam created a rhythmic grid of verticals and horizontals, broken by splashes of brilliant color. Black and white lines create the sense of open gate, fence, and edging boards. Once limned, the space is enlivened by less articulate dashes of pink, yellow, red, and white that suggest a profusion of poppies mixed with other blossoms. The tall spikes of larkspur are sometimes given a linear edge to help the viewer retain a sense of their shape against the fence.

Hassam's pastel captures the magical, detached quality of the garden plot, set on a hill overlooking the ocean. However, during the early part of the season, the garden appeared rough and haphazard, as Thaxter fought what Nathaniel Hawthorne labeled "the wicked luxuriance of weeds," as well as stormy weather and natural pests, hoping to protect her precious flowers long enough for them to mature. She was especially eloquent on the subject of slugs, "the snail without a shell . . . beyond description repulsive." She said with grim satisfaction, "When I rise I go at once into the garden at four o'clock and make a business of slaughtering them till half past five, when I stop for breakfast."[18] Thaxter also imported toads to decimate the slugs, and as for cutworms she found "there is no remedy so sure as seeking a personal interview and slaying them on the spot."[19]

Elsewhere Thaxter described protective devices:

I have little cages of fine wire netting which I adjust over some plants, carefully heaping the earth about them to leave no loophole through which the enemy may crawl, and round some of the beds, which are inclosed in strips of wood, boxed, to hold the earth in place, long shallow troughs of wood are nailed and filled with salt to keep off the pests.[20]

Sticks festooned with old fishing nets, canvas sheeting, and other makeshift provisions can be seen in photographs of the garden (Figs. 2.9, 2.10, 2.11).

Of course, as the summer went on, some of the supporting stakes, chicken wire, and twine would have been buried under flourishing foliage. In any case, it didn't matter to a painter seeking the garden in its glory. While Hassam's vibrant watercolors and oils are sometimes accented with picturesque tidbits of architecture, he minimized or completely edited out any garden detritus he might have observed. *Larkspurs and Lillies*, a book illustration, isn't compromised by the artist's abbreviated suggestion of sticks and strings that helped the gardener fulfill the promise of "a wealth of white and gold and azure by and by" (Plate 21).[21]

Richly colored, highly keyed, Hassam's sensuous garden images reveal that Thaxter planted her beds as she arranged cut flowers, with an eye towards free-form combinations of color and texture.

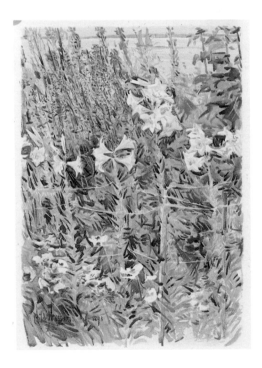

Clockwise from upper left:

FIGURE 2.9
Southeast corner of Celia
Thaxter's garden, c. 1895
Photograph
Courtesy private
collection

FIGURE 2.10
Karl Thaxter
Celia Thaxter's garden,
looking southwest, c. 1892
Photograph
Courtesy Star Island
Corporation

PLATE 21
Armstrong & Company
After Childe Hassam
Larkspurs and Lillies, 1893
Chromolithograph
From *An Island Garden*,
1894
Private collection

FIGURE 2.11
Celia Thaxter's garden
trellis, c. 1892
Photograph
Courtesy private
collection

In the early 1880s, when she began gardening in earnest, Thaxter's flower beds were unusual. She avoided the mid-Victorian practice of carpet gardening, which reduced the flowers to a vegetal approximation of a living room rug:

> *I have not room to experiment with rockworks and ribbon-borders and the like, nor should I do it even if I had all the room in the world.*[22]

The garden did not contain long-flowering, harshly colored annuals set in sharply contrasted formal patterns. Instead Thaxter favored a naturalistic, amorphous explosion of softer tints and tones, planted in irregular drifts and masses that intertwined and overlapped.[23]

Her island garden and the enthusiasm it engendered were part of America's reawakened interest in things colonial, which followed the country's Centennial in Philadelphia. Quaint annuals and humble perennials evoked the "olden tyme." Thaxter preferred such flowers, noting, "They are mostly the old-fashioned flowers our grandmothers loved."[24] Thaxter's was a cottage garden—unpretentious, rambling, sincere.

The cottage garden was also known in Britain, where it called forth similar nostalgia during a machine age. When British landscape theorist William Robinson inveighed against mid-century garden formality, he cited casual cottage gardens as prime evidence in his argument against trite and costly "bedding out."

Robinson and his associate Gertrude Jekyll did much to popularize these new ideas in print as well as in practice. But garden historian Deborah Nevins warns us that Thaxter had no actual known contact with either British gardener:

> *Although the informality of the garden and the arrangement of the flowers in Thaxter's cottage remind one of the gardening philosophy of William Robinson and Gertrude Jekyll, we must understand that this garden developed independent of direct contact with them. It was a naturalist's garden, both created and maintained as Thaxter's way of knowing nature better.*[25]

Elsewhere Nevins comments, "In the 1890s neither William Robinson nor Gertrude Jekyll were household words among American gardeners, although they did influence the most sophisticated designers of the period."[26] As Thaxter's salon was a sophisticated environment, not an ordinary household, we may safely speculate that she had some knowledge of Robinson's myriad publications, whether or not they actually met.[27] Thaxter traveled to Europe in the autumn of 1880, and might well have seen raised flower beds during her brief tour.[28] Her colorful plots were laid out in a manner that seems, at least superficially, to be in harmony with the teachings of Robinson and Jekyll.

However, Thaxter was no slave to their tenets. Her garden was even more casual than the cottage gardens admired by Robinson. *Hollyhocks, Isles of Shoals (see* Plate 20) records the wooden boards that edged Thaxter's raised beds. Robinson disapproved of the use of such base materials.[29]

And Candace Wheeler, who admired Thaxter's sensitivity to color, deplored the garden's haphazard appearance:

> A great part of the beauty of Mrs. Thaxter's house in the Isles of Shoals was made up of flowers. It was far more enjoyable than her garden, where the flowers grew luxuriantly at their own sweet wills, or at the will of the planter, never troubling their heads about agreeing with their neighbors. I remember it as a disappointment that a woman with so exquisite a sense of combination and gradation in the arrangement of flowers, should have so little thought of color effect in her garden.[30]

Thaxter considered her fifty-by-fifteen-foot plot to be essentially a cutting garden that provided the raw material for elaborate floral arrangements in her parlor. She told one visitor, "I plant my garden to pick, not for show. They are just to supply my vases in this room."[31] But the garden showed anyway, and visitors to Appledore flocked to it:

> Her garden . . . was unlike any other garden, although more beautiful, perhaps, than the more conventional gardens I have seen lately; for it was planted all helter-skelter, just bursts of color here and there, —and what color![32]

The garden's wildness and helter skelter color kindled Hassam's imagination. As one journalist generalized, "A broad bed of beautiful Poppies, which flutter gracefully in every passing breeze, is not to be displaced by a carpet-patterned bed of Pelargonium and Centaurea gymnocarpa, without the loss of something essentially aesthetic!"[33]

Despite her tangled masses of flowers, Thaxter integrated the beds well into the constricted sloping site, surrounding the narrow rectangle with a high board fence to break the wind while supporting a border of mixed flowers. Her garden was by no means a modern *hortus conclusis*, or enclosed garden. She planted many flowers beyond the confines of her carefully cultivated plot. Some were near the fence, and she also dropped a sloping bank of flowers down towards Sandpiper Beach and the ocean:

> I finished the afternoon by planting Shirley Poppies all up and down the large bank at the southwest of the garden outside. I am always planting Shirley Poppies somewhere![34]

Hassam was particularly fond of painting this bank. A watercolor in the Mead Art Museum at Amherst (Plate 22) was probably the basis for the chromolithograph in *An Island Garden* (Plate 23). A related, slightly earlier watercolor is also known (Plate 24). All these images capture the "torrent of flowers rushing down outside the fence."[35]

A watercolor, *Home of the Hummingbird*, includes a bit of fence and pathway to set the viewer clearly within the flower beds (Plate 25). A green foreground wash enlivened with single touches of darker green, bright red poppy heads created in overlapping piled-up strokes of varying opacity, and

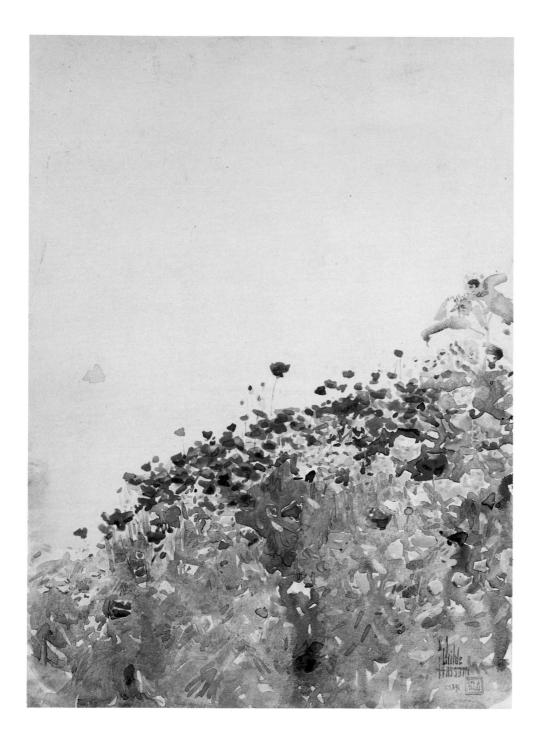

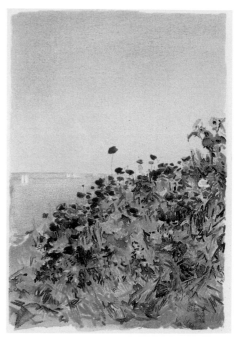

PLATE 23
Armstrong & Company
After Childe Hassam
Poppy Bank in Early Morning, n.d.
Chromolithograph
From *An Island Garden*, 1894

PLATE 22
Childe Hassam
The Garden, Appledore, Isles of Shoals, 1891
Watercolor, 13³⁄₁₆ x 10 inches
Mead Art Museum, Amherst College,
Gift of William Macbeth, Inc., 1950

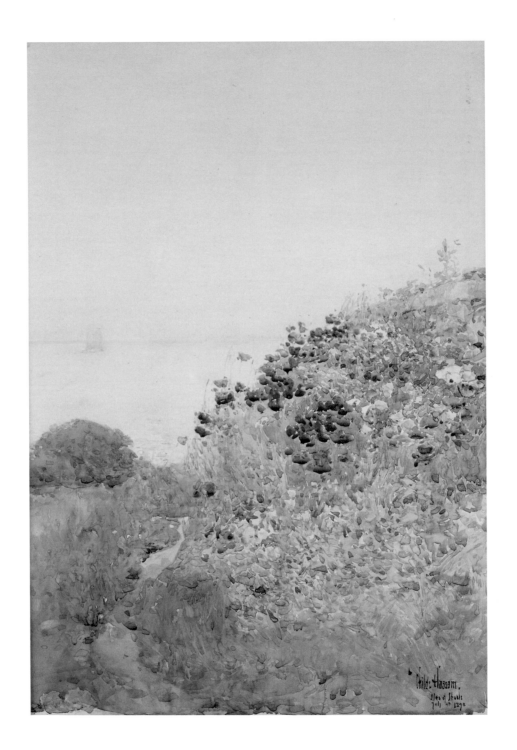

PLATE 24
Field of Poppies, Isles of Shoals, 1890
Watercolor, 20¾ x 14½ inches (sight)
Private collection

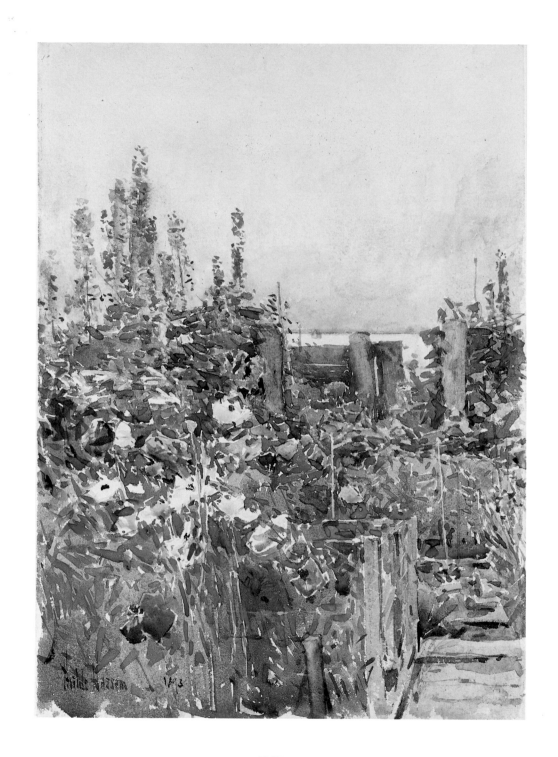

PLATE 25
Childe Hassam
Home of the Hummingbird, 1893
Watercolor, 14 x 10 inches
Mr. and Mrs. Arthur G. Altschul

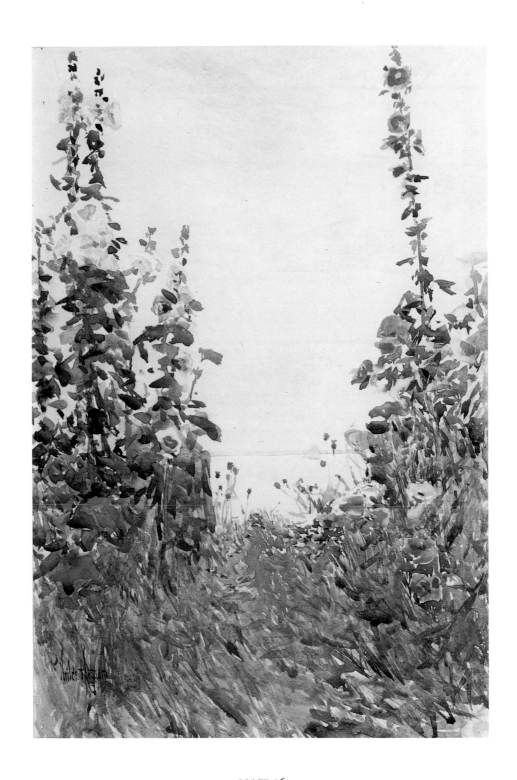

PLATE 26
Childe Hassam
Hollyhocks in Late Summer, 1892
Watercolor, 17½ x 11⅜ inches
Mr. and Mrs. Brayton Wilbur, Jr., Courtesy Hirschl and Adler Galleries, New York

FIGURE 2.12
Karl Thaxter
Celia Thaxter's garden
fence, looking southwest
towards Babb's Rock and
the bathing sheds, c. 1892
Photograph
Courtesy Star Island
Corporation

white poppies conjured out of nearly blank paper are some of the artist's painting techniques that will grow familiar as we continue to examine these watercolors. A network of slightly opaque silvery lines suggests the supporting strings that allowed the flowers to stand tall against gusty sea breezes.

The title commemorates a nearly tame hummingbird that often alighted "on a dry pea-stick near the Larkspurs." Thaxter reported that the little bird—a living jewel—would soar off "on burnished wings, away beyond the garden's bounds," returning later "to occupy his perch in triumph."[36] Similarly, Hassam ranged beyond the flower beds to find motifs for *The Island Garden* (*see* Plate 30) and other Appledore pictures.

The setting for *Hollyhocks in Late Summer* (Plate 26) is more ambiguous than *Home of the Hummingbird*. We know that hollyhocks were planted along the fence (Fig. 2.12). Yet, while the artist leads us out the west garden gate towards the shoreline, he offers very little sense of the surrounding fence or open gate itself. We can scarcely tell we are in the garden; this is true of a number of the flower pictures.

Spatial tensions, the kind Hassam frequently played with, mark this composition. Spires of hollyhocks flank the deep central space, but Hassam brought them nearly to the top of the sheet, flattening and denying that same space. He used a few touches of bright yellow—probably inspired by coreopsis growing in the garden—to focus the eye on the vacancy, and he moved the viewer's eye into the distance with a few wispy brown poppy pods that echo the tall hollyhocks.

Once again Hassam approached his subject in a consistent manner, using the general composition of *In the Garden* (*see* Plate 18). He also employed it to depict *The Bride*, a white poppy Thaxter especially admired (Plate 29). The original watercolor is unlocated, but the book illustration was composed on the same lines as *Hollyhocks in Late Summer*. All these flowers did not bloom by the garden gate, but Hassam "planted" them there, relying on the opening in the fence to heighten the drama of near and far pictorial space by adding a central expanse of distant sea, sometimes enlivened by a passing sailboat.[37]

From the Doorway offers a vista available from either Thaxter's cottage doorway or from Hassam's painting studio (Plate 27). However, the artist suppressed almost all the architectural elements in his sight line (*see* Fig. 3.10). We can just see the top board of the fence, which helps to divide the composition into techtonic registers of near, middle, and far distance.

The view to the southwest encompasses the prominent dome of Babb's Rock in the middle distance, and the curving southwest tip of Appledore Island, which trails off towards Cannon Point at the far left. Londoner's or Lunging Rock marks the horizon line.[38] This watercolor, which illustrated Thaxter's book, relates closely to a number of the most impressive oils from the Shoals. Hassam explored the possibilities of the composition thoroughly, and flowers, not rocks, are dominant. Forceful explosions of shimmering poppies spill across the foreground planes, sometimes engulfing the rocks, always contrasting the enduring bluish gray granite with their transient pinks and reds.

Fallen poppy petals introduce Celia Thaxter's thoughts on gardening (Plate 28). Poppies are not only the most frequently mentioned flower in *An Island Garden*, but also the flower Hassam most often chose to paint there.

Long connected with beauty, magic, and medicine, poppies were well on their way to becoming an international design motif by 1881 when Bunthorne, in Gilbert and Sullivan's operetta *Patience*, suggested that one might "rank as an apostle in the high aesthetic band, / If you walk down Picadilly with a Poppy or a Lily in your mediaeval hand."[39] Frequently seen in company with the humble sunflower, the common poppy lent itself to exploitation in stylized decorative art. Like the sunflower's flat radiating petals, the poppy's sinuous whiplash stem offered opportunities for flat graphic adaptation. While the sunflower was a standard symbol of the Aesthetic Movement, the poppy eventually became a principal emblem of Art Nouveau.[40] Sunflowers and poppies grew together in Thaxter's garden and are juxtaposed in several of Hassam's pictures.

The ravishing beauty of the relatively simple poppy, as well as its habit of rapidly shedding its petals, stimulated associations with extravagance or pride and its loss.[41] Prolific flowering led to connotations of fertility. Victorian annuals of Hassam's day reflect centuries-old knowledge of the flower's medicinal powers. Poppies were thought to symbolize forgetfulness, sleep, or death.[42] By the turn of the twentieth century, these sinuous long-stemmed flowers had become an easily recognized motif that could ornament a delicate book cover or splash across a tiled building facade (Figs. 2.13, 2.14).

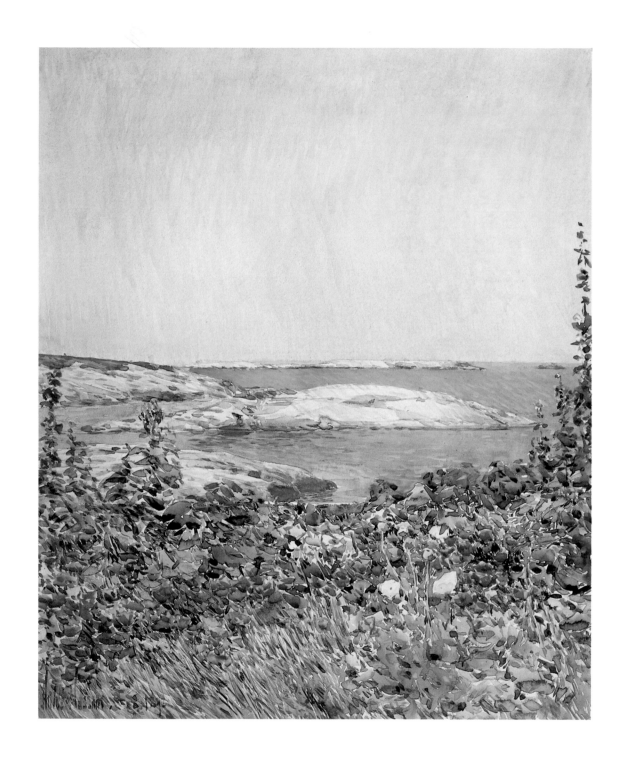

PLATE 27
Childe Hassam
From the Doorway, 1892
Watercolor, 21¼ x 17¼ inches
The Shearson Lehman Hutton Collection,
Courtesy Hirschl and Adler Galleries, New York

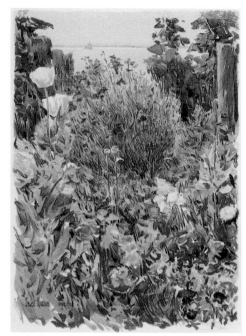

PLATE 29
Armstrong & Company
After Childe Hassam
The Bride, 1892
Chromolithograph
From *An Island Garden*, 1894
Private collection

PLATE 28
Childe Hassam
Poppy Petals, n.d.
Title page for *An Island Garden*, 1894
Watercolor, 9⅞ x 7⅝ inches
Courtesy Boston Public Library, Print Department,
Gift of Kathleen Rothe

FIGURE 2.13
Cover
For Rudyard Kipling,
Mulvaney Stories, 1897
Embossed fabric
Private collection

FIGURE 2.14
Otto Wagner
Majolikahaus, Vienna,
1898
Ceramic tile over masonry
From *Art Nouveau
Architecture* (New York:
1979)

FIGURE 2.15
Robert William Vonnoh
Poppies, 1888
Oil on canvas
13 x 18 inches
The Indianapolis Museum
of Art, James E. Roberts
Fund, 1971

FIGURE 2.16
Childe Hassam
Illuminated page, c. 1890
Watercolor over set type
From Celia Thaxter,
"West-Wind."
Courtesy Boston Public
Library, Rare Books
Department

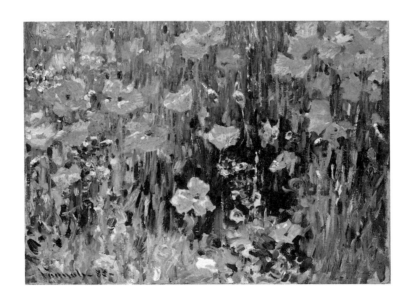

WEST-WIND.

THE barley bows from the west
 Before the delicate breeze
That many a sail caressed
 As it swept the sapphire seas.

It has found the garden sweet,
 And the poppy's cup it sways;
Bends the golden ears of wheat;
 And its dreamy touch it lays

On the heavy mignonette,
 Stealing soft its odors fine,
On the pansies dewy yet,
 On the phloxes red as wine.

Where the honeysuckle sweet
 Storms the sunny porch with flowers,

Paintings, notably by impressionists, precede the flower's turn-of-the-century vogue as a design motif. Executed in the early 1890s, Hassam's many pastels, watercolors, and drawings of poppies are among them. But Hassam's works are neither the first nor the only such pictures by an American. The poppy was frequently chosen by Hassam's compatriots. Maria Oakey Dewing, George Hitchcock, Willard Metcalf, Frank Millet, Walter Shirlaw, as well as Robert Vonnoh, Hassam's associate in Paris during the late 1880s, are some of the painters who shared Hassam's interest in this subject.[43] Vonnoh's close-up sketch of 1888 (Fig. 2.15) seems to presage a similar composition by Hassam painted in 1892 (Plate 30).

How much of the prevailing symbolism can be read into Hassam's poppies? He certainly knew Thaxter's poetry. In "Schumann's Sonata in A Minor," Thaxter wrote:

> *The stately poppies, proud in stillness, stand*
> *The silent splendor of superb attire*
> *Stricken with arrows of melodious sound*
> *Their loosened petals fall like flakes of fire*[44]

Clearly, Hassam shared with Thaxter a fondness for the flower's "wondrous variety, for certain picturesque qualities, for color and form and a subtle mystery of character," and he even sketched a poppy swaying in the wind across the page of one of her poetry books (Fig. 2.16).[45] However, while his beautiful pictures might awaken specific associations in the minds of individual viewers, simplistic generalizations about their symbolism are not appropriate. Unlike some of Hassam's more ambitious studio pictures with their layered commentary on urban or social change, the poppy pictures seem straightforward.

Hassam's most obvious stylistic stimulus—Monet—will be considered shortly, but let us preface the discussion with an observation. French impressionism in general offered the academically trained American artist a successful model for the capture of fleeting sunlight effects set down on canvas or paper in assertive, juxtaposed patches of broken color.[46] The chief importance of the poppy series lies in the opportunity it provided for Hassam to experiment with the formal problems of impressionism.

However, the poppy pictures are more than exercises in impressionist technique. Another potent influence, which can be traced to Britain rather than France, merits lengthy discussion. The culturally complex issue of exalted natural beauty is revealed in the pages of Thaxter's *Island Garden*, upon which Hassam collaborated. Thaxter was frankly indebted to John Ruskin's naturalist philosophy; indeed, Ruskin appears by page twenty-five of the book. As Thaxter went on, she quoted the nineteenth-century critic directly and at length, including this passage from *Proserpina*:

> *The poppy is painted glass; it never glows so brightly as when the sun shines through it. Wherever it is seen, against the light or with the light, always it is a flame, and warms the wind like a blown ruby. . . .*[47]

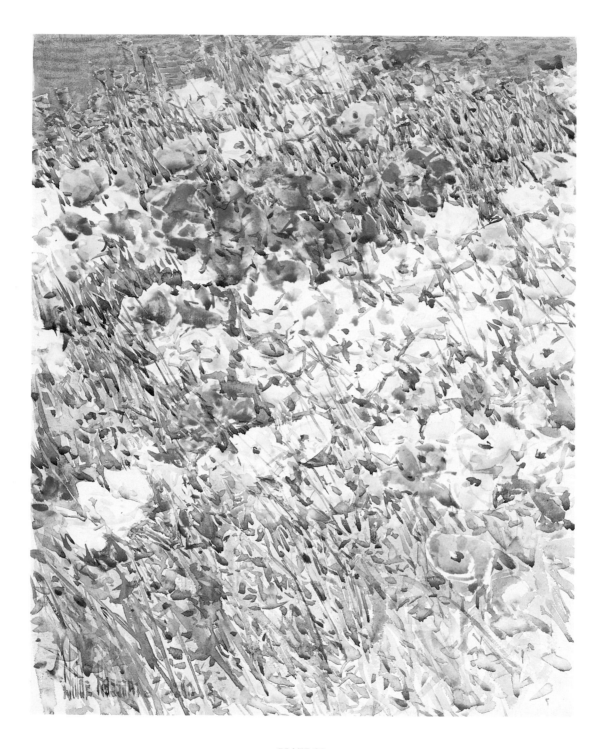

PLATE 30
Childe Hassam
The Island Garden, 1892
Watercolor, 17½ x 14 inches
The National Museum of American Art, Smithsonian Institution,
Gift of John Gellatly, 1929

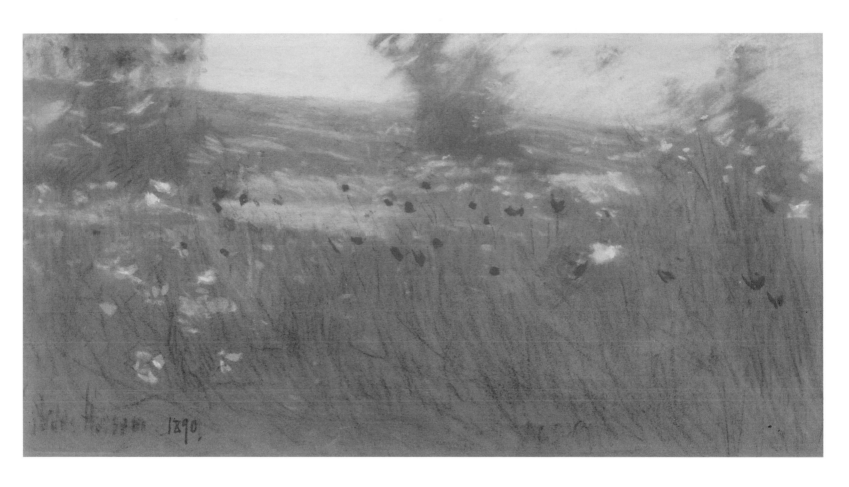

PLATE 31
Childe Hassam
Poppies, Isles of Shoals, 1890
Pastel, 7 ¼ x 13 ¾ inches
Collection of Mr. and Mrs. Raymond J. Horowitz

Hassam's ravishing watercolor *The Island Garden* offers the viewer no option but to succumb to the visual opiate, tumbling headlong into his sea of flowers (Plate 30). Hassam, like Ruskin, turned sharp scrutiny of the fragile poppy into an exultant paen to natural beauty. Hassam achieved this visual splendor by means of wet, layered strokes of red pigment, but again white flowers were brought forth from almost blank paper deftly articulated with thin blue washes. A few dots of mustard yellow float on the topmost surface.

As "old-fashioned" flower gardens were a colonial revival antidote to the fast pace of modern life, so Ruskin's excursions into botany reflect his longing for a more innocent past. *Proserpina* was subtitled "Studies of Wayside Flowers, While the Air was Yet Pure among the Alps, and in the Scotland and England Which My Father Knew." Ruskin believed that a "condition of childhood" made it possible to create instinctive, energetic, vital works of art that didn't rely on rote solutions to long-familiar problems. His "innocent eye" became the "primitivism" of early modernists, and Hassam's desire for an annual summer escape to out-of-the-way Appledore prefigures the refreshment sought by participants at remote artists' colonies of the twentieth century.[48]

Boston was the American stronghold of Ruskinian philosophy, and many of its advocates were fond of sojourns in the carefree, rustic atmosphere of the hotel and cottage on Appledore. Of course, Ruskin's ideas were discussed in Celia Thaxter's parlor. Like Ruskin, Thaxter carefully examined flowers to know them better, but both writers avoided scientific analysis in favor of description. Thaxter found it wise "to carry in one's pocket a little magnifying glass, for this opens so many unknown gates into the wonders and splendors of Creation."[49] The knowledge thus garnered was the pathway to imaginative sensibility.

Hassam's many treatments of the poppy in oil, watercolor, and pastel suggest that he, too, looked at the plants carefully, but he joined Ruskin and Thaxter in using observations of nature as a springboard for the imagination. Two breezily rendered pastels convey an invigorating offshore wind tossing the delicate flower heads. In one of them, Hassam left much of the paper blank, touching his chalks to the surface as lightly as a passing zephyr (Plate 31). In the other, a greater amount of pigment builds a sensuous surface that takes on an abstract life of its own with colors that have remained bold and fresh (Plate 32). In these two works, the artist offers us not so much a record of place as an intimation of spirit, communicating what it was to pause for a moment amidst such resplendent blossoms.

Ruskin's mixed feelings towards science dictated an emotive floral mythology.[50] His attempts at botany were based on the fierce scrutiny of plant life, but his work was informed by Thomas Carlyle's dictum, "To know a thing . . . a man must first *love* the thing, sympathise with it: that is, be virtuously related to it."[51] *An Island Garden* palpably demonstrates such a relationship between gardener and garden. "The flowers know that I love them," Thaxter wrote.[52] Hassam's reaction to the garden is equally engaged.

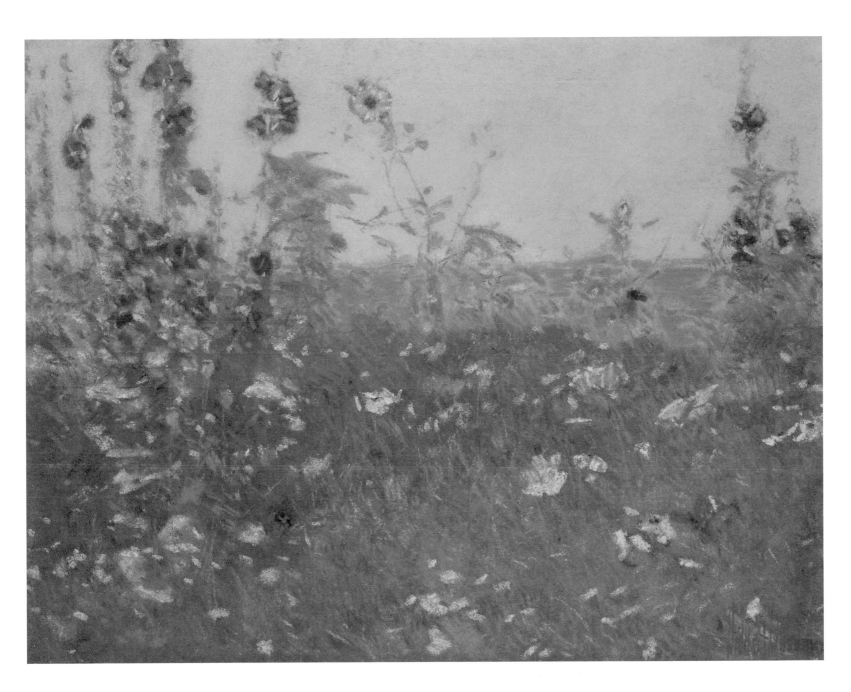

PLATE 32
Childe Hassam
Isles of Shoals, c. 1890
Pastel, 9¾ x 12¼ inches
Private collection,
Courtesy Hirschl and Adler Galleries, New York

Ruskin saw nature as a manifestation of God, and Thaxter seems to have espoused the conventional religious views of her era.[53] Her island garden can be understood in part as an inspiring symbol of godliness rooted in the nourishing intellectual soil of transcendental New England.[54] But religious underpinnings allowed Thaxter to indulge in a nearly pagan sensuality, as witness her exalted descriptions of color harmonies, or even her prosaic description of the small steam tug *Pinafore*:

> . . . *a pretty sight . . . when she starts out from the old brown wharves and steams away down the beautiful Piscataqua River, with her hurricane deck awave with green leaves and flowers, for all the world like a May Day procession.*[55]

Some of Hassam's ravishing flower pictures barely skirt the unbridled sensuality that smelled of danger for earlier New Englanders, including Nathaniel Hawthorne, whose short story "The Maypole of Merrymount" explores the topic. Related to Hawthorne on his mother's side, Hassam shared a patrician New England background, but he left little written comment on his moral beliefs. It would be an act of overinterpretation to read his highly wrought Shoals pictures as palimpsests of transcendental ideas.

Indeed, one hallmark of late nineteenth-century modernism was the lack of obvious moralizing. A neutral stance and an emphasis upon facture was recognized in Hassam's work early on. "There is a fine absence of moral purpose in Hassam's pictures; he is as irresponsible as a Frenchman and bows to the aesthetic deities alone," wrote a critic of an early Hassam exhibition at Doll and Richards' gallery in Boston.[56]

In Ruskin's aesthetic deification lies his link to Hassam, for the British critic was not only a moralist, but also the most important aesthetic authority of the nineteenth century. Ruskin suggested in *Modern Painters* that one "associate his study of botany, as indeed all other studies of visible things, with that of painting."[57]

A Pre-Raphaelite echo is evident in Hassam's precise, elegant watercolor, *Flower Garden* (Plate 33), which relates closely to the illustration *Larkspurs and Lillies* (*see* Plate 21). These images remind us that Hassam grew up during the heyday of the Pre-Raphaelite movement in America. Hassam would have known of Ruskin's impact on the American founders of the Association for the Advancement of Truth in Art, which flourished in the 1860s. As Linda Ferber has written, "their prototypes and models for landscape were located in the realm of site-specific documentation and properly recorded natural history, with 'the photograph' and the 'topographical report' as standards of accuracy."[58] Watercolor was a favored medium and close studies of plant life were favorite subjects. *Anemones*, by Henry Roderick Newman, literally reflects Ruskin's comment that "the most beautiful position in which flowers can be seen is precisely the most natural one—low flowers relieved by grass or moss" (Fig. 2.17).[59]

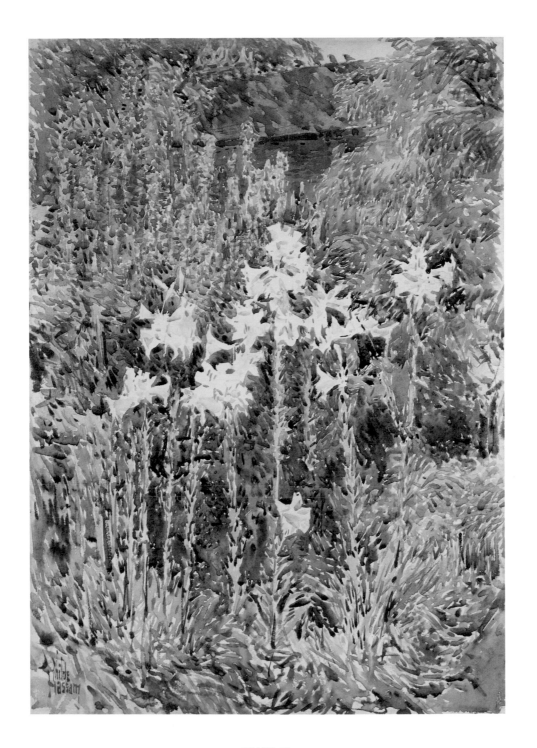

PLATE 33
Childe Hassam
Flower Garden, 1893
Watercolor, 19⅝ x 13⅞ inches
Mr. and Mrs. George M. Kaufman

Relentlessly precise watercolors of woodland blossoms were still being made when Hassam began to visit the Shoals in the mid-1880s. But if we compare Newman's carefully executed *Wild Flowers* of 1887 with Hassam's ethereal image of cultivated poppies and larkspur painted just a few years later (c. 1890), we see how far towards expressive brushwork Hassam moved following his exposure to French impressionism (Fig. 2.18, Plate 34). Newman tells, Hassam suggests.

In Hassam's lyrical watercolor, pink washes are strengthened with touches of deeper red, lavenders are intensified with blues, and white poppies are again evoked with almost no pigment at all. We can barely make out the artist's indication of the garden fence to the left. This fresh sheet is a visual tonic.

In oil, as well as watercolor, Hassam responded to atmospheric effects and glorious swaths of color created by wild flowers growing in profusion near rocky shores. Vigorous open brushwork characterizes a small, richly worked blue and green panel, *Hazy Day, Appledore* (Plate 35). The impact

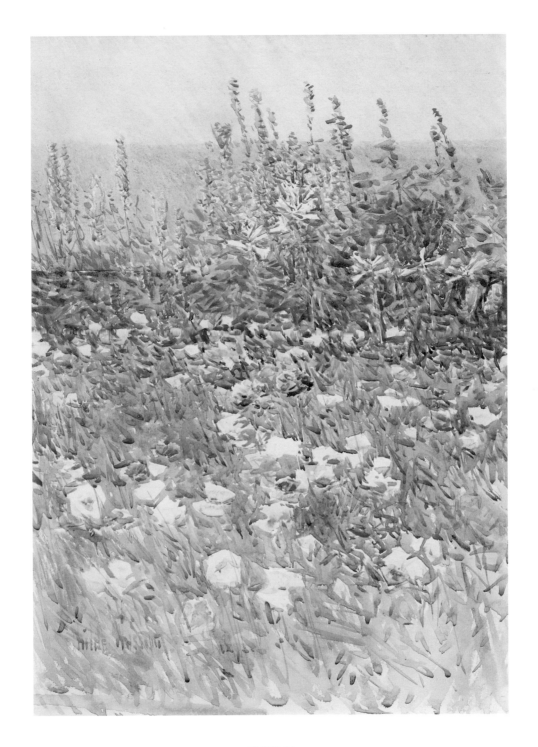

PLATE 34
Childe Hassam
Flower Garden, Isles of Shoals, 1893
Watercolor, 19½ x 13½ inches
Private collection

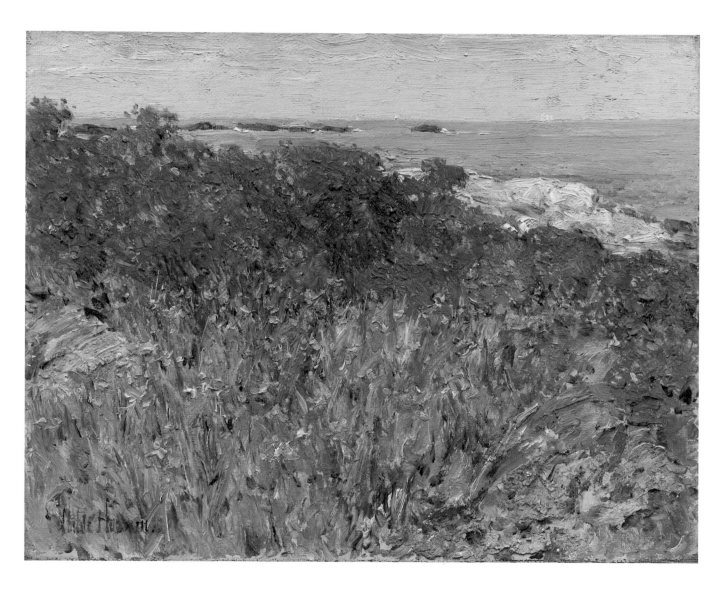

PLATE 35
Childe Hassam
Hazy Day, Appledore, c. 1890
Oil on canvas board, 7⅛ x 9 inches
Private collection

of impressionism is evident, but we need not think that Hassam completely forgot Ruskin while in France. In *Elements of Drawing*, a standard beginner's text of the era, Ruskin advised:

> Look much at the morning and evening sky, and much at simple flowers—Dog-roses, Wood-hyacinths, Violets, Poppies, Thistles, Heather, and such like,—as Nature arranges them in the woods and fields. If ever any scientific person tells you that two colours are "discordant," make a note of the two colours, and put them together whenever you can. I have actually heard people say that blue and green were discordant; the two colours which Nature seems to intend never to be separated, and never to be felt, either of them, in its full beauty without the other! a peacock's neck, or a blue sky through green leaves, or a blue wave with green lights through it, being precisely the loveliest things, next to clouds at sunrise, in this coloured world of ours.[60]

Ruskin's concern with color was sympathetic to the development of abstract painting. He commented tartly, "A single dusty roll of Turner's brush is more truly expressive of the infinity of foliage, than the niggling of Hobbema could have rendered his canvas, if he had worked on it till doomsday."[61]

Hobbema, a seventeenth-century Dutch landscapist, was noted for endless, detailed images of trees. But in *Hazy Day*, Hassam is as expressive as Turner, swiftly applying olive green and periwinkle blue pigments that evoke the splendor of a wild iris field seen through a pellucid haze: "Every bit of swampy ground is alive with the waving flags of the Iris . . . full of exquisite variety of tint and shade . . . set like amethysts in the rich greens and browns of turf and mossy space."[62] Robert Herbert neatly ties Ruskinian theory to the aims of impressionist artists, emphasizing that Ruskin's vision was that of a painter, not an architect or sculptor. The critic's writings are imbued with a passion for light and color.[63] As Monet crisply informed a British reporter, "ninety percent of the theory of impressionist painting is . . . in *Elements of Drawing*."[64]

Hassam must have found Ruskin's emphasis on aesthetics congenial. Ruskin believed that "the flower exists for its own sake,—not for the fruit."[65] Art for art's sake was fundamental to Hassam's creative output, and he cannot have disagreed with Ruskin's comment, "Wherever men are noble, they love bright colour, and wherever they can live healthily, bright colour is given them—in sky, sea, flowers . . . ".[66] In retrospect, Ruskin's comment seems to encapsulate the topics Hassam chose during his painting campaigns on the Isles of Shoals.

Ruskin emphasized the primacy of pure color: "The arrangement of colours and lines is an art analogous to the composition of music, and entirely independent of the representation of facts." But he pointed out that "good colouring does not necessarily convey the image of anything but itself." He went on, "good colouring does not consist in . . . imitation, but in the abstract qualities and relations of [juxtaposed colours]." Since he believed that "the noblest art is an exact unison of the abstract value with the imitative powers of forms and colours," Ruskin insisted on analyzing both abstraction and imitation.[67] These two qualities coexist in Hassam's paintings. Ruskin observed that "accurately

balanced form" and the "perfectly infused colour of the petals" together made up the essence of the poppy.[68] Form and color were the fundamental poles for painting at this time, and Hassam would have heard the debate at length in Boston and Paris during the late 1880s. That Ruskin did not find form and color mutually exclusive could have reinforced the underlying premise of Hassam's artistic career: the exercise of academic skills can be enlivened by an emotional response to color. This essential blend of linear and painterly expression characterizes Hassam's impressionist pictures. Even when objects depicted in space are created out of broken color, rather than limned with hard edges, Hassam was reluctant to abandon his sense of shape.

If we consider Hassam's enormous oeuvre in its entirety, we will find much that is uneven. His problems lay chiefly in drawing and composition, especially in his later years. But Hassam consistently employed color with a sure hand, as more than one critic observed:

> *It is always color that stirs him . . . form, in essence, is not his metier. By color we mean . . . an element in which his best ideas live and breathe and have their meaning.*[69]

Ruskin honored the ability to color as the highest instinctual gift, and his own response to color in nature was as instinctive as it was eloquent:

> *I have in my hand a small red Poppy . . . an intensely simple, intensely floral, flower. All silk and flame: a scarlet cup, perfect-edged all round, seen among the wild grass far away like a burning coal fallen from Heaven's altars.*

Thaxter included this passage from *Proserpina* in *An Island Garden*, embroidering upon it in her own words.[70] And another wet, luscious stand of poppies by Hassam closely parallels Thaxter's extravagant prose (Plate 36):

> *Wrinkled in a thousand folds [the flower petals are] released from their close pressure. A moment more and they are unclosing before your eyes. They flutter out on the gentle breeze like silken banners to the sun . . .*[71]

Without providing a particular sense of place, the watercolor contrasts poppies with the open sea.

A lavish oil now titled *Celia Thaxter's Garden, Isles of Shoals, Maine*, anchors the viewer with a site-specific glimpse of Babb's Rock in the center (Plate 37). The entire foreground of this compelling canvas is filled with dazzling poppies, each one "a diamond of flame in a cup of gold. It is not enough that the powdery anthers are orange bordered with gold; they are whirled about the very heart of the flower like a revolving Catherine-wheel of fire."[72] The fireworks, whether written or visual, are intoxicating.

Over and over, Hassam set transient poppies against open waters and weathered rocks. The contrast of nature's temporal and enduring aspects—"the Poppy's red effrontery," as Browning put

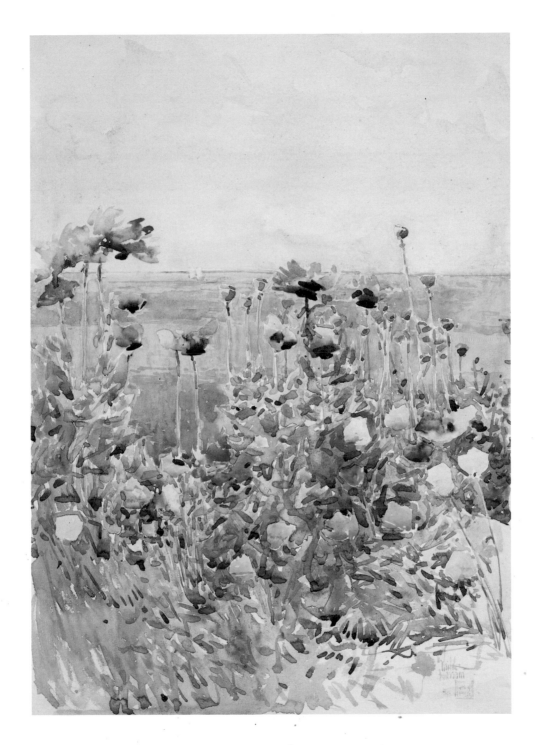

PLATE 36
Childe Hassam
Poppies, Isles of Shoals, 1891
Watercolor, 19⅞ x 14 inches
Private collection,
Courtesy Keny and Johnson Gallery, Columbus, Ohio

it—invests these pictures with lasting strength. Again we are reminded of Ruskin. As art historian Barbara Stafford has recently pointed out, "constant vigilance in observation led to Ruskin's perception of a cosmic dualism between enduring moments and fugitive effects."[73]

Writing on the eve of Hassam's departure for study in Paris in 1886, a critic for *Art Amateur* labeled Claude Monet a humble follower of Turner, one of Ruskin's championed artists.[74] The notion of Turner's influence was not particularly disturbing to the impressionists themselves. In a letter to Sir Coutts Lindsay, founder of the Grosvenor Gallery in London, nine artists, including Degas, Monet, Renoir, and Cassatt, celebrated Turner's rendering of light and movement. Given Hassam's vehement statements later in life denying any significant influence by Monet and emphasizing the importance of British art for his own development, one suspects that he would have agreed.[75]

But, no matter how tiresome Hassam must have found his early twentieth-century pigeonhole as the American Monet, the Shoals pictures bear eloquent witness to Monet's fertilization of Hassam's painting style. The most memorable Appledore images, like Monet's finest works, combine great delicacy with resonant strength.

Much has been made, by both Hassam and later writers, of the fact that the American never met the Frenchman or visited his home in Giverny. The significance of this issue can be somewhat downplayed given the jingoism that, until recently, characterized the history of American art.[76] And more germane than social appointments on Hassam's calendar are the myriad opportunities he had to examine oils by Monet lent for public exhibition.[77]

In 1886, just before Hassam went abroad, the Parisian dealer Durand-Ruel tested the American market with an initial exhibition of French impressionism in New York. Hassam probably saw it. Durand-Ruel displayed one of four Monets depicting the artist's garden at Vetheuil.[78] We are not certain which canvas was on view in New York, but it was singled out for attention in the press. Any one from this series (Plate 38) could inform Hassam's composition of *The Garden in Its Glory* (*see* Plate 16).

Although the records are not precise, two poppy pictures were among the forty-eight Monets shown by Durand-Ruel in 1886 (Plate 39). Monet's poppies received press coverage, both positive and negative, and the two pictures soon ended up in American collections.[79] Hassam began his own poppy pictures just a few years after the Durand-Ruel exhibit. The issue here is less to locate specific French sources for Hassam's work than to suggest the kind of picture that might have encouraged his gradual move away from the tightly drawn, dark compositions of his early years towards the involvement with impressionist themes and treatments that characterize his mature paintings, watercolors, and pastels.

While Hassam protested Monet's influence too much, his work was not completely transformed by the lessons of French impressionism, a problem that will receive further examination in Chapter 3. Hassam was already a remarkably mature young artist when he set up a studio in Paris and

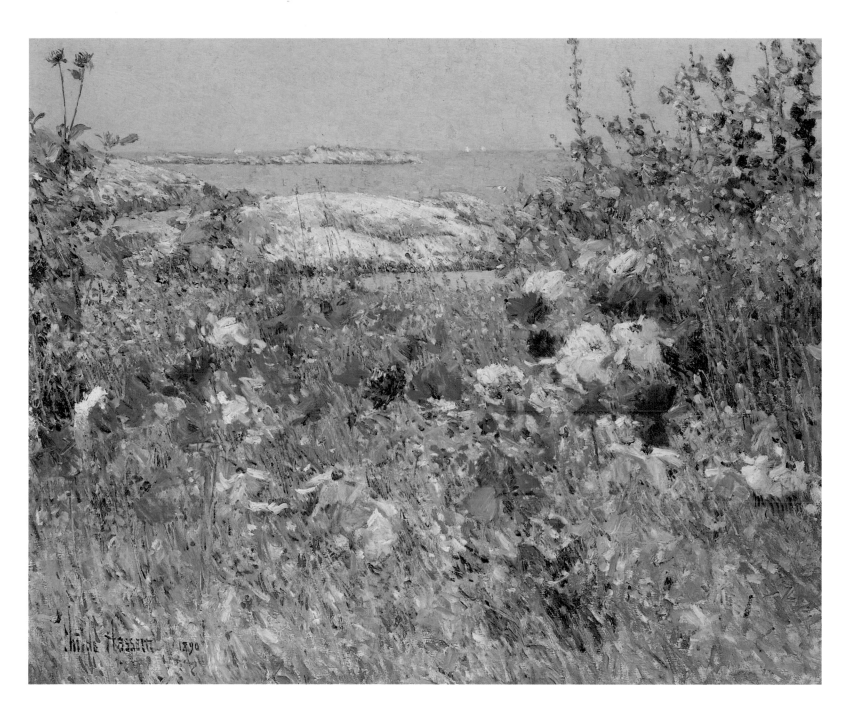

PLATE 37
Childe Hassam
Celia Thaxter's Garden, Isles of Shoals, Maine, 1890
Oil on canvas, 17¾ x 21½ inches
Private collection

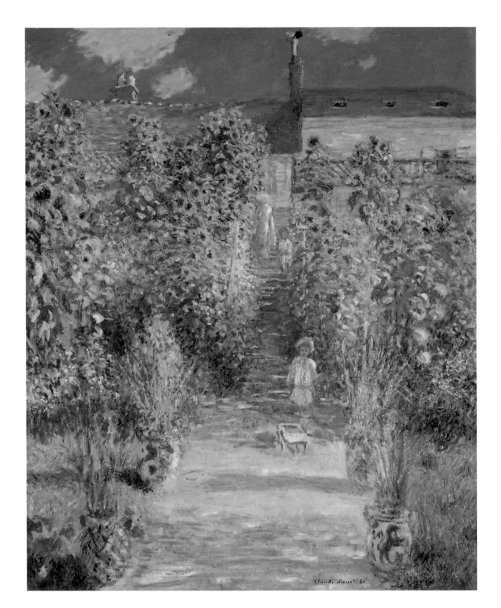

enrolled during the winter of 1887 for drawing instruction under Jules Lefebvre at the Académie Julian, an independent school popular with American expatriates.[80] We will not find a clear progression from tight to loose brushwork or dark to blond palette in Hassam's work during his Parisian period. Two flower pictures illustrate the stylistic antipodes of Hassam's French paintings during the late 1880s (Plates 40, 41). That the small, impressionistic *Gathering Flowers in a French Garden* precedes the large, academic *Chez la Fleuriste* lends credence to William Gerdts' thesis that "Hassam seems to have chosen to work in whatever manner best suited his purpose and his interpretation."[81]

PLATE 39
Claude Monet
*Poppy Field in a Hollow
near Giverny*, 1885
Oil on canvas,
25⅝ x 32 inches
Courtesy Museum of
Fine Arts, Boston,
Juliana Cheney Edwards
Collection. Bequest of
Robert J. Edwards
in memory of
his mother, 1925

Recurring themes characterize Monet's work during the 1870s and 1880s. Similarly, Hassam chose to paint the same subject from differing viewpoints in the early 1890s, as his multiple images of poppies near Babb's Rock attest. Hassam began the Appledore poppy series as Monet was ending his poppies at Giverny.[82] Monet went on to carefully orchestrated serial imagery, in the well-known cathedral and haystack pictures. Hassam's poppies, on the other hand, should not be considered a rigorously controlled series in the sense of Monet's later work. Hassam's Appledore flower pictures, like his French garden scenes, give no evidence of a chronological march from tight to painterly image.

Bright, light pigment applied with a loaded brush is perhaps the most obvious element of Hassam's French connection. But one would hardly mistake one of Hassam's poppy pictures for one by

PLATE 40
Childe Hassam
Gathering Flowers in a French Garden, 1888
Oil on canvas, 28 x 21 ⅝ inches
The Worcester Art Museum, Theodore T. and Mary G. Ellis Collection, 1940

PLATE 41
Childe Hassam
At the Florist, 1889
Oil on canvas, 36¾ x 54¼ inches
The Chrysler Museum, Norfolk, Virginia,
Gift of Walter P. Chrysler, Jr., 1971

Monet. All Hassam's poppies embody Celia Thaxter's coloristic sense of nature. She wrote of the Oriental poppy, "Its large petals are splashed near the base with broad, irregular spots of black-purple, as if they had been struck with a brush full of color."[83]

Monet's *Poppy Field in a Hollow near Giverny* (*see* Plate 39), one of the pictures Hassam probably had seen, is rich with complementary reds and greens. In the foreground, strokes in various shades of red maintain their individual integrity, going in all directions, rather like flower petals. Together these strokes describe single poppy heads. However, as Monet moved back into space, the red strokes became softer and more uniformly horizontal, blending together into a shimmering color field.

John House has carefully analyzed Monet's method, noting that to work up a background, the impressionist suggested masses without describing them in detail. Rather, Monet set his masses "in an atmospheric space." House points out that Monet was practicing a technique discussed by Delacroix earlier in the century:

> *When the touch is used as it should be, it affirms more appropriately the different planes in which objects lie. Bold and pronounced, it brings them forward; the opposite makes them recede.*[84]

House notes that Monet used color to unify different spatial registers into a single pictorial effect. In *Poppy Field in a Hollow near Giverny*, Monet flanks the red rectangle of flowers with long, soft vertical strokes of the same reds interspersed in the green grass. And above, at the upper right, Monet's soft ellipse of red-brown echoes the much more distinct poppies in the foreground, visually linking far and near space. In short, House concludes:

> *Monet variegated [his] surfaces not only to record the diversity of the scene, but also to extract a pictorial, two-dimensional coherence from the effects of space and pattern before him. Form and space were suggested by two principal means, by inflections of brushwork and by variations of colour and tone.*[85]

Field of Poppies near Giverny, created five years later, shows Monet's development of highly worked surfaces encrusted with colors that suggest, rather than describe, the natural forms before him (Plate 42). Atmospheric effects were his target, and the decorative horizontal bands of his picture make order of the nature he witnessed, transforming a field of flowers into a flat, two-dimensional artwork.

Hassam followed Monet down this particular garden path, but never to its end. Hassam's luscious floral image of 1890 (*see* Plate 37) parallels Monet's luxurious use of complementary red and green. Striated horizontal bands—near, middle, and far distance—are tied together by vertical flower stalks that cut across all three spatial registers. But the atmosphere remains clear, and Hassam moves the eye back into space through more conventional pictorial devices, reducing the scale of domical rocks as they recede in the distance. As the vertical flower stalks bracket Babb's Rock in the midground, tiny white sails bracket the distant Londoner's Rock, which Hassam brought closer to Appledore Island than it actually is. Big shapes echo little shapes, recalling the device of nearby and distant flower stalks

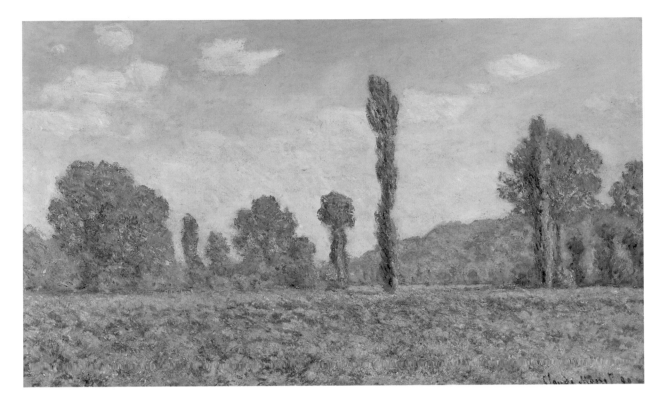

in the watercolor, *Hollyhocks in Late Summer* (*see* Plate 26). Hassam kept his brushstrokes descriptive. Whereas Monet was likely to treat a cloud the same way as a stone or a flower,[86] Hassam continued to differentiate textures: smooth sky, velvety petals, sharp-edged grasses, calm waters.

Like Monet, Hassam applied spiky little touches of color at the last minute to help unite spatial registers. Here yellow highlights in the foreground are repeated in the far distance, something we also see in watercolors such as *Dexter's Garden* (*see* Plate 19). Rendered in the same white pigments as some of the poppies, sails on the far horizon articulate the division between sea and sky. We see quite clearly that each tiny white stroke describes a canvas sail.

Hassam's brushwork is loose and easy in the Brooklyn canvas (1890), but it remains descriptive (Plate 43). Hassam has drawn us close to the voluptuous flowers, but he contained them neatly, filling one third of the composition with horizontal bands of mixed whites and pinks, punctuated with reds. Hassam broke spatial registers with truncated foliage used as a framing device on the right, and also employed his ubiquitous white sails. The artist echoed the stark white dome of Babb's Rock at the center of the picture with a modest but clearly arbitrary white cloud-puff in the sky.

An undated version of *Poppies* is constructed along the same lines from almost the same viewpoint (Plate 44). Poppies are a more prominent design element here, filling nearly two-thirds of the

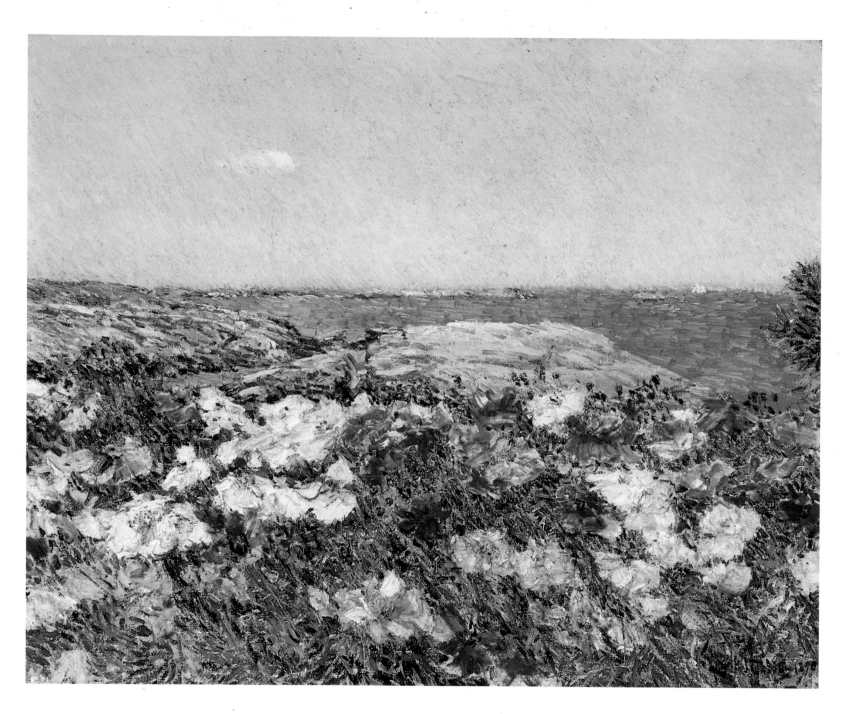

PLATE 43
Childe Hassam
Poppies on the Isles of Shoals, 1890
Oil on canvas, 18⅛ x 22⅛ inches
The Brooklyn Museum,
Gift of Mary Pratt Barringer and Richardson Pratt, Jr.,
in memory of Richardson and Laura Pratt, 1985

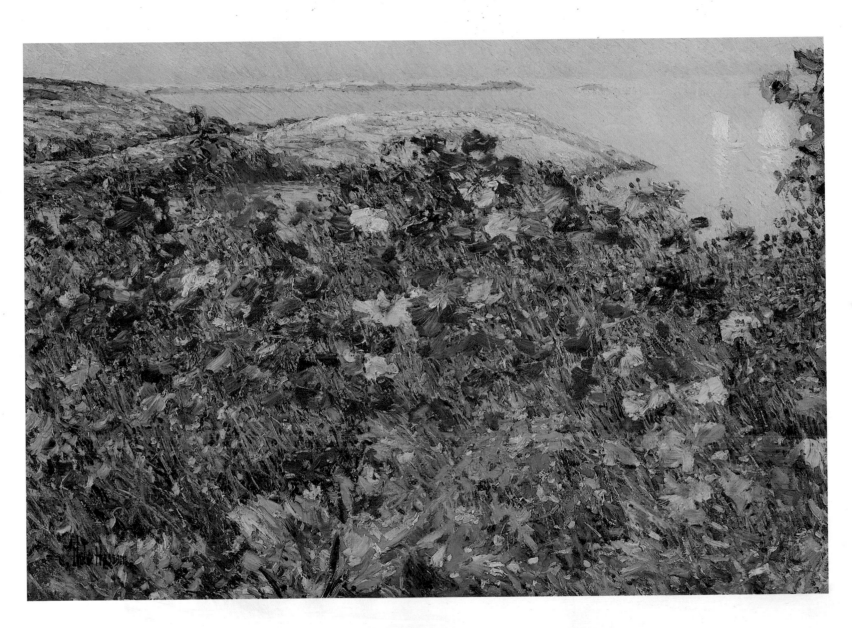

PLATE 44
Childe Hassam
Poppies, c. 1890
Oil on canvas, 18 x 25 inches
Private collection

canvas. This time, the flowers are less confined into a decorative band of broken color, and red dominates rather than accents the color harmony. As a block of broken color, the poppies rise in a gentle dome that echoes even as it partially masks Babb's Rock. Shapes are layered to move the eye back in space. Again the brushwork is both vigorous and descriptive. A yellow sunflower is the device that breaks through spatial registers this time, and the generally tilted-up picture plane gives the image a japanesque air.

The following year Hassam returned to this same spot. In another version dated 1891, Hassam once more filled the lower third of the picture plane with a contained horizontal band of poppies (Plate 45). Again Hassam positioned a rounded bush on the far right, but he kept it well below the horizon line, for this time its purpose was not to link three spatial registers. Instead, its two lobes lend a sense of symmetry to the composition, echoing the general shape of blue-gray rocks set opposite in the same register. Lush green pigment touched with yellow reinforces the sense of luxuriant growth on Cannon Point, and Babb's Rock, at the center of the picture, contains a sparkling turquoise "eye," one of the trapped pools that would evaporate as the day wore on.

Hassam's brushwork changes from one passage to the next, suggesting vertical brown and red rock faces, horizontal waves, and foliage tossed by the breeze that fills the sails of the craft heading in towards the hotel dock. His brushwork consistently distinguished individual flowers. The artist's strong color sense remains somewhat local: green foliage, red flowers, blue water, white sails. Hassam allowed a good bit of canvas to show through in the foreground, rather than encrusting the entire surface with paint as Monet might have done.

An undated oil, graced with a reticent row of red poppies, records a viewpoint slightly to the northeast (Plate 46). The blue paint of the sky and water are thickly applied and reach almost to the bottom of the canvas. With a tiny brush, Hassam painstakingly rendered his illusion of the rock's shimmering reflection. These strokes are shorter and more broken than the smoother, multidirectional slashes of pigment that establish the rock. Only the small area of poppies is thinly painted with ground showing through the sketchy greens and reds. In the distance, a zig-zag of periwinkle outlines the juncture of Londoner's Rock with the water, providing the kind of linear passage Hassam relied upon to define his subjects in space.

In another picture, painted at about the same time, the artist shifted his viewpoint even further to the right, approaching Babb's Rock so closely that the foreground flowers were eliminated altogether (Plate 47). Within the limited range of a blue-gray palette, there is coloristic nuance. While poppies in the grass are absent, tiny bits of complementary red and green articulate the waterline at the base of Babb's Rock. Hassam's sailboat is replaced by the little steamboat *Pinafore*, which animates the space like a tiny shepherd seated in a neoclassical landscape. And the miniscule flag flown from the prow of the *Pinafore* discretely ties middle and far distance together. Hassam accomplishes this with a single, almost microscopic dot of red.

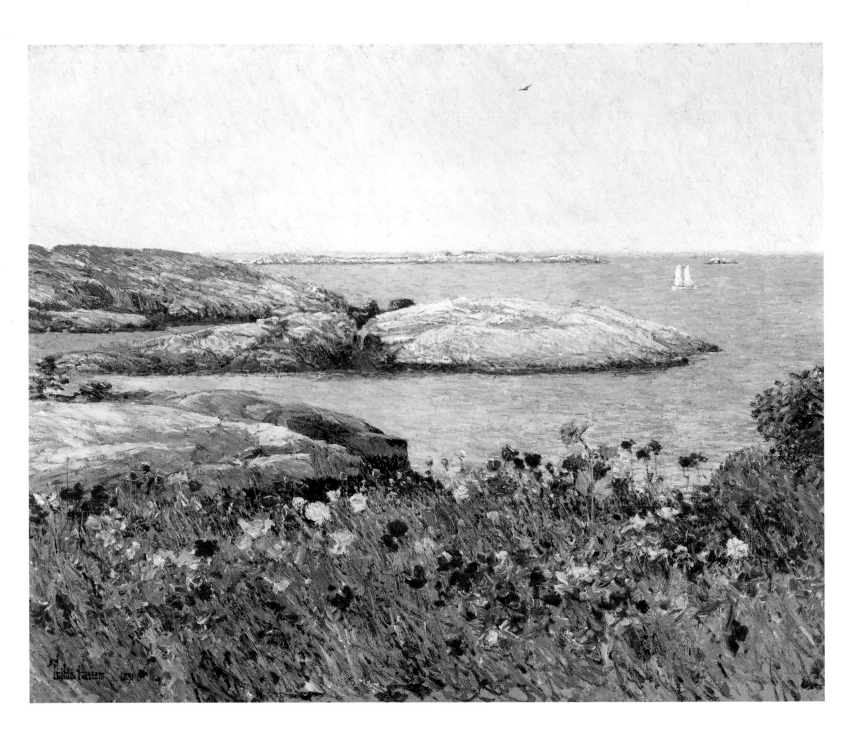

PLATE 45
Childe Hassam
Poppies, 1891
Oil on canvas, 19¾ x 24 inches
Collection of Mr. and Mrs. Raymond J. Horowitz

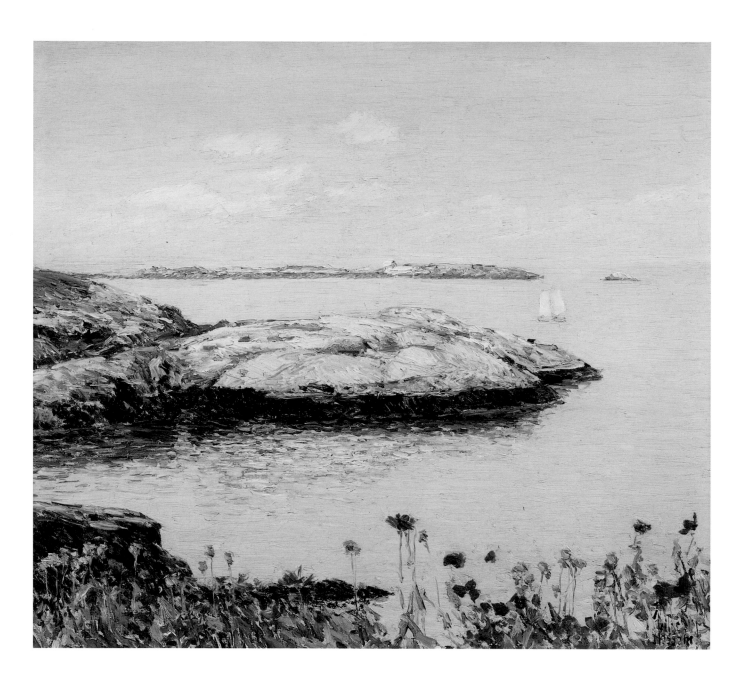

PLATE 46
Childe Hassam
Isles of Shoals, c. 1890
Oil on canvas, 15½ x 17¾ inches
Private collection,
Courtesy Graham Gallery, New York

PLATE 47
Childe Hassam
Appledore, Isles of Shoals, c. 1890
Oil on canvas, 15 ¼ x 18 ⅛ inches
Mr. and Mrs. Rodman Rockefeller,
Courtesy Richard York Gallery, New York

Hassam was by no means completely seduced by Monet's art, although he incorporated some of the Frenchman's techniques into his own style. No matter whether his brushwork is precise and delicate or vigorous and robust, the Shoals pictures are light in palette, filled with the sense of sunshine and fresh air. As one critic put it, "He saw the wisdom in Monet's impressionism. But these things opened his eyes rather than governed his brush."[87]

In all these works of art, Hassam relied upon shapes: horizontal bands of flowers, sea or sky, syncopated domical rocks in diminishing sizes, repeated flower heads, parenthetical sets of sails—to help establish a believable pictorial unity. Many of Hassam's most dependable artistic devices are drawn from the repertoire of the graphic arts with which he began his career.

Hassam's efforts to capture the garden in its glory coincide with a spreading interest in informal, "natural," or wild gardens, often considered in painterly terms. Arriving in America from Britain during the 1890s, interest lasted well into the twentieth century.[88] After Appledore, the subject of the artist's garden received wider attention. American writers used terms like "artist-gardener," and compared gardening to painting "with actual color, line and perspective"; that is, with real plants.[89]

Today's booming market for impressionist art in general and Hassam's Isles of Shoals pictures in particular can still be linked to the practice of gardening. During the past decade, America's love affair with horticulture has blossomed afresh. Statistics from the National Gardening Association indicate that spending for lawns and gardens doubled in the early 1980s. In 1988, American households spent $15.5 billion dollars on lawn and garden supplies.[90] There are nearly eight hundred books about gardens currently in print. Six magazines cover gardening matters, and one of them now circulates to almost 1.4 million readers.[91] A journalist for *Time* noted:

> Suddenly it seems as though all around the country people are going to any length to find their garden: to read about it, visit it and, if at all possible, create it. Mailboxes bulge with gardening catalogs, groceries grow on windowsills, cranes hoist trees onto city rooftops. From coast to coast, nursery owners say their business has doubled. Even baby boomers who did not have the remotest interest in the subject two years ago now rattle off the Latin names of their plants and comb suburban garden stores for just the right style of Japanese weed whipper.[92]

As during Appledore's heyday, links between literary, artistic, gardening, and collecting circles remain a part of contemporary culture. *Time* magazine recently commented, "Serious gardeners are like serious writers, painters, dancers."[93] Elaborate gardens, like expensive impressionist paintings, are important status symbols in contemporary life (Fig. 2.19). Gardening catalogues directed at well-heeled patrons go so far as to present literate educational entries and lavish illustrations reminiscent of an art exhibition catalogue.[94]

Recently, American money restored Monet's elaborate garden at Giverny.[95] Visitors flock to the French master's grounds in droves. Celia Thaxter's more modest garden has also been restored,

FIGURE 2.19
Warren Miller
Cartoon
For *The New Yorker*,
June 13, 1988

although its remote site makes it inaccessible to all but the most determined tourist. Visitors to these historic gardens can sense not only the physical beauties of the plants themselves, but also the stimulus to the imagination such gardens provide. In the hands of skillful artists, evanescent floral color and texture are translated into timeless art.

As garden historian Nevins reminds us, the idea of pictorial linkage between garden and canvas was an old idea when the impressionists took it up. For late eighteenth-century English theorists the word *picturesque* signified a literal equation between the appearance of a landscape and a painting.[96] Gardeners like Gertrude Jekyll drew inspiration from painters like J. M. W. Turner.[97] And painters like Hassam, also an admirer of Turner, learned from gardeners like Thaxter.

Stylistic changes which occurred in artistic circles over the course of the nineteenth century in Britain, France, and the United States should not blind us to shared basic principles. Hassam would have agreed with William Robinson that artist and gardener face similar design problems. Landscape painter, like landscape gardener, first sought and then manipulated elements from the ever-changing world of nature to create unique visual statements.

Two undated pictures, an oil and a watercolor, show Hassam venturing beyond the boundaries of Thaxter's garden out onto the rugged brush-covered rocks of Appledore Island. Together, they presage the formal concerns that would dominate Hassam's work at the Shoals during the early twentieth century.

PLATE 48
Childe Hassam
Mainland from the Isles of Shoals, c. 1890
Oil on canvas, 12¼ x 18⅛ inches
Private collection,
Courtesy Spanierman Gallery, New York

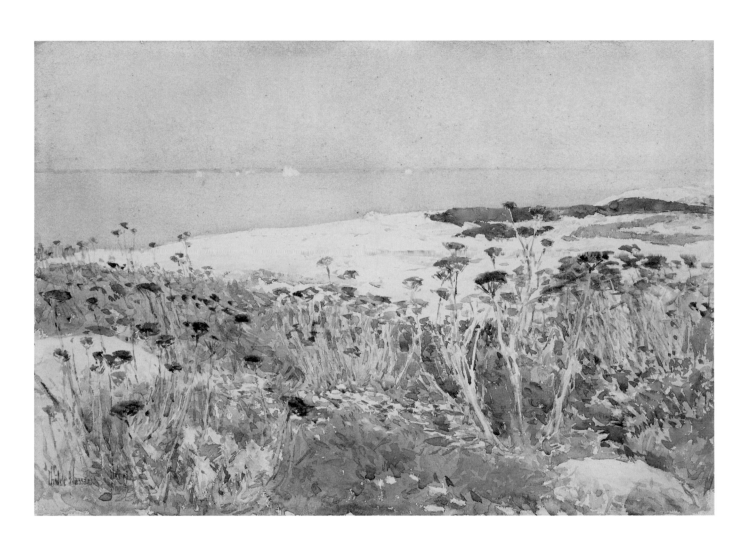

PLATE 49
Childe Hassam
Isles of Shoals, c. 1890
Watercolor, 14 x 19¾ inches
Private collection,
Courtesy Hirschl and Adler Galleries, New York

Roughly contemporary with the poppy pictures, *Mainland from the Isles of Shoals* (Plate 48) was in a private collection by 1896.[98] The image was heavily built up with pigments laid on in short, choppy strokes applied with a small brush. The handling here recalls *Hazy Day, Appledore* (*see* Plate 35). Poppies in the center of the picture are created with single, small but thick points of red and orange pigment. Multiple strokes of hot pink suggest the heads of *Rosa rugosa*. Areas of loosely applied white pigment indicate a series of rock shelves. Together the rocks form a V-shaped wedge which is, in turn, offset by a horizon line laid straight across the top of the canvas. Hassam reinforced the viewer's perception of clouds with lavender-blue underlining.

The watercolor's format (Plate 49) is virtually identical to the preceding oil. Hassam selected a rough, toothy sheet that gives the watercolor a suggestion of the more pronounced texture that characterizes the oil. The artist chose an unusual acid-yellow color scheme for this autumnal glimpse of wild grasses at the Shoals. Jade green, yellows, and reddish browns are sparked with discrete touches of orange-yellow and lemon. Hassam created a frieze-like series of sailboats across the horizon line. Using single wet splotches of nearly opaque white, Hassam distinguished the sails of a stately schooner, as well as several more distant craft. Touches of dark blue-green lie atop lighter gray washes. Spatial registers are carefully linked—weeds to rocks, rocks to water, sea to sky. Brown and sere, the spiky umbrellas of yarrow have finished blossoming and died back, a harbinger of autumn.

In the final pages of *An Island Garden*, Thaxter sensed the coming chill:

> Outside the garden this tranquil morning the soft green turf that slopes smoothly to the sea in front is shaggy with the thick dew from which the yet low sun strikes a thousand broken rainbows. The clumps of wild Roses glow with their red haws in the full light; the Elder bushes are laden with clusters of purple berries; Goldenrod and wild Asters bloom, and a touch of fire begins to light up the Huckleberry bushes, "Autumn laying here and there a fiery finger on the leaves." The gray rocks show so fair in the changing lights and all the dear island with its sights and sounds is set in the pale light summer-blue of a smiling sea as if it were June . . . [99]

It wasn't early June, but late September and Thaxter seemed to know that her own autumn was upon her (Plate 50). In this year before she died, she wrote:

> I muse over [Poppy] seed-pods, those supremely graceful urns that are wrought with such matchless elegance of shape, and think what strange power they hold within. Sleep is there, and Death his brother, imprisoned in those mystic sealed cups. There is a hint of their mystery in their shape of sombre beauty, but never a suggestion in the fluttering blossom . . . [100]

An Island Garden had been in print since Easter time in 1894, but Hassam turned away from fluttering blossoms after the poet's death later that summer. As his emotive interior, *The Room of Flowers*, memorializes Celia Thaxter's salon, the flower pictures memorialize her garden.

PLATE 50
Childe Hassam
Poppy Tops
Headpiece for *An Island
Garden*, 1894
Watercolor
9¹⁵⁄₁₆ x 7¹¹⁄₁₆ inches
Courtesy Boston Public
Library, Print Department,
Gift of Kathleen Rothe

Hassam stayed away from the Isles of Shoals for several years. When he came back, his concerns were expanding, for the century was turning and new themes were in order. Henceforth Hassam would devote himself to images of rocks and sea, and these would grow starker as the years passed by. But the delicate poppies and hollyhocks, larkspurs and lilies of his early Appledore pictures record not only the beauty of a poet's garden in its glory, but also the flowering of a young artist's dreams.

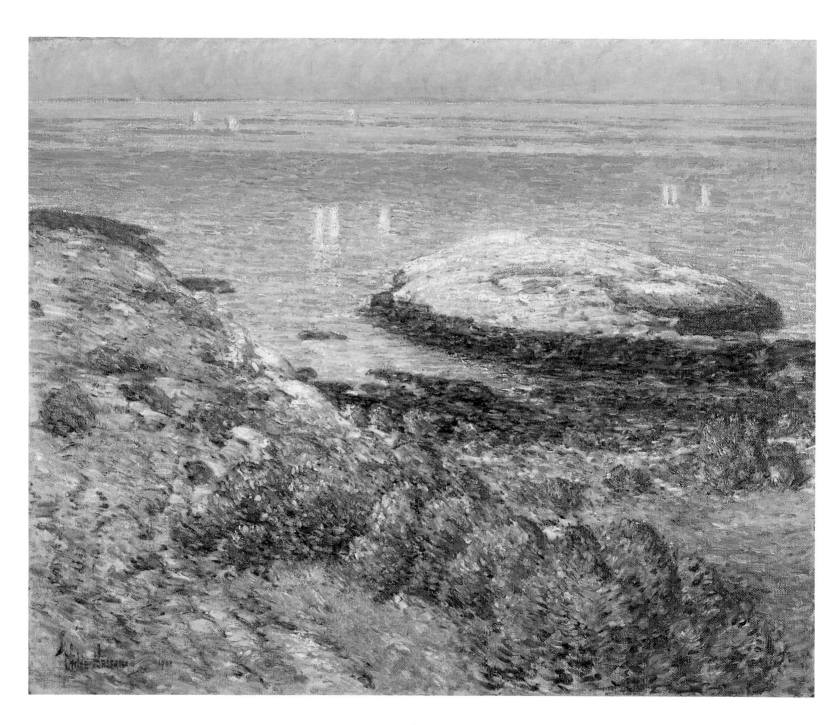

PLATE 51
Childe Hassam
Early Morning Calm, 1901
Oil on canvas, 25 x 30 inches
The Dayton Art Institute,
Gift of Mrs. Harrie G. Carnell, 1942

The Rocks of Appledore

*The glory of these islands is . . . in the rocks themselves . . . for their
soft grays and browns wed very happily with the scanty grass and
foliage, and bring forth exquisite effects of color.*

Harper's[1]

SEASCAPES DOMINATE CHILDE HASSAM'S OUTPUT AT THE ISLES OF SHOALS FROM 1899
until he stopped coming, around 1916. Two years earlier, a raging fire swept most of the buildings,
including the hotel, Celia Thaxter's parlor, and Hassam's little studio from their seemingly firm foun-
dations. The sudden obliteration of the Appledore resort serves as a harsh reminder of man's rather
tenuous hold on these glacier-scarred granite domes.

Hassam's multiple views of island cliffs and inlets record the always compelling confrontation
of ancient rocks against relentless waters. But unlike Monet and other contemporaries who traveled to
famous seaside tourist spots to explore the most powerful forces of nature (Plate 52), Hassam chose not
to grapple directly with mortal themes.

The Shoals crop up rudely from the vast expanse of the Atlantic Ocean, and initially they
seem forbidding: barren, sunbaked, and windswept. Thaxter wrote that "dark volcanic craigs and
melancholy beaches can hardly seem more desolate than do the low bleached rocks of the Isles of
Shoals to eyes that behold them for the first time." But Thaxter helped Hassam see beyond "mere
heaps of tumbling granite." He learned from her, "very sad they look, stern, bleak, and unpromising,
yet are they enchanted islands."[2] For both poet and painter, the infinitely aged Isles of Shoals were
precious stones set in a silver sea, "freshly green . . . flower-strewn and fragrant . . . musical with birds,
and with the continual caressing of summer waves."[3]

Early Morning Calm (Plate 51) sets the standard for Hassam's spirited seascapes at the Isles
of Shoals. With a loose, free brush, Hassam enlivened the bleached gray stone with bright strokes of
color. Set off by rust reds in the rocks, bits of blue, dark green, and white glimmer in the grasses.

On closer examination, the austere cliffs of Appledore, Star, Duck, White, and the other
islands provide a fragile yet fruitful environment for wild flowers and shrubs. The view back to the
mainland across ten miles of uncompromising ocean is softened during the summer months by colorful

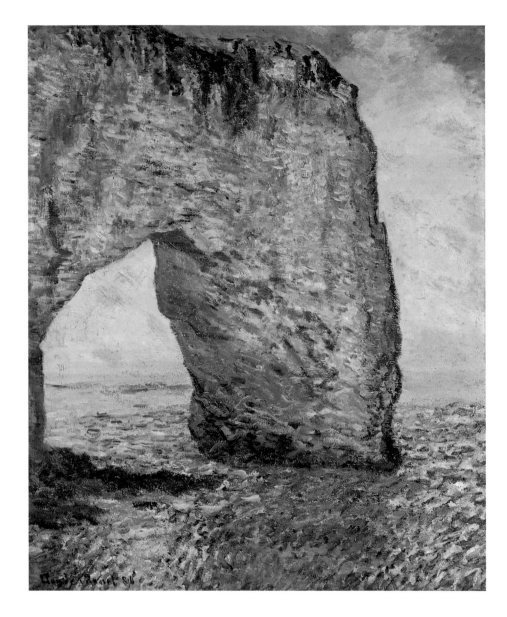

PLATE 52
Claude Monet
The Manneporte, Etretat, II,
1886
Oil on canvas
32 x 25¾ inches
The Metropolitan
Museum of Art,
Bequest of Lizzie P. Bliss,
1931

patches and stands of everything from climbing bittersweet, dwarf huckleberry, arbor vitae, and golden alexander to squaw-weed, carrion flower, and stinging nettle.[4] Hassam shows common stitchwort and other wild vegetation tumbling down the rocks towards the shore, where low tide exposes the delicate hues of aquatic plants. In the middle distance, Babb's Rock lends the scene a specific sense of place, and tiny leisure craft ply the sparkling blue waters in the liquid morning light.

Such wonderful views encouraged gazing through the windows of Thaxter's parlor or lounging on the piazza that flanked her garden. A decade before Hassam painted *Early Morning Calm,* Thaxter wrote to a friend:

Sat on the yellow sofa . . . in my corner . . . whence I can look out into the sunlit, glowing garden through the openings in the vines, on the breezy, sparkling sea, whereon the haze lies like the soft bloom on grapes, and it makes everything dreamy and beautiful, all the sails and everything. Such a mellow, golden day. . . . [5]

Thaxter's comment summarizes the general spirit of the Shoals pictures. However, many a ship came to grief "in distress of weather" on the reefs of Duck Island, hidden just below the ocean surface north-east of Appledore. A standard guidebook description reads, "in the offing Duck Island showed its ragged teeth around which the tide swelled and broke until it seemed frothing at the mouth." [6] We can see dangerous Shag and Mingo rocks next to Duck Island in Hassam's canvas of that name (Plate 53). But the artist reduced them to pleasant little fillips of pigment. Seldom do we find stormy weather. Occasional stiff breezes and crashing breakers are Hassam's most dramatic motifs (Plate 54). And only understated, suggestive narration occurs in his work here. We hardly ever meet hotel guests and never directly encounter ghosts or shipwrecks, for the lore and legends of the islands were kept to a minimum in Hassam's oils, watercolors, and pastels of the Shoals.

James Russell Lowell's poem "Pictures from Appledore" presents the island's more fear-some aspect:

A heap of bare and splintery crags
Tumbled about by lightning and frost
with rifts and chasms and storm-bleached jags
That wait and growl for a ship to be lost. . . .
Granite shoulders and boulders and snags,
Round which . . . the nightmared ocean murmurs and yearns.

But Lowell continued:

All this you would scarcely comprehend,
Should you see the isle on a sunny day;
Then it is simple enough in its way . . . [7]

Hassam preferred the islands simple and sunny. Going first to the lighthouse, he began his island images on a prosaic note. A half dozen watercolors, dated 1886, depict the White Island Light from slightly different angles. This is the earliest dated group of Shoals pictures to survive (Plate 55). [8] One of them, the reader may recall, hung prominently over the fireplace in Celia Thaxter's parlor (*see* Fig. 1.31).

Given Hassam's background as an illustrator, the lighthouse—the best known structure at the Shoals—was a logical starting place. "Few lighthouses are more picturesque in their shape or situation," enthused a writer for *Harper's New Monthly Magazine* in the 1870s. [9] According to *Nooks and Corners of the New England Coast*, an 1875 guidebook, the precariously situated lighthouse was

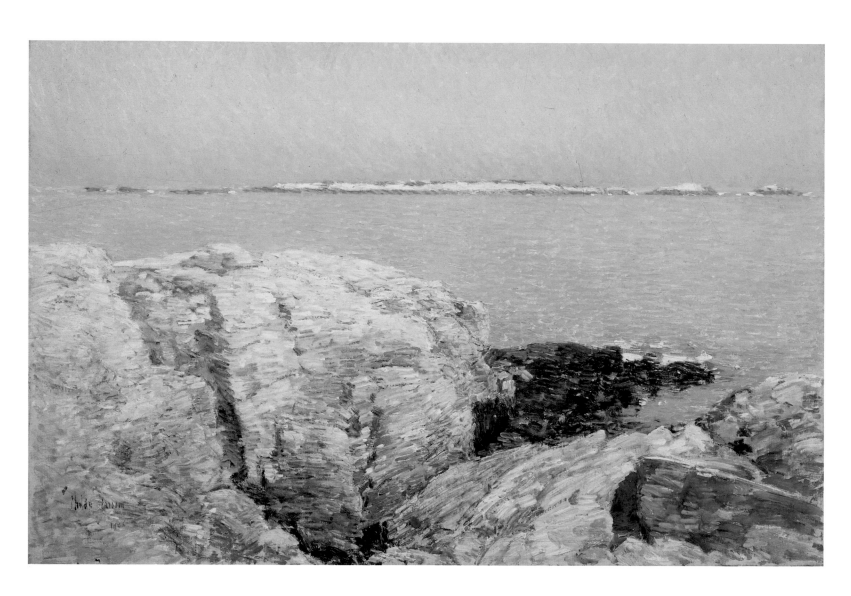

PLATE 53
Childe Hassam
Duck Island, 1906
Oil on canvas, 20½ x 31¼ inches
The Dallas Museum of Art,
Bequest of Joel T. Howard, 1951

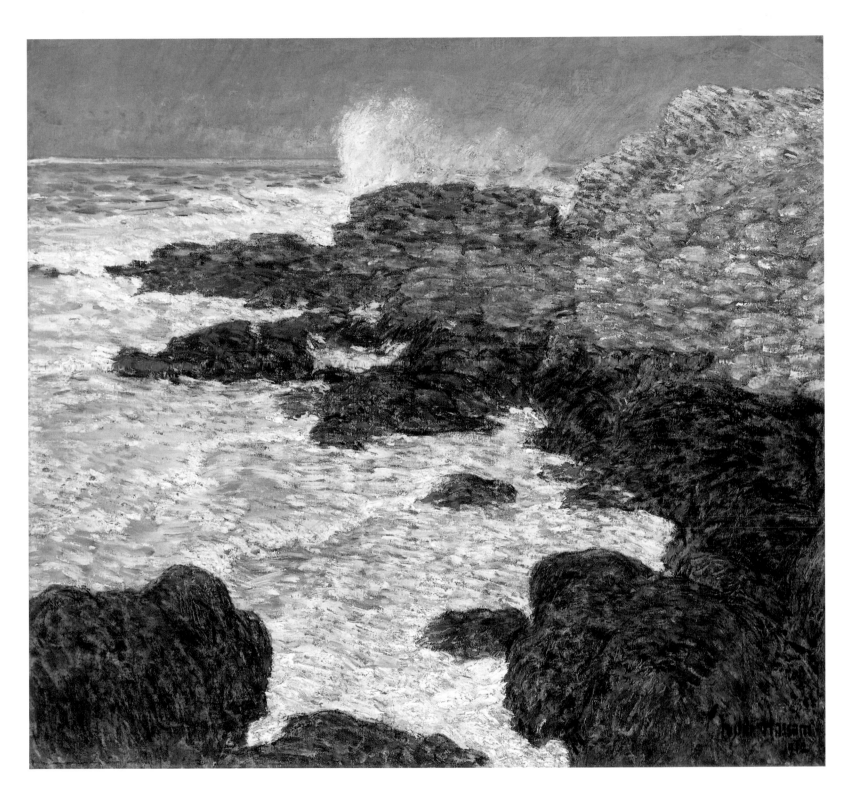

PLATE 54
Childe Hassam
Seaweed and Surf, Appledore, 1912
Oil on canvas, 25½ x 27¼ inches
The Fine Arts Museums of San Francisco,
Gift of the Charles E. Merrill Trust with matching funds
from The De Young Museum Society

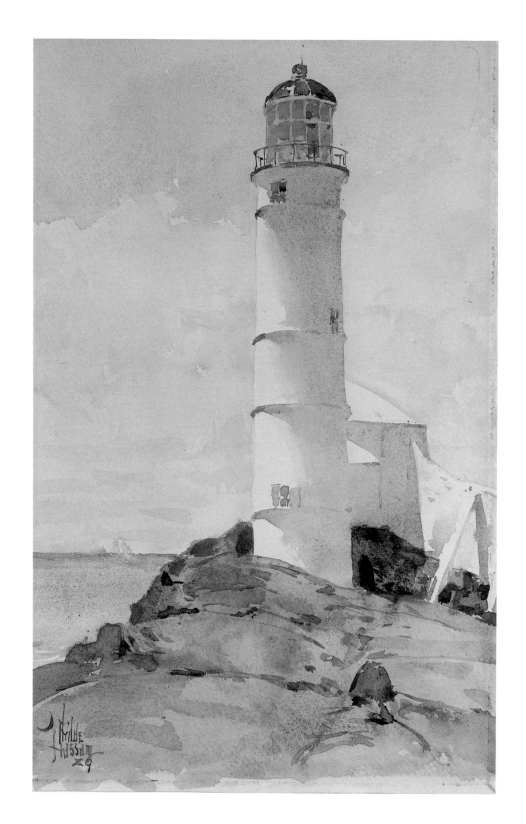

PLATE 55
Childe Hassam
Lighthouse, 1886
Watercolor, 17¼ x 10¾ inches
The Mead Art Museum, Amherst College,
Gift of William Macbeth, Inc., 1950

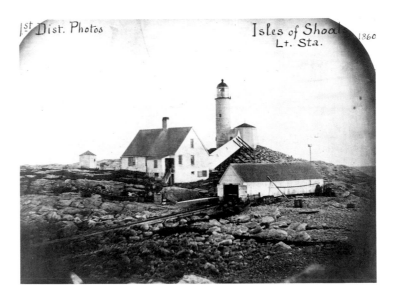

FIGURE 3.1
*New England Coast Scene,
Star Island, Isles of Shoals,*
1869
From *Appleton's Journal of
Popular Literature, Science,
and Art* (October 1869)
Wood engraving
Courtesy Portsmouth
Library

FIGURE 3.2
White Island Lighthouse,
1860
Photograph
National Archives,
Courtesy Portsmouth
Library

"much visited in summer, especially by those of a romantic turn."[10] The lighthouse can be seen clearly from the southern end of either Appledore or Star Island. Taking the view of oft-illustrated White Island Light was an obligatory tourist activity at the Shoals (Fig. 3.1).

Put up in 1865, the lighthouse Hassam painted was not the first to stand on this site (Fig. 3.2). The truncated cone of an earlier building is next to the new tower, which maintained the commanding position of the previous structure. Some found it even more beautiful than its predecessor.[11] Convention had an impact upon Hassam's reaction to the White Island Light, for other artists consistently distinguished it in paintings and engravings. They all showed its unusual covered passageway, "well stanchioned to defy the power of wind and wave."[12] The precariously situated wooden walk spanned a deep chasm in the rock to connect tower and house.

Alfred Thompson Bricher's *White Island Light* (c. 1870) sets the lighthouse on its lonely rock, slightly shrouded in mist. Looking south, Bricher echoed and emphasized the distinctive angular bulk of the lighthouse by placing a diagonally sloped boulder in the foreground. Several sailing craft dot these peaceful waters, and one lies safely in harbor, a little rowboat at its stern (Fig. 3.3).

An illustration from Thaxter's book, *Among the Isles of Shoals*, makes a similar narrative point of the same safe harbor (Fig. 3.4). The lighthouse appears in more dramatic circumstances as well. *Harper's New Monthly Magazine* published the light holding forth against the storm (Fig. 3.5). And another wood engraving juxtaposes the lighthouse with the chapel on Star Island, both buildings aglow in the exalted rays of a dramatic sunset (Fig. 3.6).

FIGURE 3.3
Alfred Thompson Bricher
White Island Light, c. 1870
Oil on canvas
18⅛ x 32 inches
Denver Art Museum, Gift
of Richard and Sue
Williams

FIGURE 3.4
*White Island, Looking
Southward from Appledore,*
1873
Wood engraving
Courtesy Herb Jackson

FIGURE 3.5
*White Island Light in a
Storm*, 1874
Wood engraving
From *Harper's New Monthly
Magazine*, Vol. 49 (1874)
Courtesy Denver
Public Library

FIGURE 3.6
Hoskin
After Thomas Moran
*Star Island Meeting House
and White Island Light,*
c. 1870
Wood engraving
For Sarah Orne Jewett,
"On Star Island"
The Boston Atheneum

FIGURE 3.7
Edward Hopper
The Lighthouse at Two Lights, 1929
Oil on canvas
29 ½ x 43 ¼ inches
The Metropolitan
Museum of Art, Purchase,
Hugo Kastor Fund, 1962

FIGURE 3.8
William Hobbs
White Island Light
Stereopticon image
From *Stereoscopic Views of the Isles of Shoals*

If, in his first Shoals encounter, Hassam chose the same subject as more conservative artists, his aesthetic presentation reveals a forward-looking mind-set. Hassam was to develop what one critic called "the ability to see new things in familiar places."[13] The would-be modernist ignored much of the visual data and excluded all narrative editorializing. This filtering out of extraneous material came to characterize his Shoals images as a group.

In the lighthouse series, Hassam concentrated on the tower, always including at least a glimpse of the distinctive covered walkway. The artist climbed up on White Island Head, the northeast part of the island, moving slightly to the right or left to capture now one, now two or three of the stilts that support the passage. To our eyes a cropped, close-up image like the Mead Museum watercolor (*see* Plate 55) might seem of our own time—Edward Hopper springs quickly to mind (Fig. 3.7). But Hassam's rather tight, detailed watercolor is also visually linked to an old stereopticon view (Fig. 3.8).

A change occurred in Hassam's attitude towards the White Island Light after his travels to Paris from 1887 to 1889. His nonnarrative stance was strengthened by contact with European modernism. While the modernity of his pictures is a question of execution as well as imagery, Hassam the aesthetic tourist responded most promptly to the subject matter of his French contemporaries, often depicting scenes from modern life. His pastel, *At the Grand Prix in Paris*, is one of several Hassam images that appropriated one of Edgar Degas's favorite subjects (Plate 56).

Hassam adopted Degas's favorite medium as well, but the American's delivery of the French racing scene is straightforward, linear, and direct. Although he did employ the seemingly casual cropping of figures that Degas practiced, Hassam absorbed the painting techniques of French modernists more cautiously than their subject matter. We have already seen in the comparison of poppy pictures by Monet and Hassam that the latter never completely dissolved his subjects in light. While he

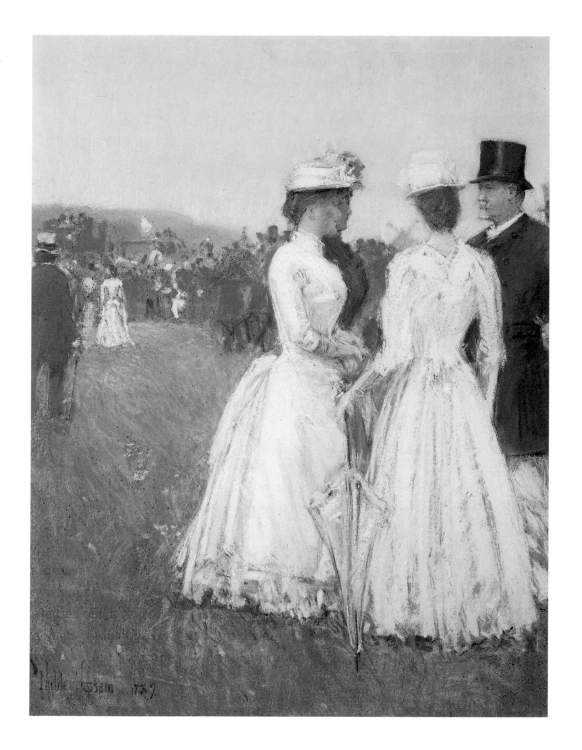

PLATE 56
Childe Hassam
At the Grand Prix in Paris, 1887
Pastel, 18 x 12 inches
The Corcoran Gallery of Art,
Bequest of James Parmelee, 1941

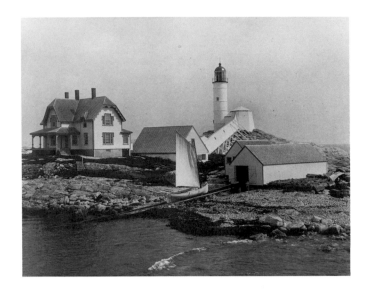

traveled to Paris several times for long periods, his reaction to French art and culture remained wary. He called the City of Light "a huge Coney Island, noisy [and] dirty." He found that the Parisians "Out American the Americans" and lamented "I miss my swim at the Shoals."[14]

Back on his beloved islands, when Hassam again chose that familiar motif, the White Island Light, he was content to view it from a distance. For the pre-Parisian watercolors, he sailed over to White Island to confront the building face-to-face. Now, in *White Island Light, Isles of Shoals, at Sundown*, he painted from the south end of Appledore (Plate 57). The deep chasm in the foreground is called the South Gorge.[15] Both the precarious pitch of the rocky declivity and the watery expanse are dramatically exaggerated. The sundown picture is accented with the iconic lighthouse silhouette and we also glimpse a two-story keeper's cottage built in the 1880s, rendered as a block of white paint at the right of the lighthouse (Fig. 3.9). These buildings serve only to establish the location of a scene which was clearly the subject of an impressionist examination of atmospheric effects at a certain time of day.

Babb's Rock lends its domical silhouette to the middle of the composition *Isles of Shoals* (Plate 58). This now-familiar rock centers numerous other images as well. A subtle reminder of the site, Babb's Rock appeared far more often than the lighthouse in Hassam's paintings of the Shoals. The rock was visible from the hotel verandah, from Thaxter's porch, and from the studio Hassam eventually had on the island (Fig. 3.10). One could also see a pair of large rocks: Londoner's and Square. Their low profiles punctuate the horizon line of the painting *Isles of Shoals*, although a photographer contemporary with Hassam lost the rocks in the misty distance.

Hassam seems to have felt obliged to record the lighthouse in *Isles of Shoals*, but he manipulated the composition to do so. From his vantage point one could not possibly see the structure. In fact

FIGURE 3.9
White Island Lighthouse and Dwelling, 1888
Photograph
National Archives, Courtesy Portsmouth Library

FIGURE 3.10
View of Babb's Rock and bathing pool from Appledore House, c. 1900
Photograph
Courtesy Portsmouth Library

PLATE 57
Childe Hassam
White Island Light, Isles of Shoals, at Sundown, 1899
Oil on canvas, 27 x 27 inches
The Smith College Museum of Art,
Gift of Mr. and Mrs. Harold D. Hodgkinson (Laura White Cabot '22), 1973

PLATE 60
Childe Hassam
Moonlight, 1892
Oil on canvas, 25¾ x 36¼ inches
Private collection

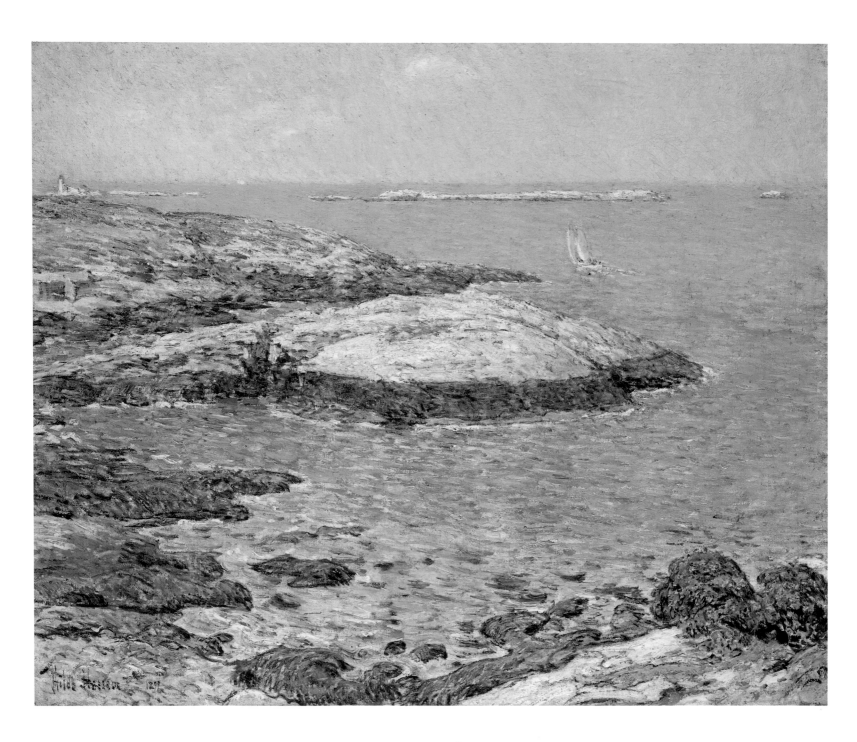

PLATE 58
Childe Hassam
Isles of Shoals, 1899
Oil on canvas, 25¼ x 30½ inches
The Minneapolis Institute of Arts,
Gift of the Martin B. Koon Memorial Fund, 1914

PLATE 59
Childe Hassam
Isles of Shoals (detail), 1899
Oil on canvas
The Minneapolis Institute of Arts,
Gift of the Martin B. Koon Memorial Fund, 1914

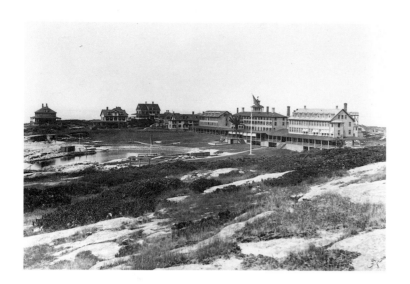

FIGURE 3.11
Appledore House and
swimming pool, c. 1900
Photograph
Courtesy Portsmouth
Library

FIGURE 3.12
Appledore swimming
pool and harbor, 1889
Photograph
Courtesy Portsmouth
Library

it would be hidden by the high hill at the left of the picture. Hassam's tilted-up picture plane, a compositional innovation derived from Japanese prints and/or French impressionism, ensures that the iconic bit of local architecture appears. In both *White Island Light* and *Isles of Shoals* Hassam avoided crisp detail to note down the lighthouse in a few bold strokes of wet pigment (Plate 59).

In an early night scene the lighthouse is further minimized. Only a tiny spot of bright pigment set precisely at the juncture of sky and rock indicates its presence (*see* Plate 60). Its beam is a modest twinkle in comparison with the brilliant moon reflected off dappled clouds and calm sea. Similarly, in the garden paintings, Hassam made much of the flowers and little of the fence. At the Shoals, natural imagery interested him more than anything manmade.

Hassam did not see fit to include the cottage in *Isles of Shoals* (*see* Plate 58). It should be to the right of the lighthouse. He did give the viewer an almost ghostly glimpse of the hotel's bathing sheds—square gray forms at mid-level on the left side of the painting. Hassam's reticent treatment of the sheds substantiates Cedric Laighton's comment to his sister Celia, that the bathing house "is built very low, so it does not intercept the view much."[16] We have quite a clear record of the little outbuildings' actual appearance from several surviving photographs (Figs. 3.11, 3.12).

Hassam represented the bathing sheds more graphically in two canvases, *August Afternoon, Appledore* and *Bathing Pool, Appledore* (Plates 61, 62). These two pictures are among his most deliberate treatments of tourist life at the Shoals. Thus, they bear comparison with Monet's *Terrace at Sainte-Adresse* (1868), an artist's complex response to middle-class leisure and its ramifications (Plate 63).

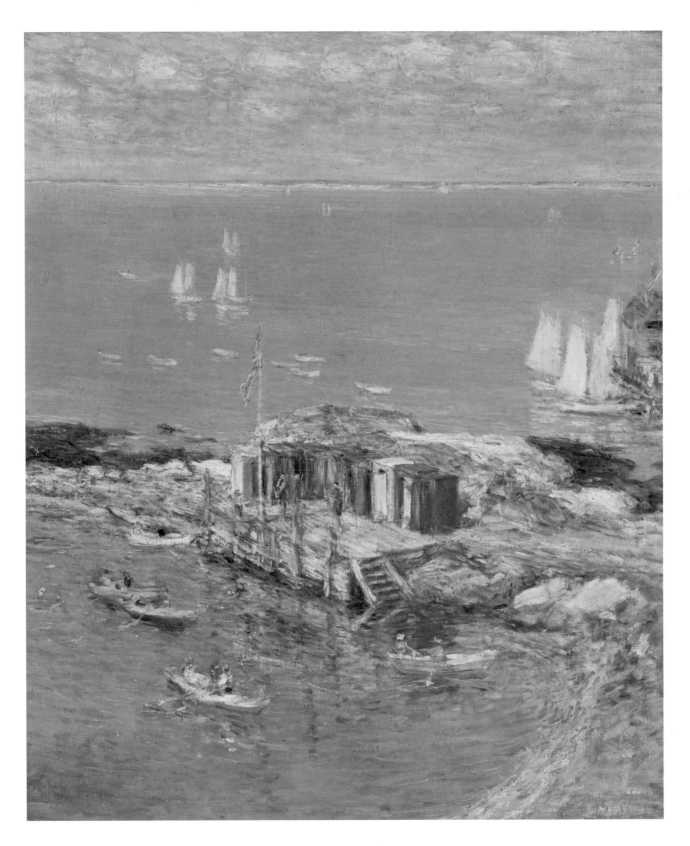

PLATE 61
Childe Hassam
Appledore, August, 1900
Oil on canvas, 22¼ x 18 inches
Mr. and Mrs. Hugh Halff, Jr.,
Courtesy Hirschl and Adler Galleries, New York

PLATE 62
Childe Hassam
Bathing Pool, Appledore, 1907
Oil on canvas, 25 x 30 inches
Courtesy Museum of Fine Arts, Boston,
Ernest Wadsworth Longfellow Fund, 1964

PLATE 63
Claude Monet
Terrace at Sainte-Adresse,
1868
Oil on canvas
38⅝ x 51⅛ inches
The Metropolitan
Museum of Art,
Purchased with special
contributions and pur-
chase funds given or
bequeathed by friends of
the Museum, 1967

Hassam followed Monet's lead in using a bright, light palette, a high horizon line, and a sharp-ly up-tilted picture plane. Like Monet, he used color to link parts of the picture—blocks of orange and blue-green in the bathing huts are echoed in the orange and blue geometries of the flag in *Bathing Pool*. Splashes of white occur in every register of *August Afternoon*, from the foreground rowboats to the distant mainland shore.

Yet Hassam's two thematically similar pictures, painted over thirty years after *Sainte-Adresse*, are less daring compositions. Unlike the Frenchman's abrupt transitions from one spatial register to the next, Hassam created a more traditional recession, easy to enter via the gentle S curve that forms the backbone of each Appledore view. In *August Afternoon*, the eye can sweep round the curve of the bathing pool and then skip across the open water on receding white sails to reach the distant shore. The curves of the bathing pool, Babb's Rock, and the distant Londoner's and Square Rocks provide a similar path in *Bathing Pool*.

Monet's work is filled with carefully structured geometries and meaningful juxtapositions. Various types of boats suggest the era's transition from sailing to steam ships. A fisherman's ketch with cheap brown sails nudges the brightly lit parasol of a wealthy vacationer.[17] Hassam's details seem less calculated, although the American flag sanctions the scene in *Appledore August* just as the French tricolor waves over Monet's image. The Appledore pictures are less personal in their content than Monet's work. Relationships between the young and old couples in *Sainte-Adresse* are an important part of its meaning, but Hassam populated his spaces with barely articulated, completely anonymous strangers. All are tourists.

We know that Hassam was interested in urban change, something he first witnessed in Boston and encountered apace in Paris. Painted upon his return, *Charles River and Beacon Hill* contrasts old and new Boston—the venerable golden dome of the Massachusetts Statehouse looks down on the brand-new buildings of the Back Bay (Plate 64). As Carol Troyen has noted, Hassam

> chose an unremarkable, yet significant viewpoint to capture the random activity of the city, while at the same time alluding to historic changes in its social fabric. He made clear that the momentous and the incidental were inseparable in the new city; with the seemingly casual placement of the figure in the blue overcoat, who looks neither at the artist nor at the new city behind him but rather gazes out at the river in a moment of private introspection, Hassam indicates the anonymity of the new urban life.[18]

Again, certain pictorial conventions of French modernism—an obvious, sharply receding wedge of empty space, colors applied in broad, broken strokes, cropping that seems as casual as the random observer's rapid glance—invest Hassam's canvas with immediacy.

The bourgeois ladies and gentlemen at leisure on the Isles of Shoals were also a reflection of urban social change. During the 1860s and 1870s, young Claude Monet witnessed the displacement of humble fishermen by wealthy Parisians who bought properties along the French Atlantic coast for use as summer homes. Likewise, tourism, not the fishing industry, fueled the Appledore economy at the turn of the century.

Depictions of the island natives by Hassam are rare indeed, although he, like Thaxter, must have sensed their visual appeal:

> The eye is often struck with the richness of the color of some rough hand, glowing with mingled red, brown, and orange, against the gray-blue water, as it grasps an oar, perhaps, or pulls in a rope.[19]

Hassam's sketch of an Appledore fisherman carries no sense of place and could just as easily have been attributed to Gloucester or another fishing village had not the artist taken the time to inscribe it (Fig. 3.13). Thaxter lamented the passing of the fisher's way of life:

> Twenty years ago Star Island Cove was charming, with its tumble-down fish-houses, and ancient cottages with low, shelving roofs, and porches covered with the golden lichen that so loves to embroider

PLATE 64
Childe Hassam
Charles River and Beacon Hill, c. 1892
Oil on canvas, 18⅞ x 20⅞ inches
Courtesy Museum of Fine Arts, Boston, Thompkins Collection, 1978

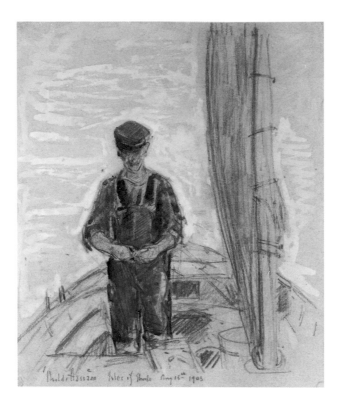

FIGURE 3.13
Childe Hassam
Fisherman, Isles of Shoals,
1903
Crayon and watercolor
11⅜ x 9¹⁵⁄₁₆ inches
The Corcoran Gallery of
Art, Bequest of James
Parmelee, 1941

old weather-worn wood. Now there is not a vestige of those dilapidated buildings to be seen; almost everything is white and square and new.[20]

An occasional glimpse of bygone days can be found in vintage photographs, but not in Hassam's pictures of the Shoals (Fig. 3.14).

Tourists had thronged the islands since the 1850s (Figs. 3.15, 3.16). There are numerous photographs showing Hassam enjoying the relaxed atmosphere of Appledore over the course of his career (Figs. 3.17, 3.18, 3.19, 3.20). But Hassam's pictures of the Shoals contain minimal reference to people.

As *Early Morning Calm* indicates, the artist sometimes got to work before slumbering vacationers were out and about (*see* Plate 51). A visitor arriving at Appledore around 5:00 A.M. found

such a cheerfulness of solitude and exhilaration of loneliness with nature that he would count the day blessed which had this beginning. The great crowd in the summer hotel would not be met at the early morning hour, and all the obtrusiveness of a throng of people would not be encountered. It is likely that the visitor might pass from one end of the island to the other and would be able to take a prolonged view of [the] islands, and pick a large bouquet of wild roses upon his return without coming upon another intruder. . . .[21]

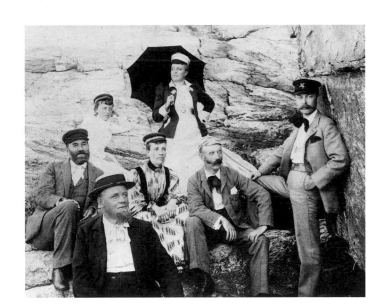

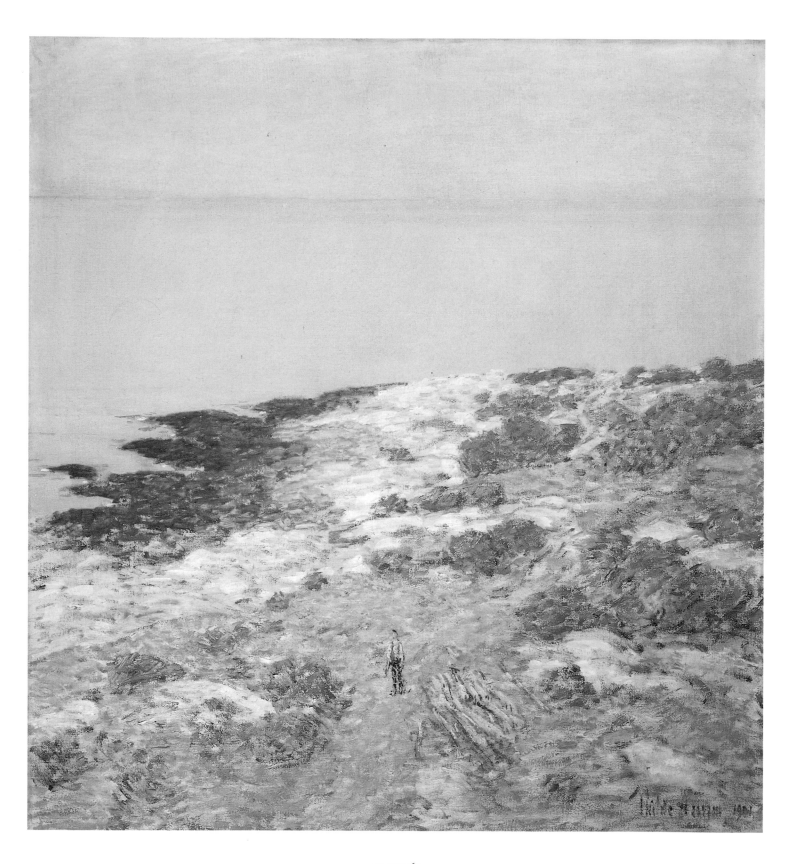

PLATE 65
Childe Hassam
Morning Calm, Appledore, 1901
Oil on canvas, 26 x 25 ⅛ inches
The Addison Gallery of American Art, Phillips Academy, Andover, Massachusetts

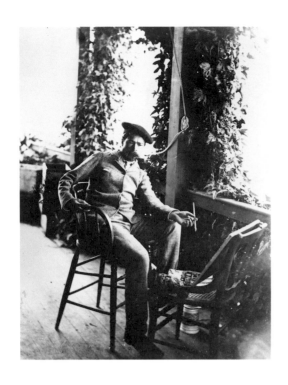

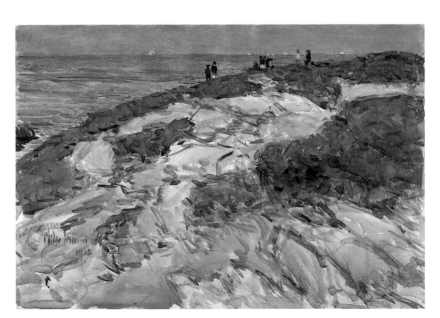

Clockwise from upper left:
FIGURES 3.17, 3.18, 3.19,
3.20
Childe Hassam: on
Thaxter's porch, c. 1886;
in Thaxter's garden,
c. 1905; playing dom-
inoes, Appledore, c. 1905;
and on the rocks, c. 1905.
Photographs
Courtesy Star Island
Corporation and private
collections

PLATE 66
Childe Hassam
*Sunday Morning,
Appledore,* 1912
Watercolor
13⅞/16 x 19⅞/16 inches
The Brooklyn Museum,
Museum Collection Fund,
1924

· 139 ·

FIGURE 3.21
Turnstile on Appledore,
c. 1890
Photograph
Courtesy Star Island
Corporation

In *Morning Calm, Appledore* a lone stroller enjoys such solitude (Plate 65). Only a few tiny figures punctuate the brow of the hill in *Sunday Morning, Appledore*, a similar composition painted in watercolor a decade later (Plate 66).

Hassam liked to paint late in the season, as the tourist tide began to ebb. Advertising copy promised that "guests satisfied with a plain table after 10th September can be accommodated by special arrangement until the end of the month" (*see* Fig. 1.5). Hassam was one such guest. Lingering at the Shoals, he produced successful works. When a now-unlocated watercolor, *September, Isles of Shoals*, was exhibited at the Art Institute of Chicago in 1891, a reporter for the *Tribune* found it "charming" and admired the "exquisite effect, touched with the beauty of the American autumn."[22]

As Hassam's chief objective was not to document tourist life at the Shoals, architecture also plays a minor role in these pictures. Architectural bits prove difficult to identify. The grid-like little oddity on the brow of the hill in *Isles of Shoals* is an old turnstile gate erected on the slope southwest of Appledore House (Plate 67). The gate, which no longer survives, once stopped cows from wandering out of the rocky pasture onto the hotel grounds (Fig. 3.21).

A little structure in *Headlands* nestles into the sloping curve of the rock (Plate 68). Hassam gives it the solidity of a house, but the structure is more likely a pavilion that used to stand on the cliff beside Broad Cove (Fig. 3.22).[23] Hassam painted such a structure again in *Northeast Headlands, Apple-*

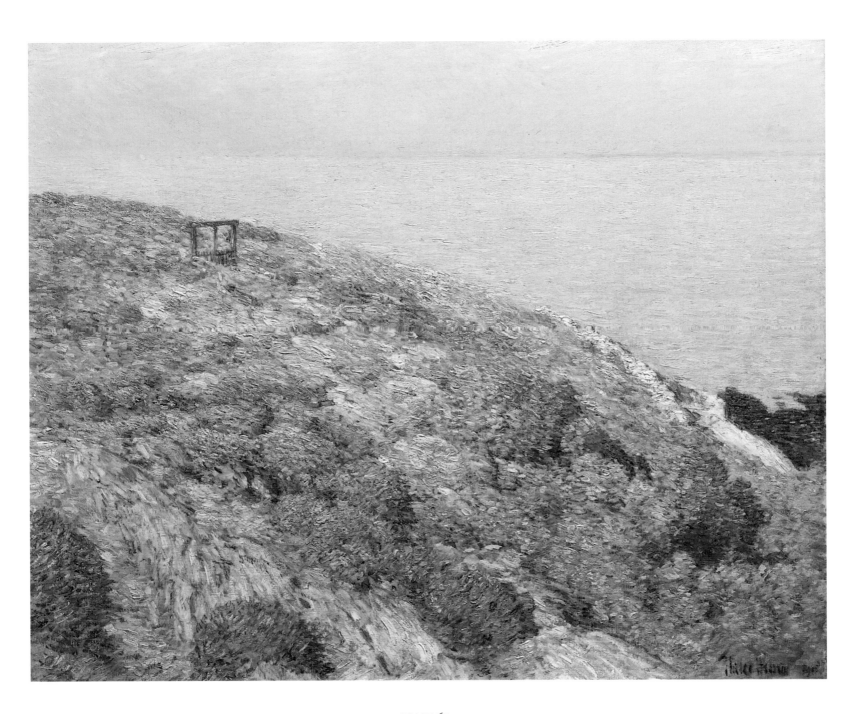

PLATE 67
Childe Hassam
Isles of Shoals, 1915
Oil on canvas, 25 x 30 inches
Private collection,
Courtesy Vose Gallery, Boston

FIGURE 3.22
Karl Thaxter
Pavilion by Broad Cove,
c. 1886
Photograph
Courtesy Star Island
Corporation

dore (Plate 69). The roof, now a distinct red, is fitted into the landscape very carefully; indeed, close examination reveals that Hassam moved it. The squarish white rock to the right of the house masks the earlier placement of the roof itself.[24] Hassam balanced the roof by using a splash of red in the center of the picture. The crest of the roof is edged with broken tan dashes.

These images may have been stimulated by Monet's extensive series of cliff-top cottages silhouetted against the sea (Plate 70). Monet painted many during the 1880s and 1890s, and Hassam, an avid gallerygoer, could scarcely have avoided encountering one or more of them.[25] In Hassam's paintings, as in Monet's, isolated man-made structures remind us of human activity.

However, with a few exceptions, the guests on Appledore were rarely shown by the artist. Hassam executed very few portraits there. The most famous, of course, depicts Thaxter in her garden (*see* Plate 18). Hassam also recalled painting "a life size of Oscar Laighton at the Shoals. He was the brother of Celia Thaxter." Hassam went on about

> *another picture of a child, life size, which I painted at the Shoals with a collie dog. That name escapes me. They all wanted their portraits painted, but I hesitated to do it. There was no special economic reason why I should. So I dodged commissions for portraits.*[26]

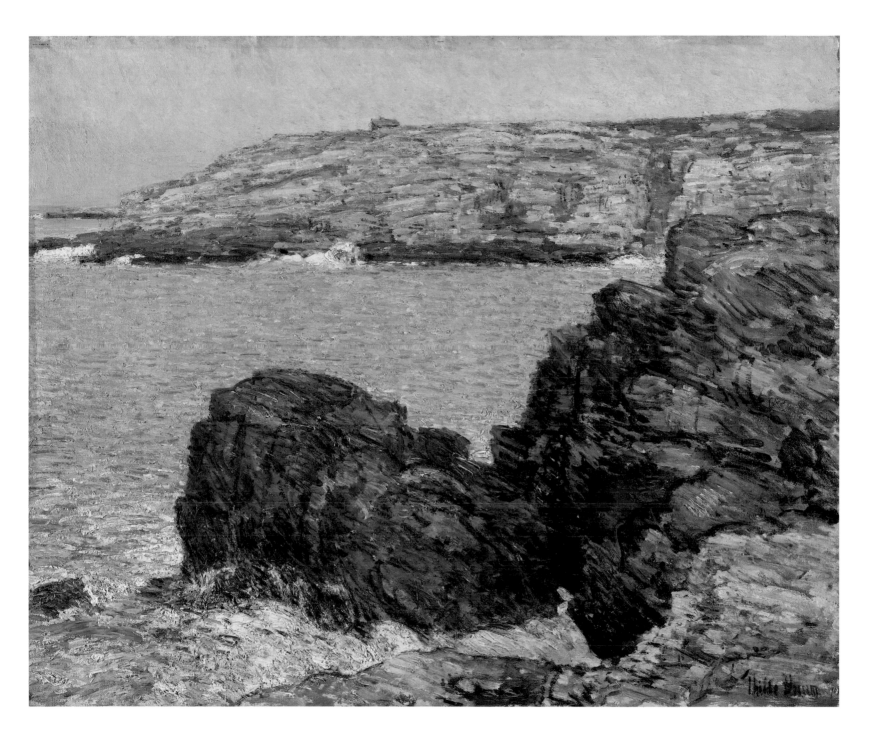

PLATE 68
Childe Hassam
Headlands, 1908
Oil on canvas, 24¼ x 29¼ inches
Courtesy Fogg Art Museum, Harvard University,
Gift of Archer M. Huntington, 1936

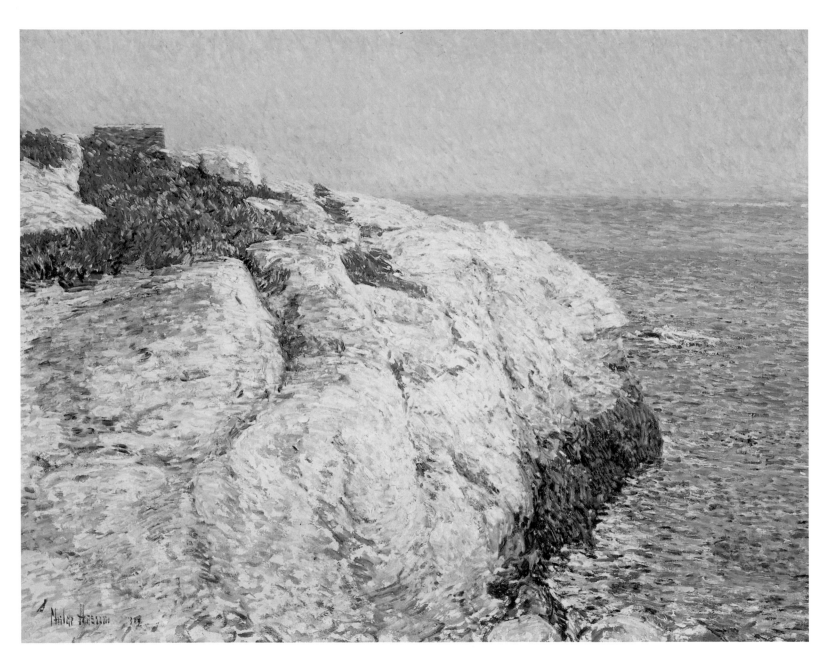

PLATE 69
Childe Hassam
Northeast Headlands, Appledore, 1909
Oil on canvas, 28⅞ x 37¼ inches
The Carnegie Museum of Art, Pittsburgh,
Gift of the Sarah Mellon Scaife family, 1970

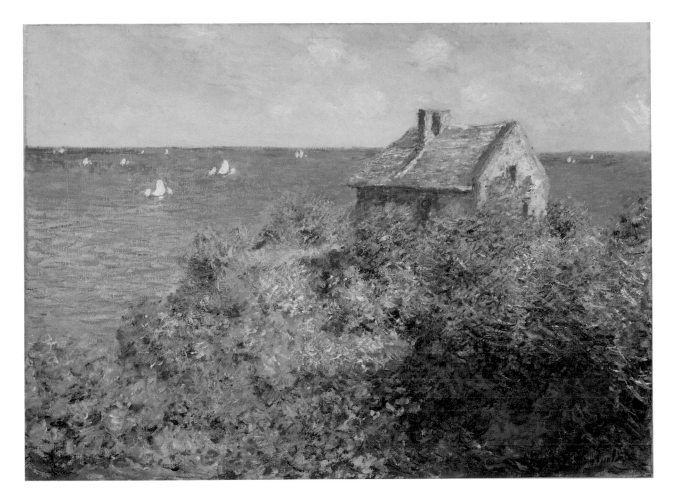

PLATE 70
Claude Monet
*Fisherman's Cottage off the
Cliffs at Varengeville*, 1882
Oil on canvas
24 x 34¾ inches
Courtesy Museum of
Fine Arts, Boston,
Bequest of Anna Perkins
Rogers, 1921

When Hassam chose to concentrate on a figural subject at Appledore, the picture was not always successful, as witness the large, somewhat clumsy *Woman by the Sea* (Fig. 3.23). In later years, the artist concentrated on mythological nymphs and sprites, but the results were not much better. Some of the large Appledore nudes suffer from awkwardly posed figures that are not integrated with their surroundings. A title like *The Nymph of the Beryl Gorge* somehow implies semiprecious gems, but Hassam delivered dross (Fig. 3.24).[27] When he kept the figures tiny, the pictures are less discouraging (Plate 71), but on the whole, one must agree with a critic who grumped that such images were "more highly endowed with avoirdupois than grace."[28]

Why were Hassam's efforts at mythological landscapes such failures? Perhaps it has to do with his own failure to reconcile conflicting elements: the escapist atmosphere of summer resort life, the detachment of the tourist-stranger, the demands of evolving painting styles during the early twentieth century, and an uncritical deference to the classical past.

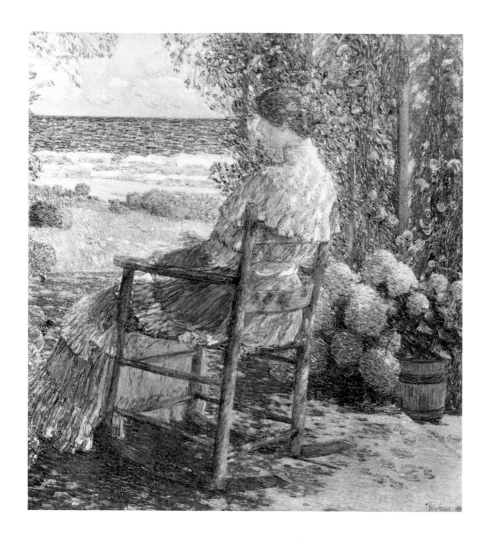

FIGURE 3.23
Childe Hassam
Woman by the Sea, 1892
Oil on canvas
61 x 56 inches
Private collection
From *American Art
Review* (January 1978)

FIGURE 3.24
Childe Hassam
*The Nymph of the Beryl
Gorge*, 1914
Oil on canvas
34⅛ x 16¾ inches
The Art Institute of
Chicago, Gift of Mr. and
Mrs. Carter H. Harrison,
1935

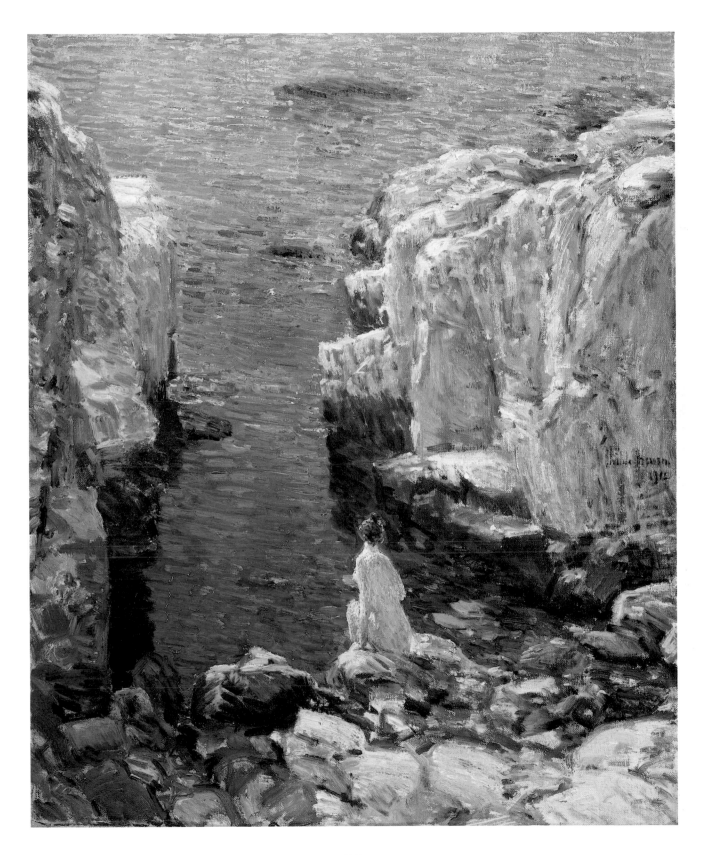

PLATE 71
Childe Hassam
The Isles of Shoals, 1912
Oil on canvas, 22 x 18 inches
The Virginia Museum of Fine Arts, Richmond,
Museum purchase: the Adolph D. and Wilkins C. Williams Fund, 1970

By the time Hassam undertook his second major series of painting campaigns at the Shoals, he was already an experienced aesthetic tourist, ever in attendance at one passing parade or another. He sometimes went to several summer resorts in the same season. Yet Hassam spoke of the artist's need for isolation:

> *As the artist practices his peaceful profession he can hold himself aloof from the rabble without the least danger or damage to his work. He is alone. If this is happiness, he has it. . . . He has what saints sought for in the desert.*[29]

While the studio pictures he created in New York during the winter months center upon urban themes, they too are often motivated by detached observation.[30] Some of his studio pictures, including *Washington Arch, Spring*, embellished an article written by Marianna Van Rennselaer for *Century Magazine* (Plate 72). The publication, we recall, was edited by Hassam's Appledore acquaintance, Richard Watson Gilder. Van Rennselaer contrasted recollections of old New York with the commercial values of the 1890s. She said of the arch in Hassam's picture, "Here the real Fifth Avenue begins," and sighed, "when I think how things have happened elsewhere in New York, I am ready to affirm that Washington Square has thus far led a reasonably conservative life."[31]

Although late-nineteenth-century critics considered Hassam to be a progressive artist, the passage of time lets us more readily see that he too led a somewhat conservative intellectual and artistic existence. At least one critic remarked upon his commitment to a consistent painterly execution:

> *Hassam is interesting for the steady way in which he adheres to the point of view with regard to technique which he chose years ago.*[32]

We have already noted the allure of isolated island resorts in a period of intense social change. Hassam's city views are also tinged with a backward-looking sense of regret at the fast pace of modern life, something that intensified for him during the last decades of his career, when he spent as much time as possible in his eighteenth-century colonial house on Long Island.

For decades Hassam painted "the perpetual scene and stage and picture gallery of our Babylon." At his death, it was predicted that his reputation would rest upon New York scenes with their "curious shifting atmosphere . . . restless change and movement . . . somberness . . . brilliancy."[33] Hassam's detached perceptions were those of a permanent theatergoer. He couldn't synthesize all the elements required for exalted mythological subjects in natural settings and his attempts don't work. In *The Lorelei* and a surprising number of related images, a descendant of Ingre's Valpincon bather goes to the beach (Figs. 3.25, 3.26).[34] For *Young Apollo and the Flying Swans*, Hassam abandoned the classical for the contrived (Fig. 3.27). And *Adam and Eve Walking Out On Montauk in Early Spring* are nothing more than out-of-place, underdressed tourists (Fig. 3.28).

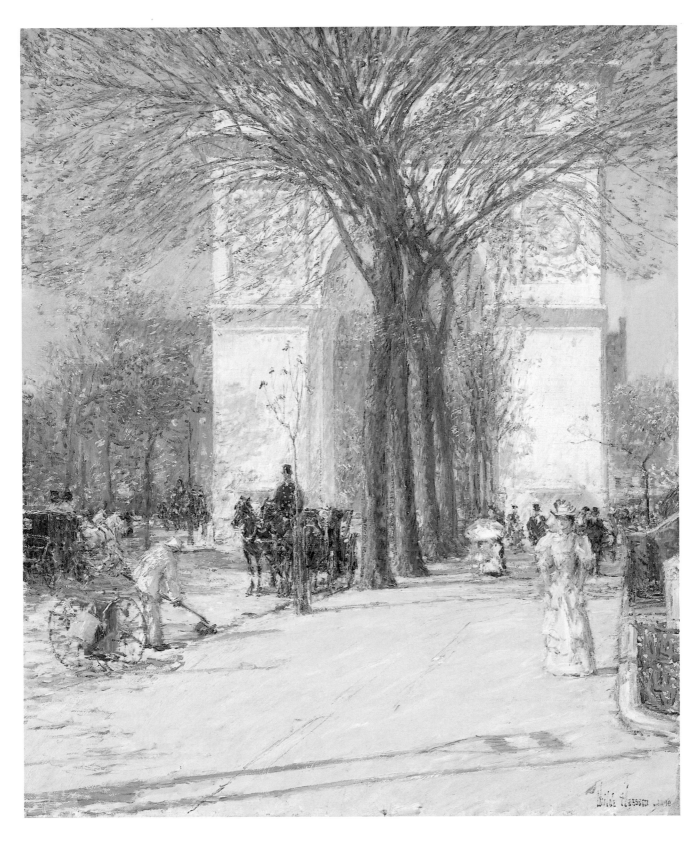

PLATE 72
Childe Hassam
Washington Arch, Spring, 1890
Oil on canvas, 27⅛ x 22½ inches
The Phillips Collection, Washington, D.C.

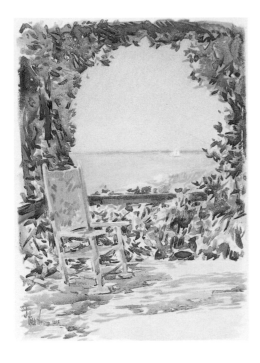

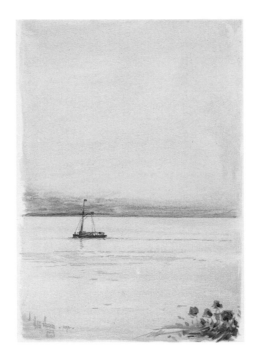

As a rule, the solitudes of Appledore were better left unpeopled in Hassam's pictures. The rocking chair on Thaxter's piazza seems most eloquent empty and on a small scale, as it appears in *An Island Garden* (Plate 73). In the artist's delicate glimpse of the little steamer *Pinafore* freighted with holidaymakers and puttering across a glassy sea, the sailors remain unseen (Plate 74, Fig. 3.29).[35]

Legends veil the Shoals in romantic mystery. Undoubtedly, Hassam heard tales of pirates, ghosts, and treasures in Thaxter's parlor. But evidence of their impact is scant in his pictures. He painted Babb's Rock frequently, but his sunny renditions of the granite dome, half-obscured by brilliant flowers and set off by sparkling waters, give no indication of popular Shoals legends regarding the grisly ghost of Philip Babb, a man "supposed to have been so desperately wicked when alive that there is no rest for him in his grave."[36]

Another famous tourist site, "Miss Underhill's Chair," was located on the southeast tip of Star Island (Fig. 3.30). Miss N. J. Underhill was a New Hampshire schoolteacher who liked to vacation at the Shoals, where she would sit and read at this favorite spot on the rocks. Alas, in 1848 she was swept to her death by a sudden tidal wave. Another tourist sourly assessed the spot:

> *a jutting ledge of rock . . . occupied years ago by some voluntary Andromeda, who no Theseus came to rescue as a monster wave from the advancing tide boldly grasped her shrinking form and bore her away over the waste of waters.*[37]

FIGURE 3.30
Miss Underhill's Chair
Photograph
From Lyman V. Rutledge,
*The Isles of Shoals in Lore
and Legend* (Boston, 1965)
Courtesy Portsmouth
Library

Shelf-like "seats" exist on several of the islands. Painted just after he returned from studies in France, *Summer Sunlight* depicts a woman reading on the rocks, her parasol folded beside her (Plate 75). She looks like one of the visitors conjured up in a passage from Thaxter's *An Island Garden*:

> *lovely women in colors that seem to have copied the flowers in the garden . . . all steeped in sweet dreams and fugitive fancies as delicate as the perfumes that drift in soft waves from the blossoms below. Beyond . . . the bleached white ledges . . . the ocean . . . shimmers and sparkles beneath the touch of the warm south wind.*[38]

The picture's title, *Summer Sunlight*, is vague. It was probably painted on Appledore Island rather than Star, and there is no hint of a literary maiden in mortal danger of being swept away. We would have no intimation whatsoever of horrific local history were we to depend upon Hassam's picture alone.

A number of famous tourist sites on the islands were linked with tragedies that informed Thaxter's writing. The wreck of a Spanish ship on the treacherous rocks off Smuttynose Island early in the nineteenth century was the subject of a poem Thaxter sometimes read aloud in her salon. "The Spaniards' Graves at the Isles of Shoals" concludes melodramatically:

> *O Spanish women, over the far seas,*
> *Could I but show you where your dead repose!*
> *Could I send tidings on this northern breeze*
> *That strong and steady blows!*

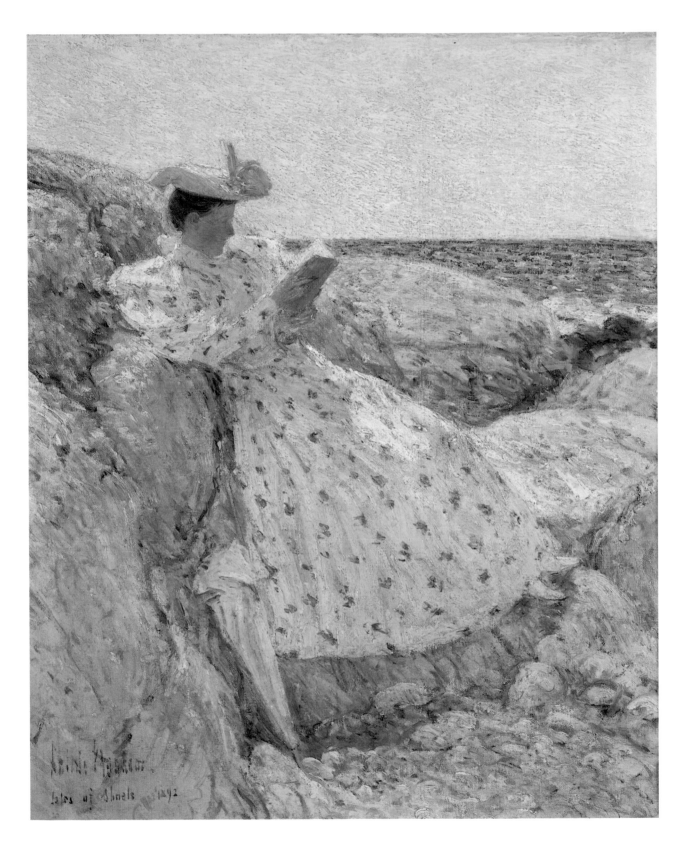

PLATE 75
Childe Hassam
Summer Sunlight, 1892
Oil on canvas, 23⁹⁄₁₆ x 19¹¹⁄₁₆ inches
Collection Israel Museum, Jerusalem
Gift of Mrs. Rebecca Shulman, New York, 1955

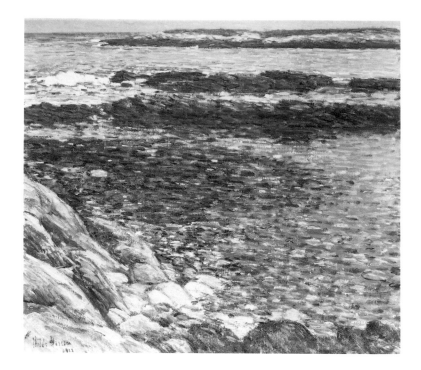

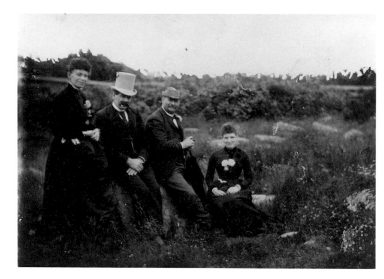

FIGURE 3.31
Childe Hassam
Spanish Ledges, 1912
Oil on canvas
22 ¼ x 24 inches
Private collection,
Courtesy Sotheby's Inc.,
New York

FIGURE 3.32
Visitors to the graves of
Spanish soldiers, Smutty-
nose Island, c. 1880
Photograph
Courtesy Rosamond
Thaxter

Dear dark-eyed sisters, you remember yet
These you have lost, but you can never know
One stands at their bleak graves whose eyes are wet
With thinking of your woe![39]

Hassam painted the site as an inviting picnic spot (Figs. 3.31, 3.32).

Hassam would have heard the melancholy story of William Morris Hunt's death by drowning, and how Thaxter found him in the pond, located up behind the hotel on Appledore. Hassam certainly had the opportunity to read her vivid account, but he seems to have been little affected, at least on canvas, by her emotive recollections.[40]

With its fresh, chilly palette, its flat, almost unmodulated sky, and its delicate, detailed handling of paint, *The Little Pond, Appledore* is unusual in Hassam's Shoals works (Plate 76). Compared to numerous, freely painted flower pictures from the same period, it is austere and reserved. Here white yarrow and water grasses nod in a gentle breeze that barely disturbs the enclosed pool's sheltered surface. The low pink flowers may be scarlet pimpernel, a flower Thaxter called "the poor man's weather glass" for its ability to give silent warning in advance of a storm by folding in upon itself.[41] Ghostly, barely visible on the far horizon, a single sailing craft puts out to sea. The sense of elegy in this picture is present, but Hassam states it gently.

PLATE 76
Childe Hassam
The Little Pond, Appledore, 1890
Oil on canvas, 16 x 21¹⁵⁄₁₆ inches
The Art Institute of Chicago,
Restricted gift of Friends of American Art, Walter H. Schulze Memorial Fund, 1986

A tiny pond centers *Summer Sea, Isles of Shoals* (Plate 77). Hassam spins the composition around one of the brilliant turquoise pools that were temporarily trapped in granite hollows "like bits of fallen rainbow."[42] The pool offers a transient bit of beauty. This elusive jewel among the rocks will be gone almost as quickly as one of Thaxter's poppies faded in her garden. Like fingers, rocky ledges stretch tenuously into the vast ocean, much as the inheritors of Ruskinian naturalism reached out for both an understanding of, and a relationship to, the natural world around them. For, while Hassam gave little thought to local lore and legend, his pictures reflect his concern with the larger artistic issues of his day. Barbara Stafford writes:

> [*Ruskin's*] Modern Painters *is rife with examples of the "two eternities," of "the Vacancy and the Rock" pitted against transitory manifestations, the colored "gradations" of clouds, sunsets, and storms. These opposites, through their reconciliation, would transcend the beauty of material things by adding their force to individual consciousness.*[43]

As one critic rightly noted, "The 'natural magic' in which Mr. Hassam deals is not the magic of the dreamer, the man of imagination, it is that of the sensuous observer."[44]

Visitors to the Shoals, whether curious tourist or serious artist, sharpened their consciousness by observing the wondrous physical features of the rocks of Appledore. Thaxter found the island's eastern shoreline striking with

> *rifts and chasms, and roughly piled gorges, and square quarries of stone, and stairways cut as if by human hands. The trap rock, softer than the granite, is worn away in many places, leaving the bare perpendicular walls fifteen or twenty feet high. . . . In some places, the geologist will tell you, certain deep scratches in the solid rock mean that here the glacier ground its way across the world's earlier ages.*[45]

Tourists had themselves photographed atop the rocks, or took away stereopticon slides and views to treasure in albums (Figs. 3.33, 3.34). Thaxter wrote at length about the haunting beauty of these ancient rocks, and many of Hassam's pictures of the Isles of Shoals concentrate on the same natural wonders, directly linking painter as well as viewer to aeons past.

Hassam's view of *North Gorge, Appledore* was executed in 1912, decades after a guidebook woodcut recorded a nearly identical view, complete with tiny schooner at the horizon line (Figs. 3.35, 3.36). Dominated by their geological subjects, Hassam's canvas and the popular print share pictorial conventions that reflect the legacy of illustrated travel accounts. As an aesthetic tourist, Hassam followed in the footsteps of much earlier artist-draftsmen who abandoned the pleasures of the grand tour for more purposeful voyages informed by an alliance of art and science. On their fact-finding travels they were fascinated by the visual appeal of

> *the basalt prisms of the Giant's Causeway and the Auvergne, arches, natural bridges and clefts, massive peaks and cliffs, mountain scenery, individual mountains, caves, grottoes, mines and quarries,*

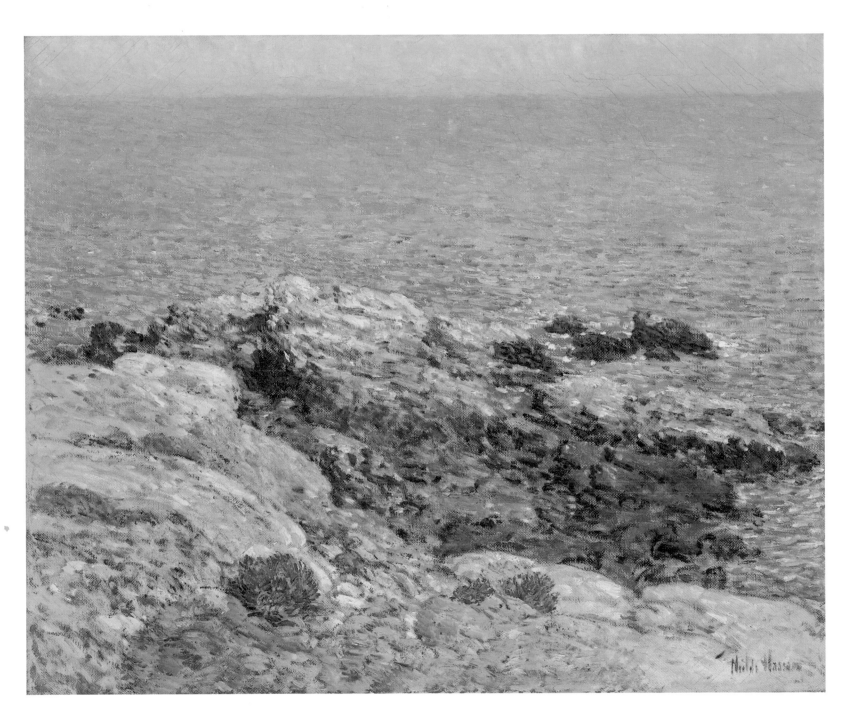

PLATE 77
Childe Hassam
Summer Sea, Isles of Shoals, 1902
Oil on canvas, 25³⁄₁₆ x 30⁵⁄₁₆ inches
The Toledo Museum of Art, Toledo, Ohio,
Gift of Florence Scott Libbey

FIGURE 3.33
Davis Brothers
Trap dike, stone forma-
tion on Appledore Island,
c. 1900
Stereopticon image
Collection Joseph Copley

FIGURE 3.34
Lookout—Appledore,
1881
Photograph from album
of Reverend Charles E.
Dunn
Courtesy Portsmouth
Library

FIGURE 3.35
Childe Hassam
*The North Gorge, Apple-
dore, Isles of Shoals,* 1913
Oil on canvas
20 x 14 inches
The Columbus Museum
of Art, Bequest of
Frederick W. Schumacher

FIGURE 3.36
Gorge on Appledore Island,
Wood engraving
From *Among the Isles of
Shoals* (Boston, 1873)

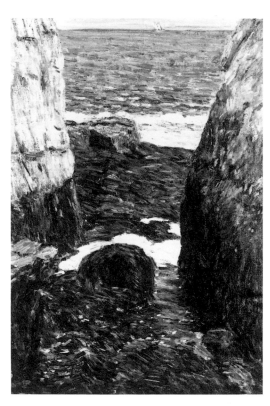

coastal profiles, atolls and reefs, volcanoes . . . plains, tundra, steppes, veldt, savannahs . . . deserts . . . valleys, forests . . . swamps, lakes and rivers.[46]

Explorers wanted to record what they saw precisely and accurately, "giving persons who cannot travel trustworthy knowledge," as Ruskin put it.[47]

Using visual rather than verbal imagery, Hassam's oils, watercolors, and pastels of the Shoals also take armchair travelers to an utterly remote spot. A comment made around 1914 still holds:

> *Mr. Hassam . . . has continued to make [the Shoals] his favorite painting ground and he has helped to make the rocky coves and surf-washed headlands familiar to thousands who have never seen the place itself.*[48]

Stafford analyzes the visual appeal of "natural masterpieces" and considers the inevitable use of subjective elements to create specific lithographs, etchings, aquatints, woodcuts, drawings, and paintings that were supposed to present objective images of the real world. She argues that during the period from 1760 to 1840, when natural history expanded to its current parameters, artist-draftsmen had to confront natural forms directly, and their illustrated travel accounts "brought the methodology of direct encounter with nature to nineteenth-century aesthetics."[49]

By the mid-nineteenth century, Stafford notes, a shift in emphasis had occured, from the discovery of physical to social spaces. The artists and writers who directly encountered nature at the Shoals discussed their experiences in Thaxter's parlor, an eminently comfortable social space. Her guests would have known about eighteenth-century natural science and its illustration through their studies of John Ruskin, whose "complex and shifting opinions reflect, refocus, and recast many major themes encountered in the factual travel account."[50]

A trained ornithologist, Celia Thaxter's husband went trekking in remote coastal regions from Maine to Florida in search of rare specimens, many of them now in the Peabody Museum at Harvard University (Fig. 3.37). Mrs. Thaxter not only studied plant life, but also wrote detailed reports of shore birds. Her voluminous writings on the subject form a model of clearly conveyed observation.[51] Hassam began his Shoals work directly confronting Nature herself (Fig. 3.38). And, long after Thaxter's death, he continued to base his Appledore rock pictures upon intense study of the site.

His unpopulated introspective seascapes are imbued with the sense of private contemplation Hassam brought to their creation. Thaxter thought the tiny coves where the artist was fond of setting up a portable easel were "the most delightful places in the world":

> *lovely with their . . . mosaic of stone and shell and sea-wrack, tangles of kelp and driftwood—a mass of warm neutral tints—with brown, green, and crimson mosses, and a few golden snail-shells lying on the many-tinted gravel, where the indolent ripples lapse in delicious murmurs.*[52]

PLATE 78
Childe Hassam
Diamond Cove, Appledore, 1907
Chalk, 7¼ x 9¼ inches
The Museum of Art, Rhode Island School of Design,
Gift of Mrs. Gustav Radeke

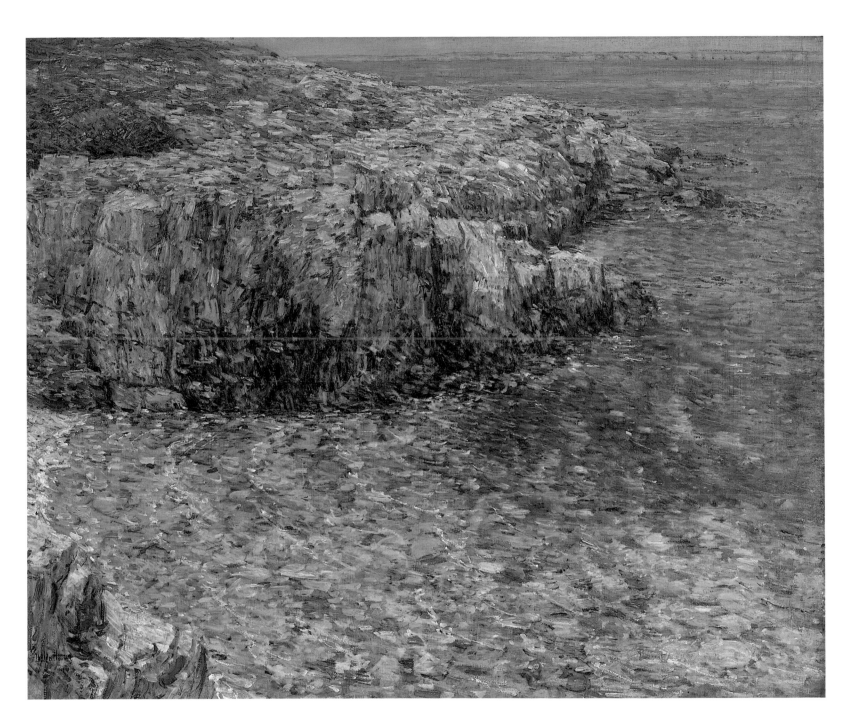

PLATE 79
Childe Hassam
Isles of Shoals, 1907
Oil on canvas, 26 x 31 inches
The Portland Art Museum, Oregon Art Institute,
Gift in memory of William Maxwell Wood IV, 1982

FIGURE 3.37
Levi Thaxter and son
Roland, 1868
Photograph
From E. L. Goss,
*Collecting Sea Birds from
Florida to Maine*
Courtesy Rosamond
Thaxter

FIGURE 3.38
Childe Hassam painting
at Appledore, c. 1886
Photograph
Courtesy Boston
Public Library,
Print Department,
gift of Charles Childs

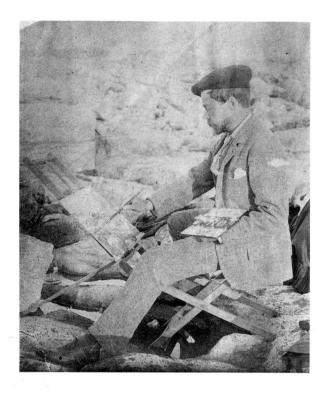

Hassam returned again and again to draw inspiration from natural treasuries hidden in intimate spots such as Diamond Cove, on the southwest side of Appledore. An exquisite chalk sketch dashed off on a piece of tinted stationery is a rare study for one of the rock pictures (Plate 78). The general anatomy of the site was laid out in a few quick black strokes before Hassam articulated the vertical cliff face with a series of up-and-down scribbles. A bit of green tints the far slope, and further suggestions of color appear in the rocks and water, where barely articulated form is touched with pink, minty green, rusty orange, and various shades of blue.

A tide of color floods the inlet in the oil painting where Hassam carried out and refined his initial idea (Plate 79). Again the cliff face is built with vertical strokes and slashes, while touches of color shimmer over submerged, circular rocks. Some of the chalky white overlays along the cliff tops in the drawing were realized as thick, nearly pure white highlights in the painting.

The following year, Hassam painted Diamond Cove from a slightly different angle (Plate 80). He chose to eliminate the green hillock, intensifying the interplay of blues, browns, and ochers. The

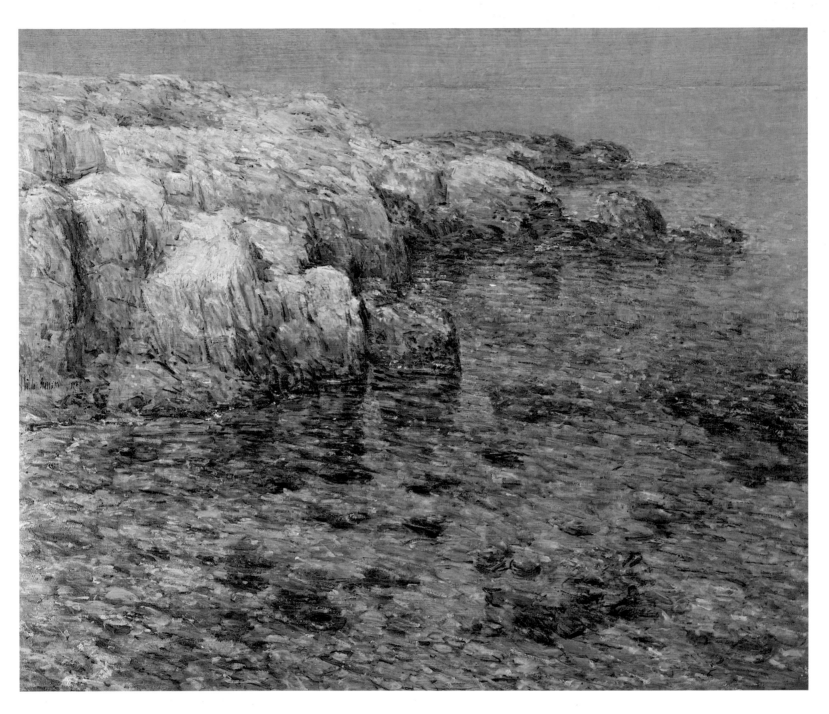

PLATE 80
Childe Hassam
Diamond Cove, Isles of Shoals, 1908
Oil on panel, 25 x 30 inches
Gallery of Art, Washington University, St. Louis

absence of both far vista and foreground boulders makes this oil a more confrontational image than the Portland canvas. Here the viewer is suspended, without solid footing, perilously close to the gray, roughly rounded pebbles strewn upon the beach. On close examination these often prove to be

> smoother [bits of] coarse gravel . . . principally composed of shells ground fine by the waves, a fascinating mixture of blue and purple mussels, lined with the rainbow tints of mother-of-pearl, and fragments of golden and ruddy snail-shells, and striped and colored cockles; with here and there a piece of transparent quartz, white or rosy, or of opaque felspar, faintly straw-colored, or of dull-purple porphyry stone, all clean and moist with the odorous brine.[53]

The low tide seems purposefully to have drained the sea away

> to show to eager eyes what lies beneath the lowest ebb, banks of golden-green and brown moss thickly clustered on the moist ledges are exposed, and the water is cut by the ruffled edges of the kelps that grow in brown and shining forests on every side. At sunrise or sunset the effect of the long rays slanting across these masses of rich color is very beautiful.[54]

Hassam even sought lush color effects after the sun went down. A large moonlight scene is simple in composition and rich in surface textures (Plate 81). Exhibited soon after its completion, the picture attracted favorable attention:

> Conspicuous on the broad wall is a moonlight shore scene from the Isles of Shoals, in which small clouds swarm about the moon like fish round a golden bait. Depth of perspective and a happy suggestion of color in the shoals make this nocturne one of the most successful pieces of the collection.[55]

The critic's use of the term "nocturne" leads us to a further consideration of Whistler's impact. As has been noted earlier, Whistler's *Ten O'Clock* lecture was part of Hassam's summer reading at the Shoals. Hassam's high regard for the American expatriate once prompted him to visit the collection of Charles Lang Freer. Hassam recalled, "I admired his Whistlers so much. The small street things are very interesting, the things that I have painted, the little shop windows . . ." (Plates 82, 83).[56] Hassam didn't confine himself to copying Whistler, however. He subsumed a sensitivity to color that Whistler himself might have envied.

On Whistler's death, Hassam wrote to J. Alden Weir:

> Whistler I see has "stepped over the ropes" and I suppose that the dealers and collectors are now busy marking their Whistlers up. I am sorry that I never knew him—he is surely one of the big men.[57]

Nonetheless, Hassam learned a great deal from the elder statesman of aestheticism. Early on, critics were quick to pick up Whistlerian overtones in Hassam's work, calling him "a butterfly artist."[58] Their works were sometimes compared directly:

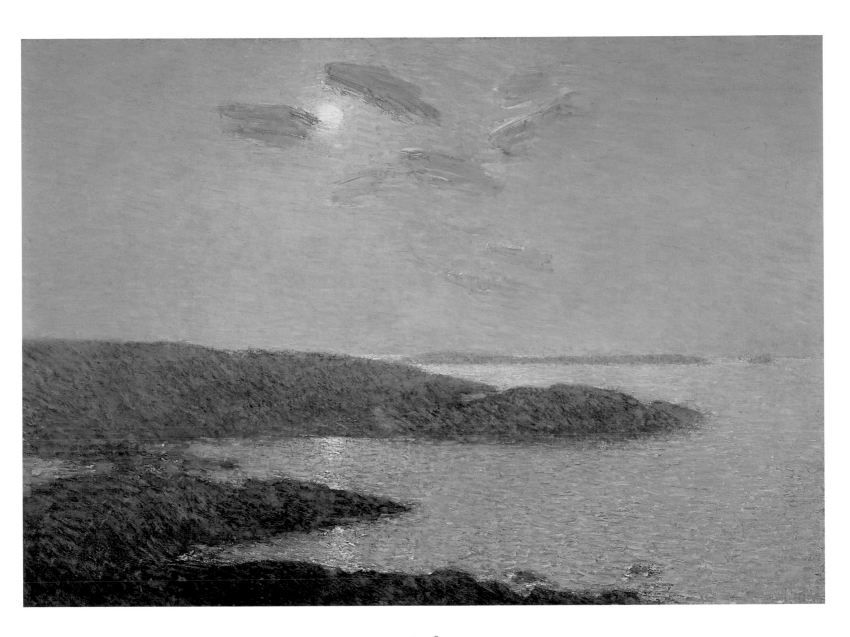

PLATE 81
Childe Hassam
Moonlight, 1907
Oil on canvas, 25¾ x 36¼ inches
Shaklee Corporate Art Collection, San Francisco, 1983

That [*Hassam*] *could be subtly delicate, is seen by the lovely* Appledore, August *of 1891, a develop-
ment of tonality almost Whistlerian in its tenderness.*[59]

Whistler's sunsets were essentially decorative in nature. Executed in a rococo-inspired pink and blue
palette first seen in his architectural decorations of the late 1860s, they are among his most abstract
works (Plate 84). Whistler divided landscapes into horizontal bands of color, three or four in number.
His treatment of nature did not differ significantly from his designs for walls or rugs.[60] And Hassam's
approach to similar subjects did not differ much from Whistler's. Sunsets and moonlights tempted
Hassam with opportunities for highly keyed Whistlerian symphonies.

A number of the Shoals landscapes are dominated by a simple formal structure in which a
large geometric arc bisects the decorative surface (*see* Plates 65, 67). These canvases are almost abstract
statements of lavish color and brushwork. Ravishing fields of pink, purple, orange, yellow, and tur-
quoise fill Hassam's large square *Sunset at Sea* (Plate 85). Broad swaths of complementary color in the
sky yield to choppier brushwork of varied hue in the expanse of ocean that fills nearly two-thirds of
the canvas. A single schooner breaks the horizon line in what would otherwise be a nonfigurative
work. Yet Hassam was inspired by actuality. He saw what Thaxter also admired, "a splendor of wild
clouds at sunset, dusk heaps with scarlet fringes, scattered flecks of flame in a clear crimson air above
the fallen sun."[61]

PLATE 83
Childe Hassam
L'Epicerie, 1889
Oil on panel, 8½ x 12½ inches
Courtesy Dumbarton Oaks Research Library and Collection, Washington, D.C.

PLATE 84
James McNeill Whistler
Southend: Sunset, 1880s
Watercolor, 10 x 7 inches
Courtesy Freer Gallery of Art, Smithsonian Institution,
Gift of Charles Lang Freer, 1905

PLATE 85
Childe Hassam
Sunset at Sea, 1911
Oil on canvas, 34 x 34 inches
Rose Art Museum, Brandeis University, Waltham, Massachusetts,
Gift of Mr. and Mrs. Monroe Geller, 1958

PLATE 86
Childe Hassam
West Wind, Isles of Shoals, 1904
Oil on canvas, 15 x 22 inches
The Beinecke Rare Book and Manuscript Library, Yale University,
Bequest of Sinclair Lewis to the collection of American Literature,
University Library

PLATE 87
Childe Hassam
West Wind, Isles of Shoals
(detail), 1904
Oil on canvas
The Beinecke Rare Book
and Manuscript Library,
Yale University, Bequest
of Sinclair Lewis to the
collection of American
Literature, University
Library

In another gem-like canvas, *West Wind, Isles of Shoals*, the distant shoreline is "a beautiful, undulating line of land, which, under the touch of atmospheric change, is almost as plastic as the clouds, and wears a new aspect with every turn of wind and weather" (Plate 86).[62] Little whitecaps fleck the surface, indicating the passage of a "delicate breeze that many a sail caressed as it swept the sapphire seas."[63] A schooner, the largest boat in the picture, occupies an area of about a quarter-inch square. A patch of white pigment, applied in a single stroke, forms the mainsail and a smaller citron yellow stroke enlivens the billowing canvas. A minute vertical touch of blue-green sparks the yellow, at the same time delimiting the corner of the upper left quadrant. An even tinier touch of red evokes a fluttering pennant, and a hairline brick-red stroke, next to a slightly thicker white one, gives us the knife-edged hull. The two corresponding touches of red bracket the division between sky and water, and seem to staple the two spatial registers together (Plate 87).

Hassam restates the shimmering blue harmonies more succinctly in another Whistlerian nocturne, the pastel, *Evening Star* (Plate 88). Crosshatched blue strokes explode across the brown paper in varying densities. Their swirling yet graceful energy is held in check by a single dot and broken vertical slash of rich golden strokes, suggesting dreams of infinity and endless space. Hassam made more than one such composition. A related oil, *Eternity*, received a good deal of notice in the press:

PLATE 88
Childe Hassam
The Evening Star, 1891
Pastel, 20 x 24 inches
The Beinecke Rare Book and Manuscript Library, Yale University,
Bequest of Sinclair Lewis to the collection of American Literature,
University Library

PLATE 90
Childe Hassam
Red Sky, Sunset, c. 1907
Oil on panel, 6 x 8⅛ inches
Private collection, Courtesy Hirschl and Adler Galleries, New York

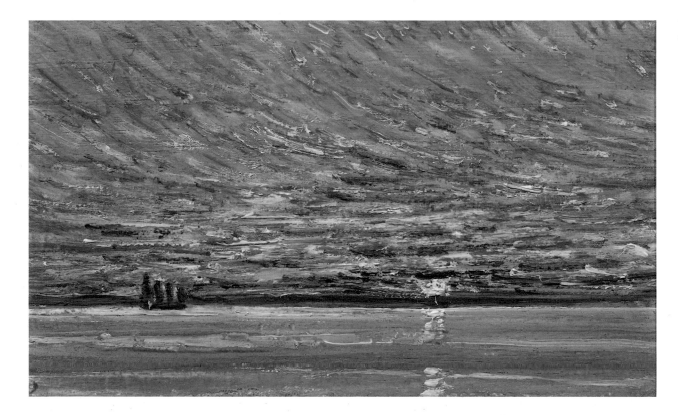

PLATE 91
Childe Hassam
Sunset Sky, 1908
Oil on panel, 6 x 8 inches
Private collection

Blue, endless sea, blue deep, vibrating sky, a track of far-reaching light on the water—its commence-
ment the only thing that defines the horizon—these things probably come as near to representing
eternity as anything else that an artist can attain to.[64]

Hassam made a group of striking color harmonies in 1907 and 1908. Thickly applied pig-
ments on small wood panels, some of them cigar-box tops, radiate joyous reds, glowing yellows, and
shimmering blues (Plates 89, 90). Whistler's impact is further seen in the original Hassam frame that
surrounds Plate 89. Like Whistler, Hassam chose varied tones of gilding to complement his palette of
oils. Eloquent color evokes Thaxter's admiration for the evening skies of Appledore where sunsets

flame in piled magnificence of clouds [as] a long bar lies, like a smouldering brand, along the horizon,
deep carmine where the sun has touched it. . . .[65]

Whether the composition was small or large, Hassam often broke the horizon line with a sailing craft
or emphasized it with a narrow atmospheric band of contrasting color. In another tiny panel, all
Whistlerian pinks and grays, dark sails "gather the dusk within their folds" (Plate 91).[66] In each case,
the act of painting is clearly paramount, and the visual impact of pure, brilliant pigments is sufficient to

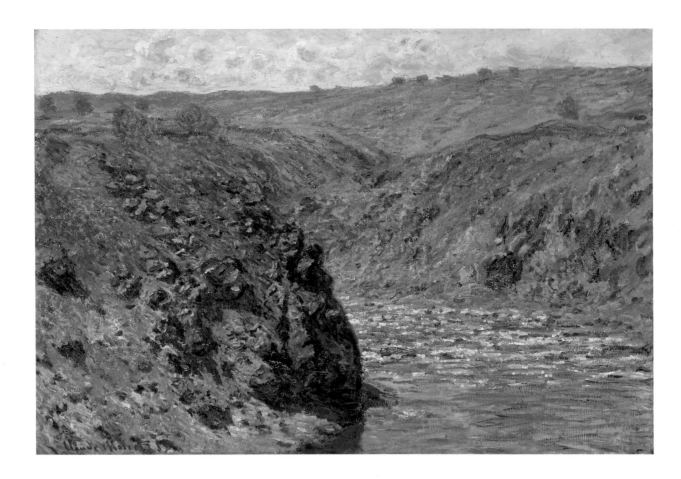

carry the picture. Such works support the generalization in Hassam's obituary that he "could create design by color."[67]

Whistler's impact is clear, and Hassam welcomed it. We know also that Hassam admired Turner's abstract, exalted color. Hassam's interest in highly decorative images probably was reinforced by his friendship with his colleague Weir, a member of the Tile Club and an acquaintance of Whistler's.[68]

But despite Hassam's endless protestations to the contrary, the intricate textures and graphic compositions of his seascapes are also linked to a vast number of canvases Claude Monet painted along the coast of Normandy and in the Creuse Valley.[69] The Shoals pictures just discussed recall the shimmering colors of Monet's Creuse series, which found American buyers shortly after their completion (Plate 92).[70] Hassam, like Monet, discovered a wealth of color in remote rocky regions near the water's edge.

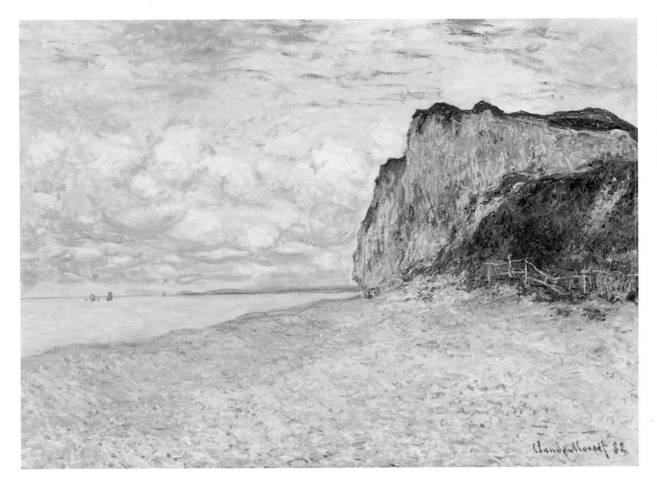

PLATE 93
Claude Monet
Cliffs Near Dieppe, 1882
Oil on canvas
23 ½ x 32 inches
The Carnegie Museum
of Art, Pittsburgh,
Acquired through the
generosity of the Sarah
Mellon Scaife family,
1973

After 1881, Monet often painted boldly asymmetrical juxtapositions of massive cliffs and open sea (Plate 93). They were regularly exhibited in Europe and the United States.[71] In analyzing these canvases, John House comments:

> [*Monet's*] *cliff tops rarely show a single sweep of terrain. Instead there are breaks in space; the eye progresses into depth by a succession of jumps; distance is expressed by successive planes overlapping each other and by atmospheric rather than linear perspective—by the softening of focus and changes of colour. Nor is the viewer securely placed in relation to the scene; Monet generally introduced a jump in space between his (and our) viewpoint and the nearest visible plane.*[72]

The effect was to provide a landscape that captured "a pictorial equivalent to nature's unexpected vistas and surprising effects."[73] These landscapes were spectacles, but not spaces that the viewer could easily enter.

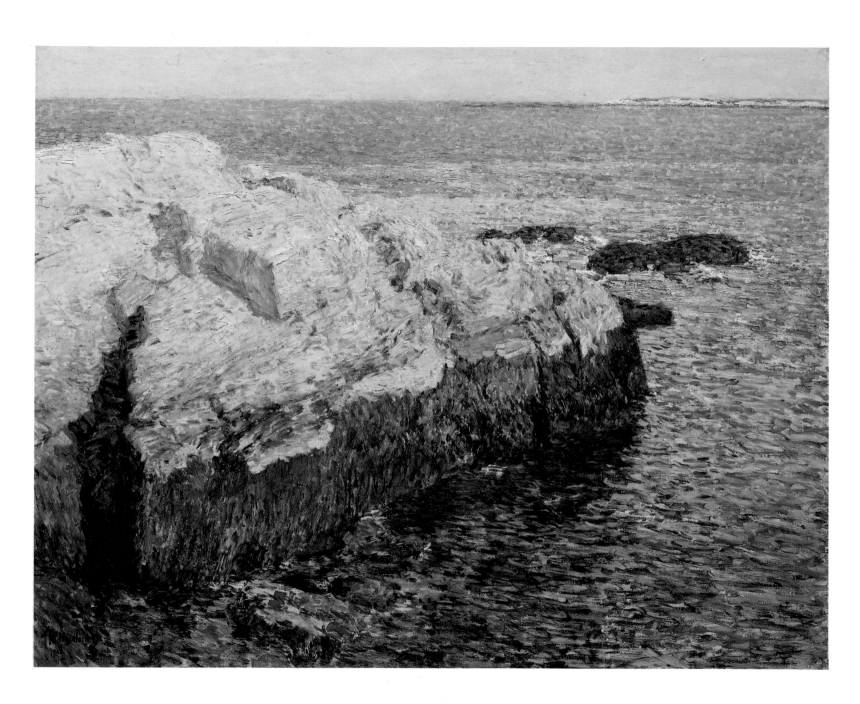

PLATE 94
Childe Hassam
Cliff Rock, Appledore, 1903
Oil on canvas, 29 x 36 inches
The Indianapolis Museum of Art,
John Herron Fund, 1907

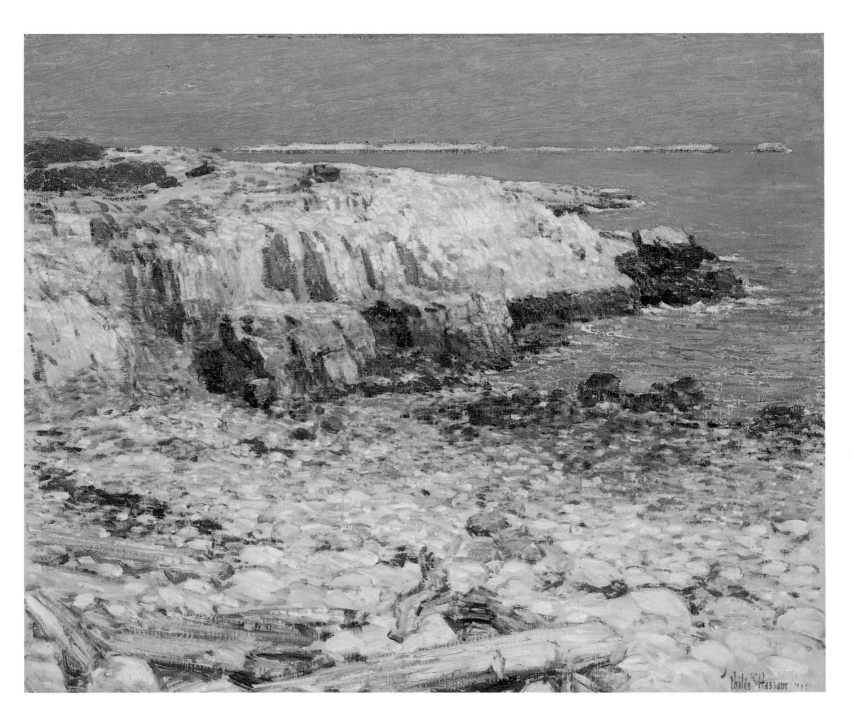

PLATE 95
Childe Hassam
Northeast Headlands, New England Coast, 1901
Oil on canvas, 25⅛ x 30⅛ inches
The Corcoran Gallery of Art, 1907

Similarly, Hassam's *Cliff Rock, Appledore* leaves the viewer teetering on the brink of a majestic vista (Plate 94). Like Monet, Hassam offers the observer no place to stand. The eye jumps from the shallows of the cove to the massive rocks of the east headlands, then abruptly out to sea. Only a narrow section of Duck Island at the right side of the canvas stands between the viewer and the vast ocean deep. Hassam looked north over Broad Cove, on Appledore's ocean front, to paint this subject. There, the configuration of fissured and tumbled granite was most dramatic:

> *Each island presents its boldest shore to the east, to breast the whole force of the great Atlantic, which every year assails the iron cliffs and headlands with the same ponderous fury.*[74]

At the Shoals

> *Each island has its peculiar characteristics . . . no two are alike [although] all are of the same coarse granite, mixed with masses and seams of quartz and felspar and gneiss and mica-slate, interspersed with dikes of trap running in all directions.*[75]

While Hassam's use of serial imagery was never as purposeful and focussed as Monet's, both artists found infinite variety by returning to the same themes and compositions, with varying degrees of success.

In the Carnegie picture, Hassam created stone out of colorful, controlled strokes applied thickly over a pale cream ground (*see* Plate 69). Round the granite forms he went, contouring the central rocky face in pigment. He swirled the strokes onto the canvas, energizing the resulting forms. But Hassam could not always carry it off. *Cliff Rock, Appledore* (Plate 94) makes a good first impression, but does not hold up well under scrutiny. There is excitement in the color but not in the form.

Painted a little earlier than the Indianapolis work, *Northeast Headlands, New England Coast* evidences the joyous release of freely expressed paint (Plate 95). It offers essentially the same view, but on a smaller scale. With obvious relish, Hassam handled the pigments quickly and loosely. The tide has gone out completely, depositing a log-like form seen in the foreground. Probably a broken mast from a wrecked ship, it serves as a poignant reminder of the sea's pitiless strength. Thaxter often observed such flotsam and jetsam:

> *The driftwood is always full of suggestions: —a broken oar; a bit of spar with a ragged end of rope-yarn attached; a section of a mast hurriedly chopped, telling of a tragedy too well known on the awful sea.*[76]

Occasionally, Hassam's rock pictures are composite studio works. *Isles of Shoals* combines a view of Appledore's northeast headlands, viewed across Broad Cove, with a close-up of a trap dike about a quarter of a mile south of the cove (Plate 96).

But more often, Hassam focussed upon some particular detail of the island's fissured cliffs. "Nothing takes color so beautifully as the bleached granite; the shadows are delicate, and the fine, hard outlines are glorified and softened beneath the fresh first blush of sunrise," Thaxter wrote.[77] *Sylph's Rock, Appledore* offers an abrupt visual confrontation with one of the great boulders at the water's edge (Plate 97). The water is rougher than Hassam usually painted it, and the colored strokes that create the rocks are harsh and purposeful. Staccato lines of blue-gray maintain the canvas's edgy linearity.[78] A critic, while acknowledging Hassam as an impressionist, noted "one feels in his work the truths of older systems."[79]

Hassam made a similar view of a narrow gorge again in a late watercolor, *The Gorge, Appledore* (Plate 98). The gradated blue wash of the ocean is powerfully bracketed by two massive rocks, each a set of linear slashes of pink, blues, and grays, deepening in hue towards the bottom of the sheet and giving way to rust, brown, and black highlighted with red-orange. Thaxter wrote:

> There is hardly a square foot of the bare rock that isn't precious for its soft coloring; and freshly beautiful are the uncovered lichens that with patient fingering have ornamented the rough surfaces with their wonderful embroideries.[80]

She especially admired the orange varieties that "flourish with the greatest vigor by the sea." A passage of brilliant red-orange borders the deep blue sea in *Entrance to the Siren's Grotto* (Plate 99). From a seemingly perilous height, the viewer observes a large, submerged boulder a few feet under the surface. Skiffs of white foam dance across the surface of the water and Hassam suppressed a sailboat at the upper left of the composition, to make it more abstract. In a subsequent general review of his work, one journalist perceived

> [Hassam] paints as broadly as ever . . . he enlivens dull surfaces of stone and dull depths of water with splashes of yellow, red and blue that are not there, but that have their pictorial value.[81]

A decade later, in a similar composition, Hassam looked down upon a shimmering pool, capturing what Thaxter described as "the wonderful jelly-fish that spreads its large diaphanous cup, expanding and contracting as it swims, and colored like a great melting opal in the pale-green, translucent water" (Plate 100).[82]

He seems to have been alive to the same chance encounters with unexpected natural hue and pattern that fascinated Thaxter all her life:

> Sometimes in a pool of crystal water one comes upon [a baby sculpin] unawares,—a fairy creature, the color of a blush-rose, striped and freaked and pied with silver and gleaming green, hanging in the almost invisible water as a bird in air. . . . One gazes marvelling at all the beauty lavished on a thing of so little worth.[83]

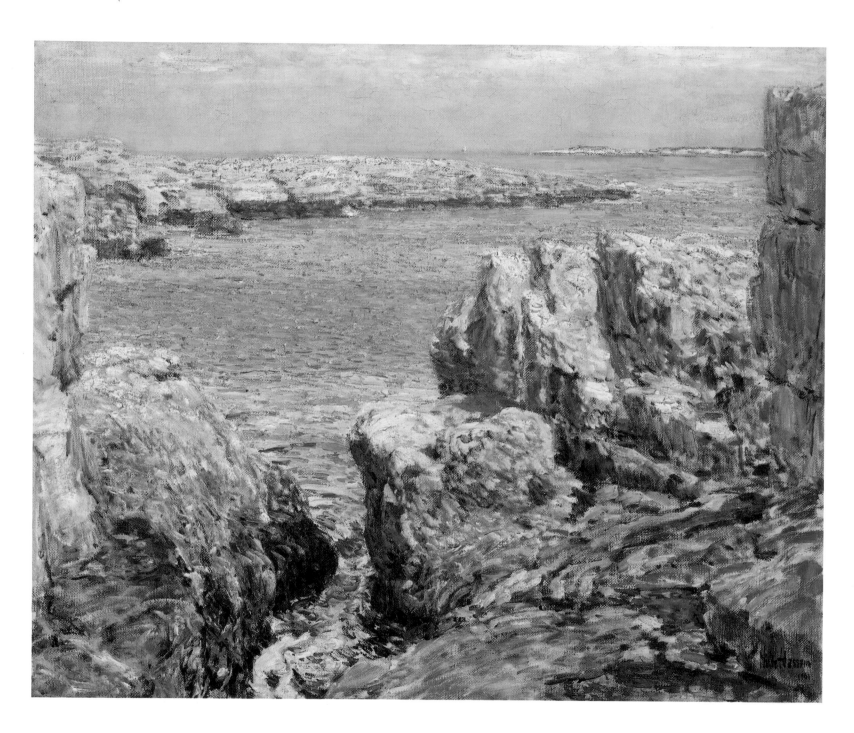

PLATE 96
Childe Hassam
Coast Scene, Isles of Shoals, 1901
Oil on canvas, 24⅞ x 30⅛ inches
The Metropolitan Museum of Art,
Gift of George A. Hearn, 1909

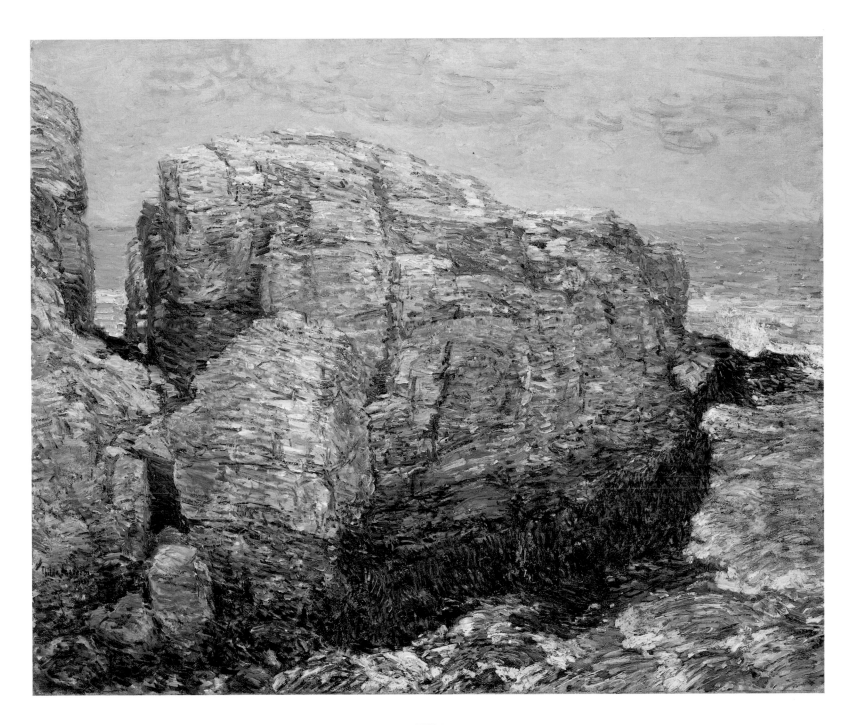

PLATE 97
Childe Hassam
Sylph's Rock, Appledore, 1907
Oil on canvas, 25 x 30 inches
The Worcester Art Museum, Worcester, Massachusetts,
Gift of Mrs. Elisha D. Buffington in memory of her husband, 1908

PLATE 98
Childe Hassam
The Gorge, Appledore, 1912
Watercolor, 13¾ x 19⅞ inches
The Brooklyn Museum, Museum Collection Fund, 1924

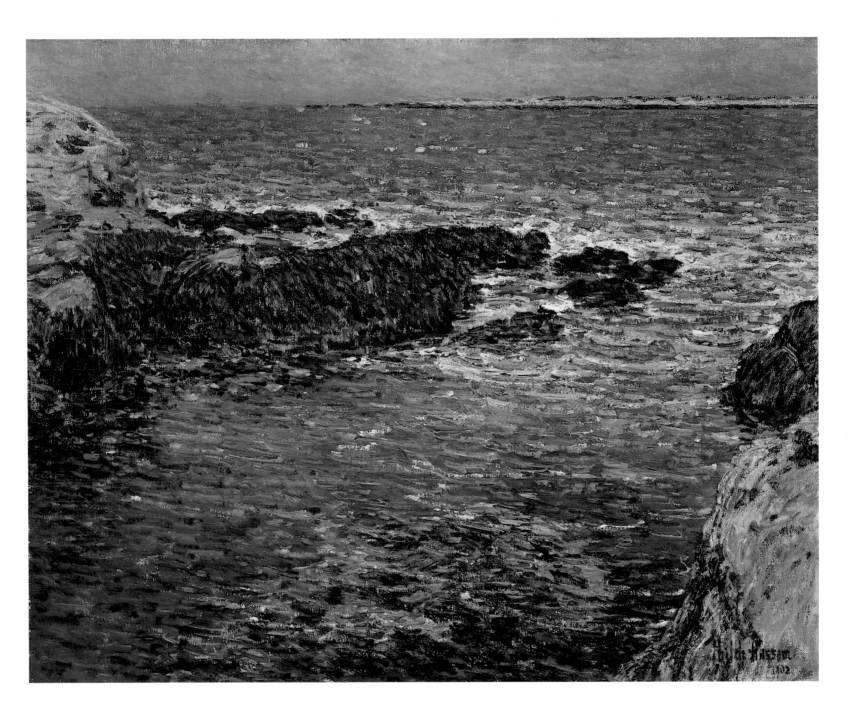

PLATE 99
Childe Hassam
Entrance to the Siren's Grotto, Isles of Shoals, 1902
Oil on canvas, 18 x 22 inches
The Ball State University Art Gallery, Muncie, Indiana,
Gift of the Muncie Art Association, 1971

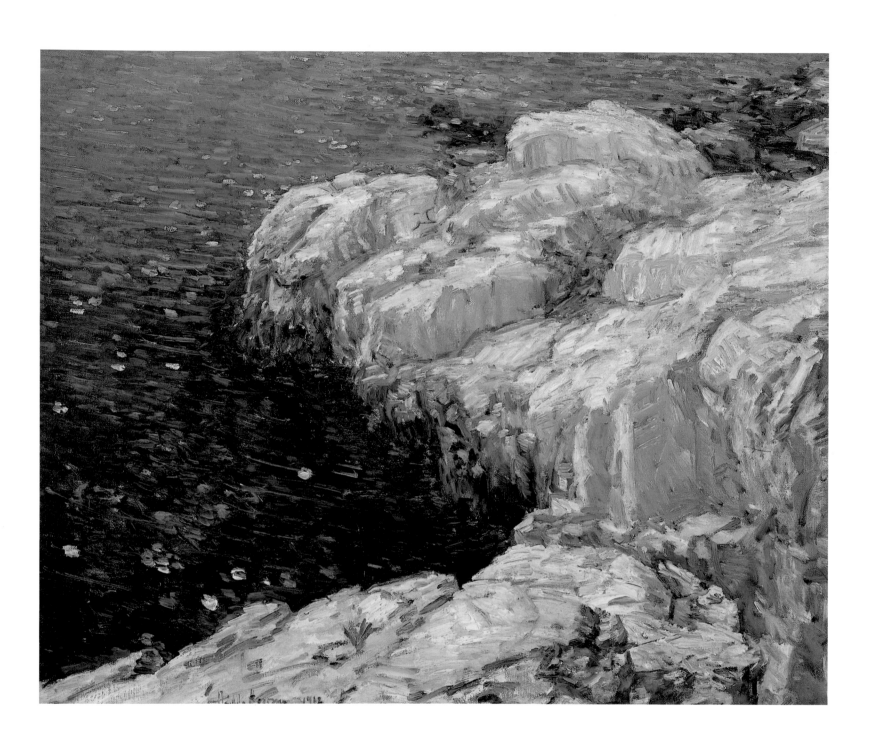

PLATE 100
Childe Hassam
Jelly Fish, 1912
Oil on canvas, 20⅛ x 24⅛ inches
The Wichita Art Museum, Wichita, Kansas,
The John W. and Mildred L. Graves Collection, 1986

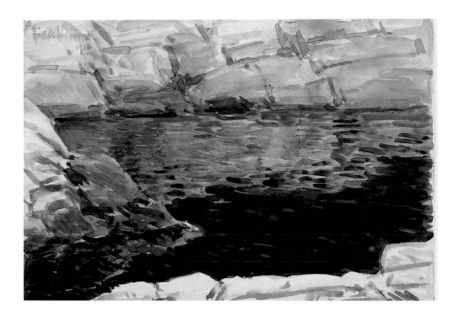

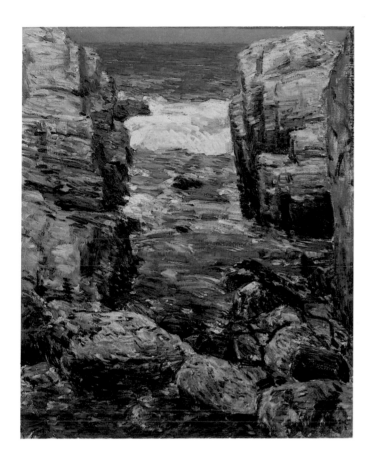

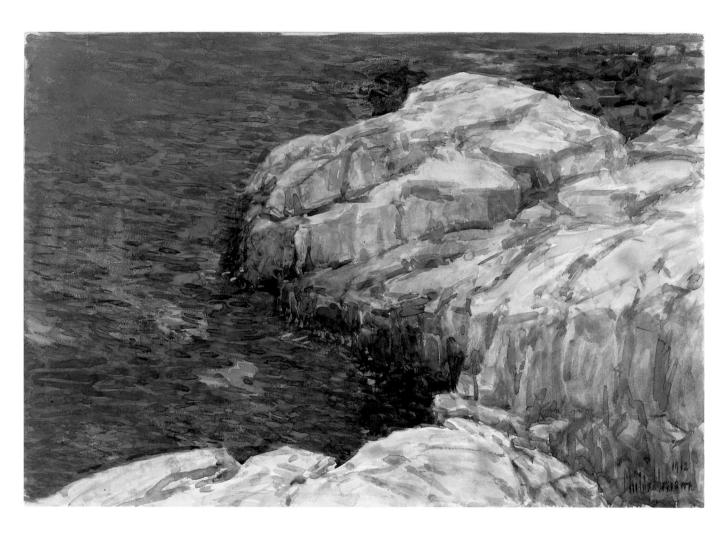

PLATE 104
Childe Hassam
East Headland, Isles of Shoals, 1912
Watercolor, 13¾ x 19¾ inches
Collection of Mr. and Mrs. Perry T. Rathbone

Beautiful purples and grays, blues, greens, turquoises, and rusts drew Hassam close to the boulders, crags, and inlets—spots of seemingly little worth—in his final important pictures at the Shoals. Hassam was working in both oil and watercolor at this point, but in oil he seldomed balanced his dynamic brushwork with really exalted color. Even the best of his late Shoals canvases seem dry, perfunctory, a bit forced, as if the artist was tiring of the challenge (Plate 101).

Yet a dozen or so spirited watercolors, many dated 1912, are another matter entirely. Despite site-specific titles, such as *Looking into Beryl Pool* (Plate 102), they convey little sense of place. Almost abstract, they seem instead to capture the very ethos of craggy rock and limpid water. In a way this series recalls the images with which Hassam began his scrutiny of the Shoals, bringing us full circle. Close-cropped shifting views rendered within a limited but evocative color range (Plates 103, 104) remind us of his fascination with the White Island Light (*see* Plate 55). And the final rocks, like the first lighthouses, are watercolors. But there the parallel ends. This last strong series passes on no data beyond the natural splendors Hassam encountered on every visit to Appledore.

Near the end of his long career, Hassam recalled, "I think I went to the Shoals for the last time the year of the outbreak [of war] in 1916."[84] By the advent of the First World War his occasional Shoals pictures had little more force than a spent wave. We must look to the earlier work, when his energies and interest were focussed on the site, if we would revisit the island garden. There

> the slowly mellowing light lies tranquil over the placid sea, enriching everything it touches with infinite beauty,—waves and rocks that kill and destroy, blossoming roses and lonely graves. . . . Afar off the lazy waters sing and smile about that white point, shimmering in the brilliant atmosphere. How peaceful it is! How innocent and unconscious.[85]

Hassam's oils, watercolors, and drawings at the Isles of Shoals are filled with peace. But neither innocent nor unconscious, the artist captured on canvas and paper the exquisite effects of color that were the glory of this remote and ancient place.

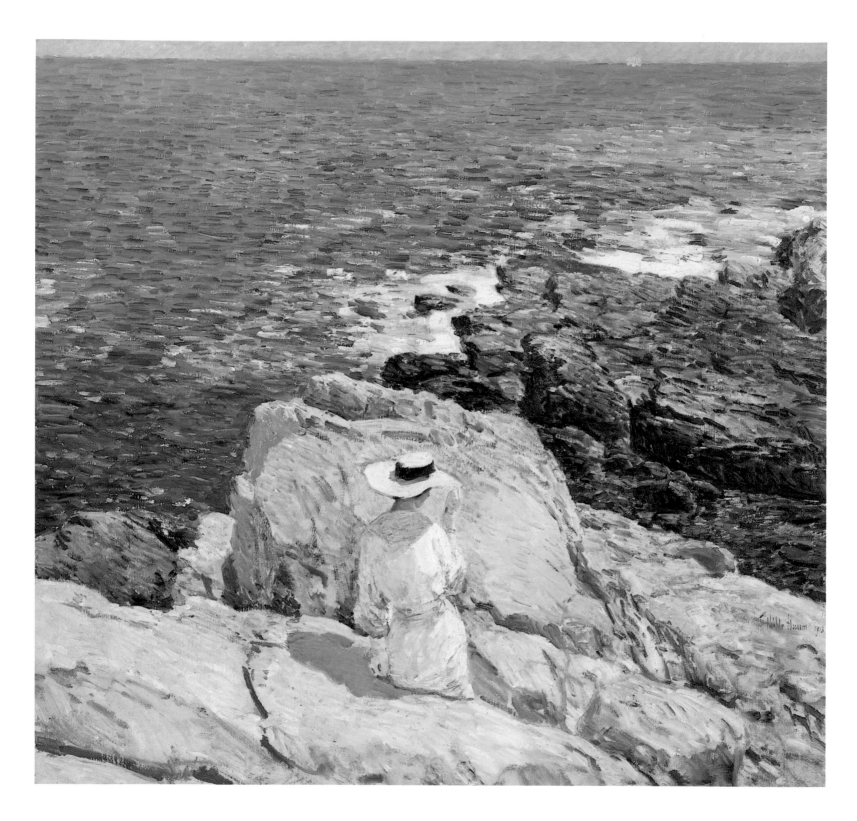

PLATE 105
Childe Hassam
The South Ledges, Appledore, 1913
Oil on canvas, 34¼ x 36⅛ inches
The National Museum of American Art, Smithsonian Institution,
Gift of John Gellatly, 1929

Epilogue: Forget-Me-Not

"If one but gazes closely into a tiny flower of the pale blue Forget-me-not, what a chapter of loveliness is there!"

CELIA THAXTER[1]

Holding the brim of her wide straw hat against the fresh breeze, a solitary figure gazes into the distance, lost in contemplation on the rocky south ledges of Appledore (Plate 105). In Hassam's picture she dominates the diagonal wedge of granite that occupies fully half the canvas. The artist used color to link figure and landscape. Lavenders in her belt and edged sleeve harmonize with magenta in the kelp-covered rocks, while the blues and purples of her hatband are repeated in the bleached ledge nearby. At the left, swaths of purple and blue divide the rocks, just as the belt divides her dress. A single yellow flower in the foreground and a schooner's white sails on the far horizon mark out the diagonal upon which Hassam built the composition.

Thaxter inquired, "What quality is hidden in this thin soil, which so transfigures all the familiar flowers with fresh beauty?"[2] The yellow blossom in Hassam's picture reminds us that the soil of Appledore was rich enough for the glorious flowering of Thaxter's garden. And, while I have touched upon a parallel richness in the long history of these seemingly barren rocks, my chief interest has been the ways in which Hassam's oils, watercolors, and drawings of the Isles of Shoals fit along the temporal continuum that always links past, present, and future painting.

We know that Hassam's cult of beauty was eventually overshadowed by other painting styles that registered other concerns. Celia Thaxter understood that the flowers and rocks themselves outshone poetry and paint, and it is worth recalling that beauty for its own sake survived in aesthetic garden design well into the twentieth century, years after being abandoned by painters. Such aesthetics were at ebb tide by World War I. Nevertheless, the sea of flowers can yet be navigated.

One might come across an Appledore image in a quiet museum gallery, or discover the islands in the pages of an old book from a second-hand store. Today we encounter Hassam's impressionist paintings as posters or magazine illustrations, while some of Thaxter's writings are once again in print. Even the garden they loved has been reproduced—as a temporary exhibition at the Denver Botanic Gardens (1989–90), and permanently, it is to be hoped, on the original site near the broken

foundations where Celia Thaxter's parlor once stood. Voices that filled the parlor are hushed now. But Thaxter's eloquent writings can still turn up the sound on Hassam's oils, watercolors, and drawings:

> *Nothing is too slight to be precious: the flashing of an oar-blade in the morning light; the twinkling of a gull's wings afar off, like a star in the yellow sunshine of the drowsy summer afternoon; the waterspout waltzing away before the wild wind.*[3]

Celia Thaxter never forgot simple refreshments:

> *There is something especially delightful in the perfumes which stream across the sea after showers, like a heavenly greeting from the land: scents of hay and of clover, spice of pine woods, balms of flowers come floating over the cool waves on the wings of the west wind, and touch one like a breath from Paradise.*[4]

The figure in *South Ledges, Appledore* remains private, her face averted, her thoughts her own. We might conclude that Hassam was wise in clinging to the beautiful. His pictures invite contemplation, reminding us that, like a breezy seaside afternoon or a common garden flower, chapters of loveliness are there for the reading, whether we choose to notice them or not.

Endnotes

Prologue: A Summer Place

1. Childe Hassam to Mrs. McClellan, 1929, facsimile letter, curatorial file, *Morning Calm, Appledore*, Phillips Andover Academy.

2. Brendan Gill and Dudley Witner, *Summer Places* (New York, 1978), p. 17.

3. Located ten miles offshore, the Isles are nine granite outcroppings that occupy a roughly quadrangular area one and a half by three miles. For a fulsome listing of flowering plants known at the Shoals, see Richard A. Howard, *Flowers of Star Island, the Isles of Shoals* (Jamaica Plain, Mass.), 1968.

Using exhibition records, auction catalogues, magazine advertisements, and various archival listings, I found record of approximately four hundred Shoals images by Hassam. Most are either watercolors or oils, a few are pastels. But by no means is every Shoals image located, and in some cases original titles have been lost, so there may be multiple titles for the same picture.

4. Hans Huth, *Nature and the American, Three Centuries of Changing Attitudes* (Berkeley, 1972), p. 116, fn. 25.

5. Celia Thaxter, *Among the Isles of Shoals* (Boston, 1873), p. 8.

6. Gill, *Summer Places*, p. 17.

7. In about 1910 a critic warned that Hassam was working too rapidly and ought to show some self-restraint. "Think of the appalling number of Hassam pictures there will be in the world by the time the man is seventy years old!" "The Abounding Childe Hassam," undated exhibition review, *Mail Express*. Papers and correspondence, 1883–1936, in collections of papers of the American Academy and Institute of Arts and Letters (hereafter Hassam Papers), roll NAA-1, frame 541, Archives of American Art, Smithsonian Institution.

8. I am grateful to Kathleen Burnside of Hirschl and Adler Galleries, New York, for bringing this series to my attention.

9. For "ghosts" see Hassam to Weir from Appledore House, 12 August 1903. For unchanging landscape, see Hassam to Weir from Appledore House, 20 July 1911. Hassam Papers, roll NAA-2, frames 68, 66, Archives of American Art.

10. Thaxter wrote, "People forget the hurry and worry and fret of life after living there awhile, and, to an imaginative mind, all things become dreamy." *Among the Isles*, p. 8.

11. Hassam Papers, roll NAA-1, frame 545, Archives of American Art.

12. Undated review of a Hassam exhibition of pastels and watercolors held in the late 1880s at Doll and Richards, Boston, cited in Susan Faxon (et al.), *A Stern and Lovely Scene: A Visual History of the Isles of Shoals* (Durham, NH: University Art Galleries exhibition catalogue, University of New Hampshire, 1978), p. 118.

Chapter 1. In Celia Thaxter's Parlor

1. Celia Thaxter, *An Island Garden* (Boston and New York, 1894), p. 5.

2. Candace Wheeler, *Content in a Garden* (Boston and New York, 1901), p. 57.

3. The majority of Hassam's illustrations for the book date from 1890 to 1892 and we may surmise that all were complete by the fall of 1893. At that time Thaxter wrote to Sarah Orne Jewett from the Shoals, "I am pegging away hard on the book, and I want to ask you lots of things. All you say is so precious, dear. I have got a little plan of the garden, as you suggested, with places of everything marked,—a sort of little map. I have got the whole thing about done, the writing, but there is much copying and arranging of parts to make a proper unity." Thaxter to Jewett, 28 September 1893, in *Letters of Celia Thaxter*, ed. Annie Fields and Rose Lamb (Boston and New York), 1895, p. 207.

In December 1893, Thaxter wrote, "My book about island flowers is to be out at Easter. 'An Island Garden.' The illustrations in color by Childe Hassam, of flowers and sea are lovely." Thaxter to Samuel Gray Ward and Anna Hazard Barker Ward, 27 December 1893, bMS Am. 465 *42M-2088; no. 1267. Houghton Library, Harvard University.

Hassam's pictures do not necessarily relate specifically to the text. Some images are more illustrational than others, but in general, the most experimental works he did at this time were not included in *An Island Garden*.

The book is dedicated to Mrs. Mary Hemenway, who had been a guest at Appledore, and who contributed financially to the publication. *An Island Garden* was issued by Houghton-Mifflin in 1894. The company reissued it in 1904 and created a facsimile reprint in 1988.

4. See Jane E. Vallier, *Poet on Demand: The Life, Letters and Works of Celia Thaxter* (Camden, Me., 1982). A bibliography of Thaxter's major works is included, p. 254.

5. William Gerdts, "Square format and proto-modernism in American painting," *Arts Magazine* 50 (June 1976): 70–75.

6. For a thorough background, see Doreen Bolger et al., *In Pursuit of Beauty: Americans and the Aesthetic Movement* (New York, 1986).

7. Donelson Hoopes speculated that the figure on the couch might be Celia Thaxter. See Hoopes, *Childe Hassam* (New York, 1979), p. 38. The girl is too young to be Thaxter, but could be Hassam's wife, Kathleen Maud Doane, whom he married in 1884. She frequently accompanied him to the Isles of Shoals.

8. Also visible are a neoclassical plaster cast, along with a number of wicker rockers, a rococo revival slipper chair, and a then highly fashionable faux-bamboo triple-lobed table, probably by Horner of New York.

9. For "idiosyncratic" See Samuel Adams Drake, *A Book of New England Legends and Folk Lore*, rev. ed. (Boston, 1910), p. 348. Trevor Fairbrother discussed the Shoals as a summer colony prototype in "Painting in Boston, 1870–1930," in *The Bostonians: Painters of an Elegant Age, 1870–1930* (Boston: Museum of Fine Arts exhibition catalogue, 1986), p. 47.

10. Thaxter, *An Island Garden*, pp. 93–94. Thaxter's house was built in 1864 and her parlor was enlarged in 1887. See map in Frederick T. McGill, Jr., ed., *Letters to Celia,*

written during the years 1860–1875 to Celia Laighton Thaxter by her brother, Cedric Laighton (Boston, 1972), facing p. 1. For additional helpful maps of the sites discussed here, see Lyman V. Rutledge, *Ten Miles Out: Guide Book to the Isles of Shoals* 6th ed., Frederick T. McGill, Jr. (Boston, 1984).

11. Thaxter, *An Island Garden*, pp. 101–2.

12. Greeley quoted in a letter from John Greenleaf Whittier to Thaxter, cited in Rosamond Thaxter, *Sandpiper: The Life and Letters of Celia Thaxter* (Francestown NH, 1963), p. 209.

13. Randall Stewart, ed., *The American Notebooks of Nathaniel Hawthorne* (New Haven, 1932), p. 272.

14. Hassam's last trip to Europe was in 1910. For a listing of his known travels, see Kathleen Burnside, "Chronology," in Stuart P. Feld, *Childe Hassam: 1859–1935* (East Hampton, NY: Guild Hall Museum exhibition catalogue, 1981), pp. 19–25.

15. Thaxter, *Among the Isles*, p. 128

16. Cedric Laighton to Thaxter, from Appledore, 22 January 1860, *Letters to Celia*, p. 3.

17. For "heart of nature," see Thaxter, *Among the Isles*, p. 123. For "eager character," see Annie Fields, "Celia Thaxter," in Celia Thaxter and others, *The Heavenly Guest, with other unpublished writings*, ed. Oscar Laighton (Andover, Mass.) 1935, p. 88.

18. *A Stern and Lovely Scene*, p. 42.

19. Levi Thaxter's was "one of the oldest families in America." For the Thaxter family history see Justin H. Shaw, "Celia Thaxter, 1835–1935," in *Heavenly Guest*, pp. 144–45.

20. Laighton had already received summer guests in an old house on nearby Smuttynose Island for two years, 1841–42. This establishment was called the Mid-Ocean House of Entertainment. Built during the winter of 1847–48, the new hotel was named Appledore House. A north wing was added in 1859 and a south wing in 1872. The building burned to the ground on 7 September 1914. See *A Stern and Lovely Scene*, pp. 43–46ff.

21. Thomas Wentworth Higginson, quoted in *A Stern and Lovely Scene*, p. 45, fn. 53.

22. Howard, *Flowers of Star Island*, p. 3.

23. Elms were planted around the Appledore House in Thaxter's day, but they must not have thrived, for in *An Island Garden*, she spoke of a single tall elm, p. 39.

24. During the revolutionary war, most of the "wealthy and respectable" occupants of the islands departed. *A Stern and Lovely Scene*, p. 36ff.

25. Surviving correspondence sent to Thaxter by her brother gives us some idea of ongoing developments at the resort: "We have taken the alleys out of the main building. . . . Today we moved the fish-house or bathing house from its old position in a direct line toward the yellow gate, and halted where the old fish-flake used to stand."

A few days later Cedric continued, "We have been busy today constructing a fish-house, situated on the bank by Babb's Cove, close by the northeast corner of the swamp. We attempted to move the old one, which you remember was parted off into a fish room and bathing room, but while we were hauling it over a hill it fell down smash, so we were compelled to stave it to pieces." Laighton to Thaxter, from Appledore, 6 December 1860 and 1 January 1861, *Letters to Celia*, pp. 9, 11.

26. Not surprisingly, Thaxter came to dislike the annual onslaught of visitors. "I am dreading people," she wrote to Ross Sterling Turner one spring. See Thaxter to Turner, 12 March [1884], *Letters of Celia Thaxter*, p. 137.

27. David Francis Lincoln, "Notes on the Climate of the Isles of Shoals, and of Nantucket," *The Boston Medical and Surgical Journal* (7 October 1875, offprint), pp. 1–7. Dr. Lincoln found the water "too cool for many persons to bathe in" and opined, "The bathing-houses are also too directly exposed to the view, being in front of the houses and near the wharves; otherwise the pretty little inclosed basin at Appledore, containing about half an acre of water of safe depths, is decidedly attractive."

28. A visitor to the Blessed Isles, "Domesticana, Life at a Summer Salon on Appledore," in *Heavenly Guest*, p. 133.

29. Maud Appleton McDowell, "Childhood Memories of Celia Thaxter," in *Heavenly Guest*, p. 127. Thaxter's gowns have an old-fashioned, eighteenth-century look, reminding us that she was influenced by the colonial revival. "She never wore any other colors, nor was anything like 'trimming' ever seen about her; there were only the fine, free outlines and a white handkerchief folded carefully about her neck and shoulders." Annie Fields, Introduction to *Letters of Celia Thaxter*, p. ix.

Trevor Fairbrother points out that garden images created by Hassam, Brown, Turner, and other artistic visitors to Thaxter's parlor "reflect a growing awareness of all things 'old-fashioned,' their rich profusion suggesting a new hunger to recapture the color and spirit of the age they symbolized. They are subtle reflections of the historicist movement that was particularly associated with architecture and the decorative arts now known as the Colonial Revival." *The Bostonians*, p. 46.

30. C. T. Young cited in Rosamond Thaxter, *Sandpiper*, p. 88

31. Annie Fields, *Heavenly Guest*, p. 94.

32. Ibid.

33. Mrs. Thaxter enjoyed mixing with the literati. She forgot "all weariness and perplexity on the crest of earthly bliss while Emerson discourses." Thaxter to James T. Fields, 25 October [1862–63]. And "It was a real delight to see Mr. Dickens and to have one's ideal of an individual so completely realized," Thaxter to James T. Fields, 6 January 1867; *Letters of Celia Thaxter*, pp. 26, 29.

34. Thaxter to Annie Fields, from Appledore, 4 May 1869, *Letters of Celia Thaxter*, p. 141.

35. Celia Thaxter's account of Hunt's death is discussed in *A Stern and Lovely Scene*, pp. 109–10. His last drawing, *The Marine View at Appledore*, is illustrated on p. 111, fig. 79.

36. Justin H. Shaw in *Heavenly Guest*, p. 148.

37. Thaxter to Whittier, 15 November [1861–63], bMS Am 1844 (305), Houghton Library, Harvard University. This is one of numerous letters between the two now at the Houghton Library.

38. Hassam Papers, roll NAA-2, frame 228, Archives of American Art.

39. For a list of artists, see exhibition list, *A Stern and Lovely Scene*, pp. 137–39.

40. *A Stern and Lovely Scene*, p. 54. Some of Thaxter's poems were set to music. She wrote from the Shoals, "I have just written one called 'Forebodings,' which Mr. Eichberg has also set to music, and which he says is the best thing he has ever composed." Thaxter to Elizabeth D. Pierce, 29 September 1874, in *Letters of Celia Thaxter*, p. 61.

41. Winch was a singer whose favorite song was "The Wandering Wave." William Mason and John K. Paine were well-known pianists.

42. Thaxter wrote from Newtonville, Mass. that her parents-in-law "brought us home Guido's 'Aurora,' engraved by Raphael Morghen . . . Oh, so splendid as it is! Levi [and I] gaze at it by the half-hour together and find new beauties in it daily." Thaxter to E. C. Hoxie, 28 March 1857, *Letters of Celia Thaxter*, p. 9.

43. Thaxter to Elizabeth D. Pierce, from Appledore, 29 September 1874, *Letters of Celia Thaxter*, p. 60. Thaxter thanked J. Appleton Brown for his gifts of pictures, saying, "I am delighted with them, and shall have them framed and hung up immediately for the admiration of all beholders." Thaxter to Brown, 13 July 1877, *42M-41, Houghton Library, Harvard University.

44. Robert Herbert, *Jean-Françoise Millet* (Paris: Louvre exhibition catalogue, 1975), pp. 78–79.

45. "Domesticana," *Heavenly Guest*, p. 131.

46. Robbins' determined attempts at verism sometimes fooled her audience. Cedric Laighton wrote that her "picture of the autumn leaves is a perfect wonder . . . a couple of friends who are paying the Shoals a short visit examined [the picture] the other day, and thought it very perfect. Mr. Manely was quite sure, at first, that real leaves were stuck on the paper. Bocky made the same mistake." Laighton to Thaxter, from Appledore, 9 November 1861, *Letters to Celia*, p. 39. For more on Robbins at the Shoals, see also Ellen Robbins, "Reminiscences of a Flower Painter," *New England Magazine* 14 (June 1896): 440–51, and (July 1896): 532–45.

47. Annie Fields, Introduction to *Letters of Celia Thaxter*, p. xvi.

48. Thaxter to Feroline W. Fox, from Appledore, 10 September 1878, *Letters of Celia Thaxter*, p. 93.

49. Thaxter to Brown from the Isles of Shoals, 22 July 1878, *42M-459, Houghton Library, Harvard University.

50. Hassam to Woodbury [before 1894], *59M-93, Letter 2; Houghton Library, Harvard University. Laurence Hutton was the literary editor of *Harper's Magazine* from 1886 to 1898. *The New Century Cyclopaedia of Names*, vol. II (New York, 1954), p. 2092.

51. Rosamond Thaxter, *Sandpiper*, pp. 195–96.

52. Marie Walther to Sharley (Charlotte Briggs), from Appledore, 23 July 1893. William Page Papers, roll 23, frame 4136–37, Archives of American Art.

53. Thaxter to E. C. Hoxie, 22 November [1857] *Letters of Celia Thaxter*, p. 13.

54. Thaxter to Mina Berntsen, from the Shoals, March, no year, quoted in *Heavenly Guest*, p. 91.

55. Thaxter's handwritten copy, dated 1890, is bound into Thaxter, *The Cruise of the Mystery and Other Poems* (Boston, 1888), courtesy the Boston Public Library, Rare Books Department. The sonnet recalls similar poems written by Thaxter for other artists and musicians. See *Heavenly Guest*, pp. 35, 41.

56. Thaxter described her first garden, a patch of marigolds she'd had at age five, as a "crescent growing into the full-rayed orb" of the flower, and she admired the "splendor of color." *An Island Garden*, p. vi.

57. Annie Fields commented, Thaxter "was almost too well known even to strangers, in these later years at the Shoals, to make it worth while to describe . . . the small silver crescent which she wore above her forehead." *Heavenly Guest*, p. 92.

58. Hassam himself recalled, "When I was not much past twenty I met Celia Thaxter who liked as so many others did (Miss Jane Hunt sister of William was another) to paint in watercolors. She said to me one day 'You should not, with an unusual name like yours, fail to take advantage of its unique character—there is a young Englishman who has just written some remarkably good stories of India. He has married an American girl, a Miss Balestier of Brattleboro, Vermont. His name is Joseph Rudyard Kipling—but he has the literary sense to drop the prefix. If your name is to become known, as Jane Hunt and I think it will, it would be better without the E.' That was quite early in my career and so I became Childe Hassam and I spent some of my pleasantest summers in the Isle of Shoals and in her salon there." Hassam to Farmer, 22 February 1933, cited in *A Stern and Lovely Scene*, p. 115.

59. Thaxter told Whittier, "I am writing poems by the yard to fit 26 Wide Awake art prints to be made into an Xmas book, an edition de luxe. You may believe it is no sham job! I have 12 done and 14 to do. Bismillah! but some of them are posers! It takes a heap of human ingenuity to get the better of them." Thaxter to Whittier from the Shoals, 24 June 1888, in *Sandpiper*, p. 221.

Thaxter wrote and illustrated "My Lighthouse," which was printed in 1890 as a Christmas card by Prang. See *Heavenly Guest*, p. 139.

60. Thaxter to Houghton, 10 February 1882. Thaxter's later correspondence indicates that the publisher complied with her wishes. She was quite successful with her illustrated books, writing "You will think me a cormorant, but I want more books if you please! I have so many orders for illustrated copies before Xmas." Thaxter to Jamison, 11 December [1882]. Both in 52 Letters to Houghton-Mifflin, bMS Am 1925 (1767), Houghton Library, Harvard University.

61. A letter to Miss Cara C. Haynes (Caroline Coventry Haynes of New York), 7 November 1902, contains two pressed and dried Shirley poppies. *42M-474 Ms Am 1272, Houghton Library, Harvard University.

62. The earliest reference I found of Thaxter's painting was a letter her brother sent: "Your elegantly illuminated letter of the thirteenth arrived last Thursday." Laighton to Thaxter, from Appledore, 24 January 1864, *Letters to Celia*, p. 63.
Thaxter had become an amateur painter by 1874. "I have taken to painting,—'wrastling with art,' I call it . . . This woodbine leaf at the top of the first page of this note I copied from nature." Not surprisingly, she wrote "I have made a little vignette of White Island." Thaxter to Feroline W. Fox, from the Shoals, 22 September 1874, *Letters of Celia Thaxter*, p. 58.
Thaxter lamented her lack of training, which she didn't remedy for several years. In 1877 she studied china painting with John Appleton Brown. In the 1880s she lived in Boston in winter, and between 1883 and 1885 she studied painting with Ross Sterling Turner and briefly with Hassam, who later recalled, "I met her in Boston." Hassam to Lockman, February 1927. De Witt McClellan Lockman, Interviews and Biographical Sketches, roll 503, frame 341, Archives of American Art.

63. Thaxter, "On the Beach," *Idyls and Pastorals. A Home Gallery of Poetry and Art* (Boston, 1886). A number of artists, including Hassam's traveling companion on his first trip abroad, Edmund H. Garret, contributed illustrations.

64. Rosamond Thaxter, *Sandpiper*, p. 156.

65. Burnside, "Chronology," in Feld, *Childe Hassam*, p. 19. She notes Hassam was at the Shoals "certainly by 1885."

66. Thaxter to Turner, 14 March 1888, in *Sandpiper*, p. 226.

67. Thaxter, *Cruise of the Mystery*, 1888. Thaxter's inscription to the Hassams is dated "Isles of Shoals, July 28th, 1890." Rare Book Department, Boston Public Library.

68. Marie Walther to Sharley (Charlotte Briggs), from Isle of Shoals, 8 July 1893. William Page Papers, roll 23, frame 4125, Archives of American Art.

69. Emma M. Anderson, "Celia Thaxter and her Gardens," *Heavenly Guest*, pp. 121–22. It was also possible to purchase flowers. Anderson noted, "At first, the garden was started entirely for pleasure, but in after years it became quite a source of revenue, as the hotel guests gladly availed themselves of the privilege to possess the lovely corsage bouquets arranged by her own hands." *Heavenly Guest*, pp. 119–20.

For a general discussion of artists' studios, see Doreen Bolger, "Painters and Sculptors in a Decorative Age," *In Pursuit of Beauty*, pp. 294–339.

70. Annie Fields, Introduction, *Letters of Celia Thaxter*, p. xviii.

71. Thaxter to Aldrich, from the Shoals, 25 June 1881, bMS Am 1429 (4285–4298), ⋆42M.1836, Celia Thaxter to Thomas Bailey and Lilian Woodman Aldrich, 1881–82. Houghton Library, Harvard University.

72. Annie Fields, *Heavenly Guest*, p. 86.

73. Thaxter to Annie Fields [1877], *Letters of Celia Thaxter*, p. 86.

74. Thaxter to Annie Fields, 2 November 1881, *Letters of Celia Thaxter*, pp. 125–26.

75. Thaxter, *An Island Garden*, p. 97.

76. Cynthia A. Brandimarte, "Somebody's Aunt and Nobody's Mother: The American China Painter and Her Work, 1870–1920," *Winterthur Portfolio* 23:4 (Winter 1988): 203–24. Brandimarte points out that few women actually found china painting profitable, which makes Thaxter's activities the more impressive.

77. Thaxter to Ellen Robbins from the Shoals, 23 September 1887, *Letters of Celia Thaxter*, pp. 148–49. Thaxter went on, "the wind makes such a noise in the empty . . . parlor, that you'd think all the ghosts of . . . summer visitors were dancing out there."

78. The report continues in some detail. See "Domesticana," *Heavenly Guest*, p. 131.

79. Advertisements for summer-home development on Appledore are reproduced in *A Stern and Lovely Scene*, p. 70.

80. Thaxter to Rose Lamb, from the Shoals, 25 September 1888, *Letters of Celia Thaxter*, p. 152.

81. A vintage copy of the photograph, now in the Collection of Prints and Drawings, Boston Public Library, is inscribed "To Ross Turner from Childe Hassam."

82. Maud Appleton McDowell, *Heavenly Guest*, pp. 127–28.

83. [*Chicago Tribune*], "Celia Thaxter, The Genius of the Isles of Shoals," *Heavenly Guest*, pp. 137–38. Thaxter's projects also included upholstery: "I have recovered the couch with nice brown cotton flannel so there's not a wrinkle anywhere, and it looks fine as brown satin; and I have covered the old handsome armchair I bought in Portsmouth with [a] gold and black cover, and put brass nails round the edges. What a job! but it fits like a Paris glove, cushion and all. And I made, of old-gold-colored, soft, thick, cotton flannel, six curtains for these windows, and they are so handsome!" *Letters of Celia Thaxter*, pp. 126–27. These projects could have come from the pages of Harriet Beecher Stowe, *The American woman's home: or, Principles of domestic science; being a guide to the formation and maintenance of economical, healthful, beautiful, and Christian homes* (1870), reprinted Hartford, 1987. Stowe had been a guest at Appledore.

84. Van Wyck Brooks, *New England Indian Summer 1865–1915* (New York, 1940), pp. 53–54.

85. Roger Stein, "Artifact As Ideology: The Aesthetic Movement in its American Cultural Context," *In Pursuit of Beauty*, p. 32.

86. James quoted in Fairbrother, *The Bostonians*, pp. 21–22.

87. Thaxter to Feroline W. Fox, from Appledore, 13 November 1873, *Letters of Celia Thaxter*, pp. 51–52.

88. Emerson quoted in Thaxter, *An Island Garden*, p. 93.

89. Seaweeds Gathered at the Isles of Shoals in 1875, unpaginated scrapbook, ⋆42M-474 Ms Am 1272, Houghton Library, Harvard University.

90. Thaxter, *An Island Garden*, p. 90.

91. *Chicago Tribune*, in *Heavenly Guest*, p. 137.

92. Ibid. pp. 137–38.

93. Dewing, *Beauty in the Household* (1882), cited in Bolger, *In Pursuit of Beauty*, p. 300.

94. I am not suggesting that the illustration was a direct source for Hassam's painting, which was, indeed, created a year earlier than the engraving was issued. The point is that artist and illustrator shared a similar cultural experience. For this general type of image, see William Gerdts, *Down Garden Paths: The Floral Environment in American Art* (Rutherford, NJ: Montclair Art Museum exhibition catalogue, 1983).

95. Emma M. Anderson, *Heavenly Guest*, p. 121.

96. Thaxter gives many examples of flowers harmonized with their containers. "Sometimes it is a spray of Madonna Lilies in a long white vase of ground glass, or beneath the picture in a jar of yellow glass floats a saffron-tinted Water Lily . . . or a tall sapphire glass holds deep blue Larkspurs of the same shade, or in a red Bohemian glass vase are a few carmine Sweet Peas, another harmony of color, or a charming dull red Japanese jar holds a few Nasturtiums that exactly repeat its hues. The lovely combinations and contrasts of flowers and vases are simply endless." Thaxter went on to describe the flowers on the table at the right side of Hassam's picture in similar detail. *An Island Garden*, pp. 96–97.

97. Maud Appleton McDowell, *Heavenly Guest*, p. 126.

98. Emma M. Anderson, *Heavenly Guest*, p. 121.

99. Maud Appleton McDowell, *Heavenly Guest*, p. 126.

100. Thaxter, *An Island Garden*, pp. 95–96.

101. Ibid., p. 99.

102. The glasses on the table at the right of Hassam's image include "pink Water Lilies in pink glasses and white ones in white glasses; a low basket of amber glass is filled with the pale turquoise of Forget-me-nots, the glass is iridescent and gleams with changing reflections, taking tints from every color near it." Ibid., p. 97.

103. Review of June 1886 cited in David Park Curry, "Total Control: Whistler at an Exhibition," *Studies in the History of Art* 19 (1987): 80, fn. 27. Whistler's "Yellow and White" exhibition was seen in New York as well as London.

104. *An Island Garden*, pp. 43–44. Princess Beatrice was a type of sweet pea.

105. Hassam to Weir from Appledore House, Isles of Shoals, 12 August 1903. Hassam Papers, roll NAA-2, frame 68, Archives of American Art.

106. Hassam later said, "I remember painting . . . at the Isles of Shoals what is said to

be the Improvisation, a young woman at the piano. It is now in John Gellatly's collection. I would be willing to stand on that picture alone." Hassam identified the model as "a niece of Celia Thaxter's, Margaret Laighton, now Mrs. Milton Forbes of Boston." He went on, "The Isles of Shoals bring up some of the pleasantest memories." Hassam to De Witt McClellan Lockman, February 1927. Lockman Interviews, roll 503, frame 372, Archives of American Art.

While *Improvisation*'s beautiful colors may have made it last in Hassam's memory, they are not those of Thaxter's parlor. The furniture and the large painting behind the piano are not seen in photographs of her salon. No large trees as seen on the canvas grew on Appledore. However, there is no evidence that every picture painted at the Shoals actually depicted a Shoals subject.

107. Thaxter refused to help promote the book until the illustrations were removed. Thaxter to Houghton-Mifflin, 21 September 1884 and 3 March 1885, 52 Letters to Houghton-Mifflin, bMs Am 1925 (1767), Houghton Library, Harvard University.

108. *See* 52 Letters to Houghton-Mifflin, Houghton Library, Harvard University. Most of the vintage copies of *An Island Garden* have olive green bindings, but some were issued with a white covering. All have the same stamped gold floral design.

109. Thaxter to Annie Fields, from the Shoals, 29 June 1876, *Letters of Celia Thaxter*, p. 80.

110. Hassam to De Witt McClellan Lockman, February 1927. De Witt Lockman Interviews, roll 503, frame 343, Archives of American Art.

111. Celia Thaxter, "Moonlight" (picture by Childe Hassam), *The Century Illustrated Monthly Magazine* XLI, no. 5 (March 1891): 696.

112. Ilene Susan Fort, *The Flag Paintings of Childe Hassam* (New York: Los Angeles County Museum of Art exhibition catalogue, 1988).

113. Thaxter, *An Island Garden*, p. 100

114. Thaxter's handwritten sonnet, dated 25 July 1890. Hassam papers, roll NAA-2, frame 26, Archives of American Art.

Chapter 2. The Garden in Its Glory

1. Thaxter, *An Island Garden*, p. 75.

2. Ibid., p. 102.

3. Ibid., p. 75.

4. The Shirley poppy, or corn poppy, is usually grown as an annual, reaching a height of two to five feet. Blossoms are red, orange, and pink. Laura C. Martin, *Garden Flower Folklore* (Chester, Conn., 1987), p. 59.

5. Thaxter, *An Island Garden*, pp. 47–48. The general effect would have been red, white, blue, and yellow. Mexican morning glory, or *Ipomoea*, has tricolored blue flowers. *Coboea*, a climbing member of the phlox family, is sometimes called "cup-and-saucer vine." It bears large violet bell flowers. Honeysuckles has white and yellow blossoms. Echinocystus, or wild cucumber, has small greenish white flowers.

6. Thaxter's garden plan is also somewhat arbitrary. There are only fifty-seven flowers listed, while many more are discussed in her text. Some words, like "vine," cover multiple possibilities. See *An Island Garden*, pp. 18, 70.

7. Thaxter describes a red, yellow, and blue color scheme in *An Island Garden*, p. 108.

8. Most of the illustrations for *An Island Garden* were taken from watercolors and some of those watercolors have variants in oil. But a watercolor version of this image has not surfaced to my knowledge.

Thaxter was not especially pleased with her portrait as it appeared in the book, or with the quality of the chromolithographs in general. They are a far cry from Hassam's originals (compare plates 22, 23). Thaxter wrote crossly to a friend, "about the reproductions least said the better, they didn't get that cotton wool rag baby in the frontispiece out of Hassam's picture anyway!" Thaxter to Sarah Orne Jewett, 21 March 1894; bound in Jewett's copy of *An Island Garden*, Houghton Library, Harvard University.

9. Iceland poppy is a tender perennial usually grown as an annual. The leaves are finely dissected, fernlike, and hairy. The large blossoms, up to three inches across, are orange, red, pink, rose yellow, cream, or white. *Garden Flower Folklore*, p. 59.

10. Thaxter, *An Island Garden*, p. 73.

11. Ibid., p. 33.

12. Sunflowers were planted on the east side of the garden. "Dexter" is likely a corruption of "Thaxter." I am grateful to Stuart Feld for this insight.

13. Monet regularly used this technique. See John House, *Monet. Nature into Art* (New Haven and London, 1986), p. 71.

14. See Thaxter's garden plan, *An Island Garden*, facing p. 72, numbers 19, 21. Karl

Thaxter was retarded, and his mother cared for him. A large number of his photographs might well be taken after compositions by artists who visited the Shoals. I don't have any evidence that Hassam used photographs in creating these paintings.

15. Thaxter, *Among the Isles*, p. 27.

16. Thaxter, *An Island Garden*, p. 48. See also Howard, *Flowers of Star Island*, p. 1.

17. Thaxter, *An Island Garden*, pp. 60–61.

18. Ibid., p. 62.

19. Ibid., pp. 7, 11.

20. Ibid., p. 8.

21. Ibid., p. 49. These little criss-cross lines can also be seen in *Home of the Hummingbird*, Plate 25.

22. Ibid., p. 71. Thaxter started seeds in eggshells and boxes during the winter and spring, setting them out at a later time. See pp. 15–17.

23. Nevins points out that Robinson used row planting, but to irregular effect: "Regularized flower beds were part of his scheme, but gardens should be arranged 'to see the picturesque effects of the plants and flowers, and forget the form of the bed in the picture.'" Nevins, Introduction, *The English Garden*, p. xvi. Thaxter also planted in rows at times, but not to create a sense of sharp edge or contrast. See *An Island Garden*, p. 28.

24. Thaxter, *An Island Garden*, p. 44. This horticultural sentiment reached its apogee in Alice Morse Earle, *Old Time Gardens*, New York, 1901.

25. Deborah Nevins, "Poet's Garden, Painter's Eye," *House and Garden* (August 1984): 156. Thaxter makes no mention of Robinson, but, on the other hand, Hassam went to some lengths to deny the influence of Monet.

26. Nevins, Introduction, *English Flower Garden*, p. xx. Nevins sees interest in cottage gardening as part of the American Arts and Crafts movement: "by the end of the first decade of the twentieth century, just as the Arts and Crafts movement was changing American taste in design, ideas had come to be highly regarded by the gardening world on this side of the Atlantic."

27. For a Robinson bibliography, see *English Flower Garden*, p. xxv. *The English Flower Garden*, his most influential book, first appeared in 1883, about a year before Thaxter began gardening at Appledore in earnest. It would have been rather hard to miss. The

1984 reprint is based upon the fifteenth edition, the last one Robinson supervised before his death in 1935.

28. For Thaxter's travels in Europe, see *Letters of Celia Thaxter*, pp. 98–124. Thaxter might have seen raised flower beds in Europe before returning to the United States in February 1881. Jane Lamb points this out, noting that when Thaxter "came back she planned this [kind of flower bed]. It's the easiest garden to take care of." Lamb, "Hollyhocks, Poppies, and Sweet Peas," *Down East* (August 1986); 77–79 ff.

29. Robinson, "Edgings, live and dead," *English Flower Garden*, p. 188.

30. Wheeler, *Content in a Garden*, pp. 56–57.

31. Maud Appleton McDowell, *Heavenly Guest*, p. 126.

32. Ibid. The observer continued, "I have been told that the sea-air makes the color of flowers more vivid than they appear in inland gardens. Certainly, it was so in this garden."

33. F. Schuyler Matthews, "Garden Flowers and their Arrangement," *Garden and Forest* (June 27, 1894): 253. Matthews concluded, "the effect of scarlet and white Poppies in brilliant sunlight, relieved against a background of shady green foliage, is incomparable."

34. Thaxter, *An Island Garden*, pp. 50, 55. She planted chrysanthemums outside the fence for fall and also spoke of moving primroses from within the plot to an area outside the fence.

35. Ibid., p. 76. A watercolor dated 1886 offers a wider view of the site. See *Isles of Shoals*, watercolor and gouache, 20¾ × 28 inches, inscribed "Childe Hassam/Isles of Shoals, July 1886." Reproduced in *A Stern and Lovely Scene*, p. 17.

36. Ibid., p. 111. Thaxter saved the hummingbird after a fierce storm.

37. Hassam often employed this device—far space glimpsed through a narrow aperture—in his later rock pictures.

38. See map, *Letters to Celia*, facing p. 1.

39. W. S. Gilbert and Arthur Sullivan, *Patience, or Bunthorne's Bride*, Act I, in Ian Bradley, *The Annotated Gilbert and Sullivan*, vol. II. (Harmondsworth, Middlesex, England, 1985), p. 149.

40. Bernard Champigneulle lists the lily, iris, morning glory, fern and poppy, as well as "the peacock, that flower-bird" as principle emblems of Art Nouveau design. Their sinuous stems and curves evolved into the iconic whiplash line. See Champigneulle, *Art Nouveau* (1972), trans. Benita Eisler (Woodbury, NY, 1976), p. 90.

41. The species name *Papaver rhoeas* means "to fall," as the poppy's petals drop easily. *Garden Flower Folklore*, p. 60.

42. Kate Greenaway, *The Language of Flowers* (1884), reprinted New York, 1978, p. 33. See also "Flora's Wreath," *Ballou's Pictorial* vol. 8 (13 January 1855): 27. According to one myth, Ceres would not rest in her search for her daughter Proserpina, so the gods caused poppies to spring up in Proserpina's footsteps. Plucking a poppy caused Ceres to sleep. The poppy is also sacred to Diana. Associated with the slain, the poppy grows especially well on old battlefields, recalling the blood of fallen warriors. This ancient association was popularized after World War I. Maria Leach, ed., *Funk and Wagnalls Standard Dictionary of Folklore, Mythology and Legend*, vol. II (New York, 1950), pp. 880–81.

43. William Gerdts has summarized the emergence of flower painting in late nineteenth-century America, noting a large number of poppy pictures created by American artists. See Gerdts, *Down Garden Paths*, pp. 67–79.

44. Thaxter, *Cruise of the Mystery*, p. 14.

45. Thaxter, *An Island Garden*, p. 79.

46. Albert Gallatin, one of Hassam's biographers, noted, "Momentary effects produced by sunlight is usually his theme, it is true, and equally true is that he paints by placing his colors in juxtaposition, in order to attain effects to be seen at a distance." Quoted in William Gerdts, *American Impressionism* (New York, 1984), p. 91.

47. Thaxter, *An Island Garden*, p. 82. The quotation is from *Proserpina*, selections from Ruskin's prose (1875–86), comprising his richest gathering of thoughts on flowers.

48. Frederick Kirchhoff, "A Science against Sciences: Ruskin's Floral Mythology," *Nature and the Victorian Image*, ed. U. C. Knoepflmacher and G. B. Tennyson (Berkeley, 1977), pp. 246–58.

49. Thaxter wrote, "The fragrant fringes of the Mignonette, how surprising and curiously beautiful they are under the little pocket microscope! What elaboration of detail, what tempered harmonies of color, what marvels of construction!" After several eloquent descriptions of minute details, Thaxter left her readers "to pursue these fascinating researches for themselves." *An Island Garden*, p. 121.

50. Kirchhoff observes that Ruskin presented "a way of knowing Nature that implies its opposite: the final elusiveness of all natural phenomena." See "A Science against Sciences," p. 247.

51. Ibid. Kirchhoff discusses this quotation from *Proserpina* in detail, pp. 247–48.

52. Thaxter once explained, "Oh I love the flowers! Other people exclaim over them and say, 'Aren't they lovely?' but I feel about them differently, and the flowers know that I love them." Thaxter quoted in "Domesticana," *Heavenly Guest*, p. 130.

53. See Robert Herbert, "Introduction," *The Art Criticism of John Ruskin* (New York, 1964), p. xxi.

54. Nevins, "Poet's Garden, Painter's Eye": 156.

55. Thaxter, *An Island Garden* p. 17.

56. "The Fine Arts. Watercolor Drawings by Childe Hassam at Doll and Richards," *Boston Transcript*, undated clipping. Hassam Papers, roll NAA-1, frame 488, Archives of American Art. One is reminded of a critic's complaint about Whistler's work: "There is no moral element in his chiaroscuro." James McNeill Whistler, *The Gentle Art of Making Enemies* (1890), reprinted New York, 1916, p. 102.

57. Cited Kirchhoff, "A Science against Sciences," p. 250.

58. Linda Ferber, " 'Determined Realists': The American Pre-Raphaelites and The Association for the Advancement of Truth in Art," in Linda Ferber and William Gerdts, *The New Path: Ruskin and the American Pre-Raphaelites* (New York: The Brooklyn Museum exhibition catalogue, 1985), p. 13.

59. Ruskin's comment, from "A Joy Forever," cited in *New Path*, p. 236. See Also Kathleen A. Foster, "The Pre-Raphaelite Medium: Ruskin, Turner, and American Watercolor," *New Path*, pp. 79–108.

60. Ruskin, *Elements of Drawing* (1857), in Herbert, *Art Criticism of Ruskin*, p. 55.

61. Ruskin, *Modern Painters* vol. I (1843), in Herbert, *Art Criticism of Ruskin*, p. xx. The landscapes of Meindert Hobbema (1638–1709) were noted for "leur minitue; sans surprises." E. Bénézit, *Dictionnaire critique et documentaire des Peintres, Sculpteurs, Dessinateurs et Graveurs*, vol. 5 (Paris, 1976), p. 560.

62. Thaxter, *Among the Isles*, p. 169.

63. See Herbert, Introduction, *Art Criticism of Ruskin*, pp. viii, ix. Robert Herbert views

Ruskin's extensive writings as the most complete examination of the elements of abstraction available during the nineteenth century.

64. Wynford Dewhurst, "What is Impressionism?" *Contemporary Review* 99 (March 1911): 296; cited in ibid., p. xiii, fn. 5.

65. Ruskin, *Proserpina*, vol. I, p. 249.

66. Ibid., p. 264.

67. Herbert, Introduction to *Art Criticism of Ruskin*, p. ix.

68. Ruskin, *Proserpina*, vol. I, cited in Kirchhoff, pp. 250–51.

69. Royal Cortissoz, "The Art of Childe Hassam Studied at Full Length." Hassam Papers, roll NAA-1, frame 548, Archives of American Art.

70. Ruskin quoted in Thaxter, *An Island Garden*, p. 81. Ruskin noted tartly, "As to the choice and harmony of colours in general, if you cannot choose and harmonise them by instinct, you will never do it at all." *Elements of Drawing*, in Herbert, *Art Criticism of Ruskin*, p. 55.

71. Thaxter, *An Island Garden* p. 271.

72. Ibid., p. 76.

73. Barbara Stafford, *Voyage into Substance; Art, Science, Nature and the Illustrated Travel Account, 1760–1840* (Cambridge, Mass., 1984), p. 479.

74. *Art Amateur* 14 (1886): 121 and 15 (1887): 4; quoted in Hans Huth, "Impressionism Comes to America," *Gazette des Beaux-Arts*, series 6, vol. 29 (April 1946): 242.

75. Hassam first toured Europe in 1883. A biographer notes, "At this time, the works of J. M. W. Turner, the great landscapist and master of the watercolor, served as Hassam's favorite models. He toured the Continent with Turner very much in mind as his renderings of Venice particularly indicate (he had seen the English artist's radiant Venetian cityscapes in the British Museum.)" Gloria-Gilda Deak, *Kennedy Galleries' Profiles of American Artists* (New York, 1984), p. 112. The outdoor watercolors of English artists including Constable, Girtin, Turner, and Bonington had great impact on the development of impressionism.

76. For an overview of this attitude and its wane, see Wanda M. Corn, "Coming of Age: historical scholarship in American art," *Art Bulletin* 70 (June 1988): 188–207.

77. Hassam probably missed the Foreign Exhibition held in Boston in the fall of 1883 because he was abroad. It is quite likely, however, that he saw an important impressionist exhibition which opened at the American Art Association on 10 April 1886, and moved to the National Academy of Design on 25 May. He didn't go to Paris until late that year. He would have missed Durand-Ruel's second impressionist exhibition at the National Academy of Design in New York in 1887.

While Hassam was in Paris, Georges Petit showed fifteen Monet canvases, including ten of the Belle-Île pictures, in May 1887. Hassam exhibited at Petit himself in 1889. In June 1888, Boussod and Valadon caused a stir by exhibiting ten of Monet's Antibes landscapes in Paris. Monet showed again at that gallery in February 1889. In June 1889, Hassam might have seen the important joint exhibition of Rodin and Monet at Georges Petit.

Back in the United States, Hassam could have seen Monet's work at the Union League Club, New York, in 1891, and the St. Botolph Club, Boston, in 1892. Pictures by Monet were among the foreign masters from American collections that Hassam could have seen at the Chicago World's Fair, which he attended in 1893. Fourteen of Monet's cathedral pictures were shown in New York in 1896.

Eventually Hassam may have managed to get at least as far as the tiny town where Monet gardened, painted, and held court. *Lilac Time*, an oil painted in 1912, is annotated on an undated checklist as "Mrs. Hassam Picking Lilacs in Giverny, France." See "Early Works by Childe Hassam, N.A.," undated brochure for John Nicholson, 19 East 57th Street, Whitney Museum of American Art papers, roll N665, frame 590, Archives of American Art.

78. Monet painted four versions, and it is not clear which was exhibited. See Daniel Wildenstein, *Claude Monet: Biographie et catalogue raisonné*, vol. I. (Lausanne and Paris, 1974), numbers 682–85.

79. Gerdts, *Down Garden Paths*, pp. 53–54.

80. Hassam exhibited his work at the Paris Salon in 1887, 1888, and 1889. He won a bronze medal at the Exposition Universelle in Paris in 1889.

81. Gerdts discusses *Grand Prix Day* as "a compendium of several aesthetics," adding that while their juxtaposition on one canvas "may seem art historically inconsistent" the artist was "concerned not with consistency but with effective painting." *American Impressionism*, p. 96.

82. See House, *Monet. Nature into Art*, p. 193ff. Monet painted poppies in 1873 and again in the late 1870s. He moved to Giverny in 1883, and painted numerous poppy pictures in 1885, more in the late 1880s, and many in 1890. See Wildenstein, *Monet, catalogue raisonné*, vols. I–III.

83. Thaxter, *An Island Garden*, p. 85.

84. House, *Nature into Art*, p. 72. House includes excellent detail photographs.

85. Ibid., p. 74.

86. Ibid., p. 100. House notes, "by the end of his second stay at Rouen in 1893 [Monet] described his paintings as an 'obstinate encrusting of colors.' The final effect of these paint surfaces has often been compared with the texture of actual stonework, but the most thickly painted areas of the sky are similarly treated."

87. Royal Cortissoz, "The Traits of the Late Childe Hassam," undated clipping, *New York Herald Tribune*. Hassam Papers, roll NAA-1, frame 681, Archives of American Art.

88. Gerdts, *Garden Paths*, pp. 108–14.

89. Nevins, introduction, *English Flower Garden*, p. xix. Beatrix Jones, "The Garden as a Picture," *Scribner's* 42 (July 1907): 2.

90. National Gardening Fact Sheet courtesy Bruce W. Butterfield, Research Director, National Gardening Association. Nelson W. Aldrich, Jr., reports, "there are 1.7 million households in New England and 7.9 million in the Mid-Atlantic states that actively engage in flower gardening." Aldrich, "Bloom Town: High-Wasp Chic at White Flower Farm," *New York Magazine* (6 June 1988): 45.

91. Nancy R. Gibbs, "Paradise Found: America Returns to the Garden," *Time* (20 June 1988): 62–70. As of August 1989 the most widely circulated gardening magazine, *Rodale's Organic Gardening*, reached over 1.3 million.

92. Gibbs, "Paradise Found," p. 62.

93. Paul Hawken, quoted in Gibbs, p. 69.

94. Aldrich sardonically comments that the White Flower Farm catalogue may have been "the first mail-order house . . . to solicit purchasers by flattering their literacy." The farm was founded by William B. Harris, an editor at *Fortune*, and his wife, Jane Grant, a reporter for the *New York Times*. See Aldrich, "Bloom Town," pp. 42, 44. The farm's customer base was 250,000 in June 1988 and had risen to 500,000 by August 1989.

95. The garden's first major benefactor was Lila Acheson Wallace, cofounder of *The Reader's Digest*, and one of America's leading

philanthropists. See Gerald van der Kemp, "Monet at Giverny," *Claude Monet: Life at Giverny* (New York and Paris, 1985), p. 7.

96. Nevins, Introduction, *English Flower Garden*, p. xviii.

97. Gertrude Jekyll, *Colour Schemes for the Flower Garden* (Woodbridge, Suffolk, England), 1982.

98. The painting has a label on the back indicating that it belonged to George A. Hearne and was purchased on 7 February 1896.

99. Thaxter, *An Island Garden*, p. 124.

100. Ibid., p. 83.

Chapter 3. The Rocks of Appledore

1. "The Isles of Shoals," *Harper's New Monthly Magazine* 49 (October 1874): 666.

2. Thaxter, *Among the Isles*, pp. 7, 13.

3. Ibid., p. 165.

4. Howard, *Flowers of Star Island*, p. 27ff.

5. Thaxter to Rose Lamb, from Appledore, 5 September 1889, *Letters of Celia Thaxter*, p. 165.

6. Drake, *Nooks and Corners*, 1875, p. 189.

7. James Russell Lowell, "Pictures from Appledore," *The Poetical Works of James Russell Lowell* (London, 1911), p. 144.

8. A letter from Deborah S. Werkman, Hirschl and Adler Galleries, New York, to Gail Stavitsky states that there are six known lighthouse watercolors. See curatorial file, *Northeast Headlands, Appledore*, Carnegie Museum of Art. For a reproduction of another in the series, this time showing five stilts, see *Childe Hassam 1859–1935* (Tucson: University of Arizona Museum of Art exhibition catalogue, 1972) p. 63, no. 24.

9. "Isles of Shoals," *Harper's* (1874): 672. The author mentions "The new tower rising eighty feet and more from its base, and thirty feet additional from the low-water mark; the truncated cone of the old tower of Mr. Laighton's time beside it; the long covered walk, well stanchioned to defy the power of the wind and wave; the tidy little cottage at its end." He added that the assistant lighthouse keeper "took me up into the tower and showed me the working of the lamp, its splendid prisms, the machinery for making it revolve. It is a Fresnel light, and the light alone, exclusive of the tower, cost about $30,000."

10. Drake, *Nooks and Corners*, p. 192.

11. Cedric Laighton wrote to his sister in January 1861, "We have just been taking a peep at the moon through the spy-glass. How beautiful the moon is! White Island light must look splendidly from the hill this evening. Was the tower finished while you were here? I think it is much prettier than the old one, much more symmetrical." Laighton to Thaxter, from Appledore, 26 January 1861, *Letters to Celia*, p. 19.

12. The lighthouse was not always well stanchioned enough. Thaxter recalled once watching as the walkway "was carried thundering down the gorge and dragged out into the raging sea." *Among the Isles*, p. 139.

13. Hassam was developing the habit of considering "pictorial capabilities, as well as picturesque elements of the common scenes and life about us, and combining them in genuine pictures full of local character— scenes that we recognize at once and in which we learn to see new things in familiar places." See "The Fine Arts," undated clipping reviewing exhibition at Doll and Richards, Boston. Hassam Papers, roll NAA-1, frame 496, Archives of American Art.

14. Hassam to Weir, from Hotel de l'Empire, Paris, 21 July 1910. Hassam Papers, roll NAA-2, frame 66, Archives of American Art.

15. A house has since been built right over the gorge so it is now impossible to take the view as Hassam would have seen it.

16. Laighton to Thaxter, from Appledore, 19 May 1861, *Letters to Celia*, p. 31.

17. Robert Herbert, *Impressionism: Art, Leisure, & Parisian Society* (New Haven and London: 1988), pp. 291–93.

18. Carol Troyen, *The Boston Tradition: American Paintings from the Museum of Fine Arts, Boston* (New York: Museum of Fine Arts, Boston exhibition catalogue, 1980), p. 166.

19. Thaxter, *Among the Isles*, p. 61.

20. Ibid., p. 55.

21. "Domesticana," *Heavenly Guest*, p. 129.

22. *Chicago Tribune*, 24 March 1891. Hassam Papers, roll NAA-1, frame 485. The picture sounds like a standard Hassam Shoals composition: "browns and dull reds of the season predominate on this flowery slope, over whose crest one sees the narrow line of the sky and at the left a bit of the distant blue sea."

23. The spot is identified in a labeled photograph from an album now at the Houghton Library, Harvard University. There are so many similar compositions looking northeast across Broad Cove that one suspects Hassam found it quite convenient to paint from underneath the shelter of this pavilion.

24. Traces of red and maroon can be detected under the whites and tans applied later, and Hassam's slashing brushwork helps to obscure the change.

25. *La Maison du Pêcheur à Varengeville* was exhibited at the St. Botolph Club in Boston in 1892 and again in Copley Hall in 1903 and 1905. See Wildenstein, *Monet, catalogue raisonné*, vol. II, no. 805. Compare also Wildenstein, vol. II, nos. 730–43.

26. Hassam to De Witt McClellan Lockman, Lockman Interviews, roll 503, frames 407–8, Archives of American Art. Hassam also recalled painting Evelyn Benedict "on Mrs. Thaxter's verandah." His portrait of Oscar Laighton is currently unlocated.

27. "Beryl" really should be called "Barrel," referring to barrel vaults, the rock formations of broken basalt columns common at the Shoals. I am grateful to geologist Irwin D. Novak for this information and for a most informative tour of the island itself.

One critic complained, "Nothing could be more poignant than the color in *The Beryl Gorge*, not only in the sea and rock, but in the cool flesh tones of the figure. But why this sudden simplicity, this primitive disregard of an elbow joint in the arm thrust back of the slim waist? In painting when primitive meets primitive everything is all right, but where primitive meets a wizard in technique a doubt is set up, and everything is spoiled." See "Childe Hassam's Works on View in Montross Galleries," undated press clipping. Hassam Papers, roll NAA-1, frame 549, Archives of American Art.

28. Clipping, *New York Evening Mail*, 18 December 1907. Hassam Papers, roll NAA-1, frame 543, Archives of American Art.

29. Hassam Papers, roll NAA-1, frame 759, Archives of American Art.

30. My comment would not apply to series like the patriotic flags.

31. M. G. Van Rennselaer, "Fifth Avenue," *Century Magazine* (November 1893): 5–18. The article includes ten engravings after city views by Hassam.

32. "A leader of the open-air school," *New York Evening Post*, 12 December 1907. Hassam Papers, roll NAA-1, frame 537, Archives of American Art.

33. "Hassam Dies," *Art Digest* 9 (1 September 1935): 13.

34. Hassam painted many nudes by the sea. Generally speaking, he had difficulty integrating figure and landscape. Examples include *Nymph and Sea*, 1900, Hirschhorn Museum and Sculpture Garden; *East Headland Pool*, 1912, Sotheby's Sale 5407, lot 119; *Appledore Gate*, 1912, at the Grand Rapids Art Museum; and an enormous version at the American Academy and Institute of Arts and Letters, New York. There are, alas, more.

35. The boat was named after the Gilbert and Sullivan operetta.

36. Thaxter, *Among the Isles*, p. 171.

37. Ella Rodman Church, "Something About the Isles of Shoals," *Lippincott's Magazine* 8 (August 1871): 195.

38. Thaxter, *An Island Garden*, pp. 103–4.

39. Reprinted in Drake, *New England Legends and Folk Lore*, pp. 354–55. Drake prefaces the poem with a discussion of the wreck.

40. For Thaxter's reaction to Hunt's death, see Thaxter to Annie Fields, from Appledore, 19 July 1879, *Letters of Celia Thaxter*, pp. 93–96.

41. Thaxter went on, "It seemed more than a flower; it was like a human thing. . . . It was so much wiser than I, for when the sky was yet without a cloud, softly it clasped its small red petals together, folding its golden heart in safety from the shower that was sure to come." *Among the Isles*, p. 128.

42. Ibid., p. 124.

43. Barbara Stafford, *Voyage into Substance*, p. 479.

44. Clipping, *New York Tribune*, 18 December 1907. Hassam Papers, roll NAA-1, frame 544, Archives of American Art.

45. Thaxter, *Among the Isles*, p. 18.

46. Cecil J. Schneer, review of Stafford, *Voyage into Substance*, *The Art Bulletin* 68, no. 4 (December 1986): 683–84.

47. Stafford, *Voyage into Substance*, p. 481.

48. "Appledore and its memories" [c. 1914], Hassam Papers, roll NAA-1, frame 623, Archives of American Art.

49. Schneer, *Art Bulletin*, p. 683. Stafford outlines several specific ways in which the legacy of the factual travel narrative shaped nineteenth-century attitudes towards landscape representation. An obsession with a specific, charged site and with the portrayal of "natural masterpieces" as potent, isolated forms centrally stationed within the picture plane, like monolithic pieces of sculpture or architecture, are pertinent to our understanding of Hassam's work at the Shoals.

50. Stafford, *Voyage into Substance*, pp. 477–78.

51. See Thaxter's correspondence with Bradford Torrey, a leading ornithologist of his day, in *Letters of Celia Thaxter*, p. 161ff. Thaxter began writing to Torrey in May 1889.

52. Thaxter, *Among the Isles*, p. 21.

53. Ibid.

54. Ibid, p. 19.

55. "A leader of the open-air school," *New York Evening Post*, 12 December 1907. Hassam Papers, roll NAA-1, frame 537, Archives of American Art.

56. Hassam to De Witt McClellan Lockman, Lockman Interviews, roll 503, frame 363, Archives of American Art.

57. Hassam to Weir, from Lyme, Conn., 17 July 1903. Hassam Papers, roll NAA-2, frame 67, Archives of American Art.

58. "The Fine Arts. Watercolor Drawings by Childe Hassam at Doll and Richards," undated clipping, *Boston Transcript*. Hassam Papers, roll NAA-1, frame 490, Archives of American Art.

59. Royal Cortissoz, "The Traits of the Late Childe Hassam," undated clipping, *New York Herald Tribune*. Hassam Papers, roll NAA-1, frame 607, Archives of American Art.

60. David Park Curry, *James McNeill Whistler at the Freer Gallery of Art* (New York: The Freer Gallery of Art, Smithsonian Institution, exhibition catalogue, 1984), plate 106.

61. Thaxter, *Among the Isles*, p. 14.

62. Ibid., p. 9.

63. Thaxter, "West Wind," *Cruise of the Mystery*.

64. Undated clipping, review of exhibition at Doll and Richards, Boston. Hassam Papers, roll NAA-1, frame 491, Archives of American Art.

65. Thaxter, *Among the Isles*, pp. 93–94.

66. Ibid., p. 164.

67. "Hassam Dies," *Art Digest* (1935): 13. "It is now generally accepted that he had worked with light and color until his pictures are a textbook of its varieties."

68. Gerdts, "Square format and proto-modernism," *Arts Magazine*, p. 73. Members of the Tile Club painted decorative compositions on square tiles.

69. This connection was not lost on journalists. One commented, for example, "Childe Hassam has followed Monet in the pursuit of sunshine," and noted that his work "can only be compared with Monet's subjects of the coast of Normandy." Clipping, 29 January 1903. Hassam Papers, roll NAA-1, frame 482, Archives of American Art.

70. Huth, "Impressionism Comes to America," *Gazette des Beaux-Arts*, p. 246.

71. *Cliffs Near Dieppe* was exhibited at Chase's Gallery, Boston, in 1891. See Wildenstein, *Monet, catalogue raisonné*, vol. II, no. 719. See also no. 1039, which was shown in New York in 1886.

72. House, *Nature into Art*, p. 55.

73. Ibid., p. 54.

74. Thaxter, *Among the Isles*, pp. 17–18.

75. Ibid. p. 17.

76. Ibid., p. 22.

77. Ibid., p. 15.

78. The picture did not entirely avoid the criticism that can be leveled at the Indianapolis canvas. One journalist complained, "often, in his attempts to get broad color effects this painter sacrifices the quality and tangibility of still-life . . . the crag is not stony and solid, and the difference between the soft slimy masses of seaweed, exposed by the ebb, and the weatherbeaten rock, is not sufficiently distinguished." See "A leader of the open-air school," *New York Evening Post*, 12 December 1907. Hassam Papers, roll NAA-1, frame 537, Archives of American Art.

79. *Brooklyn Eagle*, 15 January 1905. Hassam Papers, roll NAA-1, frame 521, Archives of American Art.

80. Thaxter, *Among the Isles*, p. 157.

81. *Brooklyn Eagle*, 15 January 1905. Hassam Papers, roll NAA-1, frame 521, Archives of American Art.

82. Thaxter, *An Island Garden*, p. 125.

83. Thaxter, *Among the Isles*, p. 86.

84. Hassam to De Witt McClellan Lockman, Lockman Interviews, roll 503, frame 385, Archives of American Art. While the last dated Shoals canvas I'm aware of is from 1916, Hassam did work motifs from the Shoals into some of his later prints.

85. Thaxter, *Among the Isles*, p. 41.

Epilogue: Forget-Me-Not

1. Thaxter, *Among the Isles*, p. 120.

2. Ibid., p. 28.

3. Ibid., p. 170.

4. Ibid.

Bibliography

Adams, Adeline. *Childe Hassam*. New York, 1938.

Benjamin, Samuel Green Wheeler. *The Atlantic Islands as Resorts of Health and Pleasure*. New York, 1879.

Bolger, Doreen, et al. *In Pursuit of Beauty: Americans and the Aesthetic Movement*. New York, 1986.

Brandimarte, Cynthia A. "Somebody's Aunt and Nobody's Mother: The American China Painter and Her Work, 1870–1920," *Winterthur Portfolio* 23:4 (Winter 1988): 203–24.

Brooks, Van Wyck. *New England Indian Summer 1865–1915*. New York, 1940.

Buckley, Charles E. *Childe Hassam: A Retrospective Exhibition*. Washington, D.C.: The Corcoran Gallery of Art exhibition catalogue, 1965.

Catalogue of the Etchings and Dry-Points of Childe Hassam, N.A. Introduction by Royal Cortissoz. New York, 1925.

Childe Hassam, 1859–1935. New York: Hirschl and Adler Galleries exhibition catalogue, 1964.

Church, Ella Rodman. "Something About the Isles of Shoals," *Lippincott's Magazine* 8 (August 1871): 191–97.

College Art Association. "Childe Hassam—Painter and Graver, 1859–1935." *The Index of 20th Century American Artists*, vol. 3, no. 1., New York, 1935, pp. 169–83.

DeCosta, Benjamin F. *Rambles in Mount Desert: with Sketches of Travel on the New-England Coast, from Isles of Shoals to Grand Menan*. New York, 1871.

Drake, Samuel Adams. *A Book of New England Legends and Folk Lore*. Rev. ed. Boston, 1910.

———. *Nooks and Corners of the New England Coast*. New York, 1875.

Earle, Alice Morse. *Old Time Gardens*. New York, 1901.

Fairbrother, Trevor, et al. *The Bostonians: Painters of an Elegant Age, 1870–1930*. Boston: Museum of Fine Arts exhibition catalogue, 1986.

Feld, Stuart. *Childe Hassam: 1859–1935*. East Hampton, NY: Guild Hall Museum exhibition catalogue, 1981.

Ferber, Linda, and William Gerdts. *The New Path: Ruskin and the American Pre-Raphaelites*. New York: The Brooklyn Museum exhibition catalogue, 1985.

Fields, Annie, and Rose Lamb, eds. *Letters of Celia Thaxter*. Boston and New York, 1895.

Fort, Ilene Susan. *The Flag Paintings of Childe Hassam*. New York: Los Angeles County Museum of Art exhibition catalogue, 1988.

Gerdts, William. *American Impressionism*. New York, 1984.

———. *Down Garden Paths: The Floral Environment in American Art*. Rutherford, NJ: Montclair Art Museum exhibition catalogue, 1983.

———. "Square format and proto-modernism in American painting," *Arts Magazine* 50 (June 1976): 70–75.

Gill, Brendan, and Dudley Witner. *Summer Places*. New York, 1978.

Greenaway, Kate. *The Language of Flowers*. 1884. Reprinted New York, 1978.

Griffith, Fuller. *The Lithographs of Childe Hassam: A Catalog*. United States National Museum, *Bulletin* 232, Washington, D.C., 1962.

Hassam, Childe. "Twenty-five Years of American Painting," *Art News* 26 (14 April 1928): 22–28.

Hawthorne, Nathaniel. *The American Note-books of Nathaniel Hawthorne*, edited by Randall Stewart. New Haven, 1932.

Herbert, Robert. *The Art Criticism of John Ruskin*. New York, 1964.

———. *Impressionism: Art, Leisure, & Parisian Society*. New Haven and London, 1988.

Hoopes, Donelson. *Childe Hassam*. New York, 1979.

House, John. *Monet. Nature into Art*. New Haven and London, 1986.

Howard, Richard A. *Flowers of Star Island, the Isles of Shoals*. Jamaica Plain, Mass., 1968.

Huth, Hans. "Impressionism Comes to America," *Gazette des Beaux-Arts*, series 6, vol. 29 (April 1946): 225–52.

———. *Nature and the American. Three Centuries of Changing Attitudes.* Berkeley, 1972.

"The Isles of Shoals." *Harper's New Monthly Magazine* 49 (October 1874): 665–76.

Jekyll, Gertrude. *Colour Schemes for the Flower Garden.* Woodbridge, Suffolk, England, 1982.

Jones, Beatrix. "The Garden as a Picture," *Scribner's* 42 (July 1907): 2–11.

Knoepflmacher, U. C., and G. B. Tennyson, eds. *Nature and the Victorian Image.* Berkeley, 1977.

Laighton, Oscar. *Ninety Years at the Isles of Shoals.* 1930. Reprinted Boston, 1971.

Lowell, James Russell. *The Poetical Works of James Russell Lowell.* London, 1911.

McGill, Frederick T., Jr., ed. *Letters to Celia, written during the years 1860–1875 to Celia Laighton Thaxter by her brother, Cedric Laighton.* Boston, 1972.

Martin, Laura C. *Garden Flower Folklore.* Chester, Conn., 1987.

Mason, William. *Memories of a Musical Life.* New York, 1901.

Mather, Frank Jewett, Jr. *Retrospective Exhibition of Works by Childe Hassam, 1890–1925.* New York: Durand-Ruel Gallery exhibition catalogue, 1926.

Matthews, F. Schuyler. "Garden Flowers and their Arrangement," *Garden and Forest* 7, no. 331 (27 June 1894): 252–53.

Nevins, Deborah. "Poet's Garden, Painter's Eye," *House and Garden* (August 1984): 92–97, 154, 156.

Pousette-Dart, Nathaniel. *Childe Hassam.* New York, 1922.

Robbins, Ellen. "Reminiscences of a Flower Painter," *New England Magazine* 14 (June 1896): 440–51, and (July 1896): 532–45.

Robinson, William. *The English Flower Garden,* 15th ed. rev. New York, 1984.

Ruskin, John. *Elements of Drawing,* vol. 15, *The Works of John Ruskin.* Edited by E. T. Cook and Alexander Wedderburn. London, 1904.

———. *Modern Painters,* vols. 3–7, *The Works of John Ruskin.* Edited by E. T. Cook and Alexander Wedderburn. London, 1903.

———. *Proserpina,* vol. 25, *The Works of John Ruskin.* Edited by E. T. Cook and Alexander Wedderburn. London, 1906.

Rutledge, Lyman V. *Ten Miles Out: Guide Book to the Isles of Shoals,* 6th ed. Edited by Frederick T. McGill, Jr. Boston, 1984.

Stafford, Barbara. *Voyage into Substance: Art, Science, Nature and the Illustrated Travel Account, 1760–1840,* Cambridge, Mass., 1984.

Steadman, William E. *Childe Hassam.* Tucson: University of Arizona exhibition catalogue, 1972.

Stearns, Frank Preston. *Sketches from Concord and Appledore.* New York, 1895.

Stebbins, Theodore E. *American Master Drawings and Watercolors.* New York, 1976.

Thaxter, Celia. *Among the Isles of Shoals.* Boston, 1873.

———. *An Island Garden.* Boston and New York, 1894.

———. *The Cruise of the Mystery and other Poems.* Boston, 1888.

Thaxter, Celia, et al. *The Heavenly Guest, with other unpublished writings.* Edited by Oscar Laighton. Andover, Mass., 1935.

Thaxter, Rosamond. *Sandpiper: The Life and Letters of Celia Thaxter.* Francestown, NH, 1963.

Troyen, Carol. *The Boston Tradition: American Paintings from the Museum of Fine Arts, Boston.* New York: Museum of Fine Arts, Boston exhibition catalogue, 1980.

Vallier, Jane E. *Poet on Demand: The Life, Letters and Works of Celia Thaxter.* Camden, Maine, 1982.

Van der Kemp, Gerald, et al. *Claude Monet: Life at Giverny.* New York and Paris, 1985.

Van Rennselaer, M. G. "Fifth Avenue," *Century Magazine* (November 1893): 5–18.

Wheeler, Candace. *Content in a Garden.* Boston and New York, 1901.

Whistler, James McNeill. *The Gentle Art of Making Enemies.* 1890. Reprinted New York, 1916.

Wildenstein, Daniel. *Claude Monet: Biographie et catalogue raisonné.* 4 vols. Lausanne and Paris, 1974–85.

Pictures in the Exhibition

All venues unless otherwise stated.

The Altar and Shrine, 1892
Watercolor, 15 × 12 inches
Private collection
Exhibited: Yale
Plate 8

Appledore, August, 1900
Oil on canvas, 22¼ × 18 inches
Mr. and Mrs. Hugh Halff, Jr.,
Courtesy Hirschl and Adler
Galleries, New York
Plate 61

Appledore, Isles of Shoals, c. 1890
Oil on canvas, 15¼ × 18⅛ inches
Mr. and Mrs. Rodman Rockefeller,
Courtesy Richard York Gallery,
New York
Exhibited: Yale, Denver
Plate 47

Bathing Pool, Appledore, 1907
Oil on canvas, 25 × 30 inches
Museum of Fine Arts, Boston,
Ernest Wadsworth Longfellow
Fund
Plate 62

*Celia Thaxter's Garden, Appledore,
Isles of Shoals*, 1890–93
Oil on canvas, 13 × 9⁷⁄₁₆ inches
The Warner Collection of Gulf
States Paper Corporation,
Courtesy Hirschl and Adler Gal-
leries, New York
Plate 1

*Celia Thaxter's Garden, Isles of
Shoals, Maine*, 1890
Oil on canvas, 17¾ × 21½ inches
Private collection
Plate 37

Coast Scene, Isles of Shoals, 1901
Oil on canvas, 24⅞ × 30⅛ inches
The Metropolitan Museum of
Art, Gift of George A. Hearn
Exhibited: Yale
Plate 96

Dexter's Garden, 1892
Watercolor, 19¹³⁄₁₆ × 14⅛ inches
The National Museum of Ameri-
can Art, Smithsonian Institution,
Gift of John Gellatly
Plate 19

Early Morning Calm, 1901
Oil on canvas, 25 × 30 inches
The Dayton Art Institute,
Gift of Mrs. Harrie G. Carnell
Plate 51

*Entrance to the Siren's Grotto, Isles of
Shoals*, 1902
Oil on canvas, 18 × 22 inches
The Ball State University Art
Gallery, Gift of the Muncie Art
Association
Plate 99

The Evening Star, 1891
Pastel, 20 × 24 inches
The Beinecke Rare Book and
Manuscript Library, Yale
University, Bequest of Sinclair
Lewis to the collection of
American Literature, University
Library
Exhibited: Yale
Plate 88

A Favorite Corner, 1892
Watercolor, 9½ × 14½ inches
Private collection, Courtesy
Hirschl and Adler Galleries,
New York
Plate 9

Field of Poppies, Isles of Shoals, 1890
Watercolor, 20¾ × 14½ inches
(sight)
Private collection
Exhibited: Yale
Plate 24

Flower Garden, 1893
Watercolor, 19⅝ × 13⅞ inches
Mr. and Mrs. George M. Kauf-
man
Plate 33

Flower Garden, Isles of Shoals, 1893
Watercolor, 19½ × 13½ inches
Private collection
Exhibited: Yale, Denver
Plate 34

From the Doorway, 1892
Watercolor, 21¼ × 17¼ inches
The Shearson Lehman Hutton
Collection, Courtesy Hirschl and
Adler Galleries, New York
Plate 28

Fourmaster Schooner, 1903
Watercolor, 13½ × 19 inches
The Gerald Peters Gallery,
Santa Fe, New Mexico
Plate 4

The Garden in its Glory, 1892
Watercolor, 19¹⁵⁄₁₆ × 13⅞ inches
The National Museum of Ameri-
can Art, Smithsonian Institution,
Gift of John Gellatly
Exhibited: Washington
Plate 16

Hazy Day, Appledore, c. 1890
Oil on canvas board,
7⅛ × 9 inches
Private collection
Plate 35

Hollyhocks in Late Summer, 1892
Watercolor, 17½ × 11⅜ inches
Mr. and Mrs. Brayton Wilbur, Jr.,
Courtesy Hirschl and Adler
Galleries, New York
Plate 26

Hollyhocks, Isles of Shoals, 1902
Pastel, 18½ × 22 inches
Private collection
Courtesy JoAnne Lyons Gallery,
Aspen, Colorado
Plate 20

Home of the Hummingbird, 1893
Watercolor, 14 × 10 inches
Mr. and Mrs. Arthur G. Altschul
Plate 25

In the Garden, 1892
Oil on canvas, 22⅛ × 18⅛ inches
The National Museum of Ameri-
can Art, Smithsonian Institution,
Gift of John Gellatly
Plate 18

The Island Garden, 1892
Watercolor, 17½ × 14 inches
The National Museum of Ameri-
can Art, Smithsonian Institution,
Gift of John Gellatly
Exhibited: Yale, Washington
Plate 30

Isles of Shoals, 1899
Oil on canvas, 25¼ × 30½ inches
The Minneapolis Institute of Arts,
Gift of the Martin B. Koon
Memorial Fund
Plate 58

Isles of Shoals, c. 1890
Oil on canvas, 15½ × 17¾ inches
Private collection, Philadelphia,
Courtesy Graham Gallery,
New York
Plate 46

Isles of Shoals, c. 1890
Pastel, 9¾ × 12¼ inches
Private collection, Courtesy
Hirschl and Adler Galleries,
New York
Plate 32

Isles of Shoals, c. 1890
Watercolor, 14 × 19¾ inches
Private collection, Washington,
D.C., Courtesy Hirschl and Adler
Galleries, New York
Exhibited: Yale, Washington
Plate 49

Isles of Shoals, 1907
Oil on canvas, 26 × 31 inches
The Portland Art Museum,
Oregon Art Institute, Gift in
memory of William Maxwell
Wood IV
Exhibited: Denver, Washington
Plate 79

Isles of Shoals, Sunset, 1907
Oil on panel, 6¼ × 9½ inches
Collection of Mrs. Jane R. Mayer
Courtesy Hirschl and Adler
Galleries
Plate 89

The Little Pond, Appledore, 1890
Oil on canvas, 16 × 21¹⁵⁄₁₆ inches
The Art Institute of Chicago,
Friends of American Art Collec-
tion, Walter H. Schulze Memorial
Fund
Exhibited: Yale
Plate 76

Mainland from the Isles of Shoals,
c. 1890
Oil on canvas, 12¼ × 18⅛ inches
Private collection, Courtesy Span-
ierman Gallery, New York
Plate 48

Moonlight, 1907
Oil on canvas, 25¾ × 36¼ inches
The Shaklee Corporate Art Col-
lection, San Francisco, California
Plate 81

Poppies, Isles of Shoals, 1890
Pastel, 7¼ × 13¾ inches
Collection of Mr. and Mrs.
Raymond J. Horowitz
Exhibited: Yale
Plate 31

Poppies, c. 1890
Oil on canvas, 18 × 25 inches
Private collection
Exhibited: Yale, Denver
Plate 44

Poppies, 1891
Oil on canvas, 19¾ × 24 inches
Collection of Mr. and Mrs.
Raymond J. Horowitz
Exhibited: Yale
Plate 45

Poppies, Isles of Shoals, 1891
Watercolor, 19⅞ × 14 inches
Private collection, Courtesy Keny
and Johnson Gallery,
Columbus, Ohio
Plate 36

Poppies on the Isles of Shoals, 1890
Oil on canvas, 18⅛ × 22⅛ inches
The Brooklyn Museum, Gift of
Mary Pratt Barringer and Rich-
ardson Pratt, Jr., in memory of
Richardson and Laura Pratt
Plate 43

The Room of Flowers, 1894
Oil on canvas, 34 × 34 inches
Mr. and Mrs. Arthur G. Altschul
Plate 2

Roses in a Vase, 1890
Oil on canvas, 20 × 24 inches
The Baltimore Museum of Art,
the Helen and Abram Eisenberg
Collection
Plate 6

The Sonata, 1893
Oil on canvas, 32 × 32 inches
The Nelson-Atkins Museum of
Art, Kansas City, Missouri
Gift of Mr. and Mrs. Joseph S. Atha
Plate 14

The South Ledges, Appledore, 1913
Oil on canvas, 34¼ × 36⅛ inches
The National Museum of
American Art, Smithsonian Insti-
tution, Gift of John Gellatly
Plate 105

Summer Sea, Isles of Shoals, 1902
Oil on canvas, 25³⁄₁₆ × 30⁵⁄₁₆
inches
The Toledo Museum of Art,
Gift of Florence Scott Libbey
Plate 77

Summer Sunlight, 1892
Oil on canvas, 23⁹⁄₁₆ × 19¹¹⁄₁₆
inches
The Israel Museum, Jerusalem,
Gift of Mrs. Rebecca Shulman,
New York
Plate 75

Sunset at Sea, 1911
Oil on canvas, 34 × 34 inches
The Rose Art Museum, Brandeis
University, Waltham, Mass., Gift
of Mr. and Mrs. Monroe Geller
Plate 85

Sunset Sky, 1908
Oil on panel, 6 × 8 inches
Private collection, Courtesy
Hirschl and Adler Galleries,
New York
Plate 91

Sylph's Rock, Appledore, 1907
Oil on canvas, 25 × 30 inches
The Worcester Art Museum,
Gift of Mrs. Elisha D. Buffington
Exhibited: Yale
Plate 97

West Wind, Isles of Shoals, 1904
Oil on canvas, 15 × 22 inches
The Beinecke Rare Book and
Manuscript Library, Yale Univer-
sity, Bequest of Sinclair Lewis to
the collection of American Litera-
ture, University Library
Plate 86

Childe Hassam's works of art
were accompanied by a vintage
copy of Celia Thaxter's book,
An Island Garden (Boston, 1894),
loaned by the Trustees of the
Boston Public Library.

Index

Photography Credits

Plates 2, 15: Nathan Rabin

Plate 7: Christie's, New York

Plate 9: Bill Burt

Plates 11, 21, 23, 27, 73, 74: Lloyd Rule, Denver Art Museum

Plate 13: Arvest Galleries, Inc.

Plate 19: Margaret Harman

Plates 20, 35, 48, 60: Spanierman Gallery, New York

Plates 26, 89, 90: Hirschl and Adler Galleries, New York

Plate 34: Coe-Kerr Gallery, New York

Plate 36: Keny and Johnson Gallery, Columbus, Ohio

Plate 46: Graham Gallery, New York

Plate 47: Richard York Gallery, New York

Plate 63: Malcolm Varon

Plate 67: Vose Gallery, Boston

Plate 75: Yoram Lehman, Israel Museum

Plate 76: © 1990 The Art Institute of Chicago. All rights reserved.

Plate 80: Scott McCue

Plate 85: Muldoon Studio, Waltham, Mass.

Plate 88: Regina Monfort

Plate 94: © 1990 The Indianapolis Museum of Art.

Plates 100, 103: Henry Nelson, Wichita Art Museum

Figs. 1.1–1.8, 1.10, 1.13, 1.15, 1.17, 1.21–1.23, 1.31, 2.1, 2.3, 2.6, 2.8–2.12, 3.1, 3.2, 3.4, 3.8–3.12, 3.14–3.22, 3.29, 3.30, 3.32–3.34, 3.37: University of New Hampshire

Figs. 1.12, 2.7: Helga Photo Studio

Figs. 1.16, 3.31: Sotheby's Inc., New York

Figs. 1.18, 1.20: Andrew Edgar Photography

Figs. 1.25, 1.26, 1.28, 1.30, 1.34, 1.36, 2.2, 2.13, 2.14, 3.3, 3.5, 3.6, 3.36: Denver Art Museum

Fig. 2.15: © 1990 The Indianapolis Museum of Art.

Fig. 2.19: Drawing by Warren Miller; © 1988, The New Yorker Magazine, Inc.

Fig. 3.24: © 1990 The Art Institute of Chicago. All rights reserved.

Fig. 3.26: Giraudon/Art Resource, New York.

Figs. 3.27, 3.28: Jay Hoops